Anthony Bailey is a writer and art historian. Many years on the staff of *The New Yorker*, he is the bestselling author of *Standing in the Sun: A Life of J. M. W. Turner*, shortlisted for the James Tait Black Memorial Prize; *Vermeer: A View of Delft*, shortlisted for the Whitbread biography prize; and many other books, including biographies of Constable and Velázquez.

'An engaging introduction.' Simon Schama

'An affectionate meditation on the mood, the texture and the circumstances of the painter's life and times. Bailey ... skillfully mingles his own impressions of Amsterdam today with the subject's. [He] moves, as Rembrandt did himself, from the tangible to the intangible, the material to the spiritual, the personal to the social. It is an appropriate way to look at an artist who ... immortalized his time and place.'

The New York Times

'Bailey has woven together a delightful image of Rembrandt's Amsterdam, of the people he knew, the houses he lived in, the streets he walked. It is an excellent book, easy to read, and filled with fascinating information about Rembrandt and his world.' *Washington Post*

'This is a book about Rembrandt, but about Rembrandt in Amsterdam, and it tells us the history of that city without losing track of the artist... modest, rich and sensitive. ... This is a book to read at many levels; no one should visit Holland again without it in his bag. It is a labour of love.' *The Irish Times*

'Bailey manages masses of detail, from established fact to whimsical lore, with impressive skill. It would not be so absorbing, nor so evocative, if it did not return again and again to the sensuous terms of Rembrandt's world. A literary triumph. It sets the standard for efforts to evoke the human reality of an artist of the past.'

Kenneth Baker, Boston Phoenix

Tauris Parke Paperbacks is an imprint of I.B.Tauris. It is dedicated to publishing books in accessible paperback editions for the serious general reader within a wide range of categories, including biography, history, travel and the ancient world. The list includes select, critically acclaimed works of top quality writing by distinguished authors that continue to challenge, to inform and to inspire. These are books that possess those subtle but intrinsic elements that mark them out as something exceptional.

The Colophon of Tauris Parke Paperbacks is a representation of the ancient Egyptian ibis, sacred to the god Thoth, who was himself often depicted in the form of this most elegant of birds. Thoth was credited in antiquity as the scribe of the ancient Egyptian gods and as the inventor of writing and was associated with many aspects of wisdom and learning.

REMBRANDT'S HOUSE

Exploring the World of the Great Master

Anthony Bailey

TAURIS PARKE
PAPERBACKS

*This edition is dedicated
To the Memory of John Updike,
1932–2009*

New paperback edition published in 2014 by Tauris Parke Paperbacks
An imprint of I.B.Tauris and Co Ltd
6 Salem Road, London W2 4BU
175 Fifth Avenue, New York NY 10010
www.ibtauris.com

Distributed in the United States and Canada Exclusively by Palgrave Macmillan
175 Fifth Avenue, New York NY 10010

First published in 1978 by Houghton Mifflin, Boston, USA, and J. M. Dent, London

Cover image: *Self-Portrait While Drawing*, 1648 (etching) (b/w photo), Rembrandt
Harmensz. van Rijn (1606–69) / Musée de la Ville de Paris, Musée du Petit-Palais,
France / Giraudon / Bridgeman Images.

ISBN: 978 1 78076 924 0
eISBN: 978 0 85773 783 0

A full CIP record for this book is available from the British Library
A full CIP record is available from the Library of Congress

Library of Congress Catalog Card Number: available

Printed and bound in Great Britain by Page Bros, Norwich

Contents

Illustrations

A Note of Thanks

I AM GRATEFUL to many people who helped me in the course of writing this book. They include Stewart Richardson, Hans Koning, Mr. and Mrs. Ton Koot, Gerda Rubinstein, Renate Rubinstein, Peter Vos, Professor Charles Wilson, Professor Jan van Wessem, Bob Haak, Professor Dr. Arie Querido, Ir. R. Meischke, Geurt Brinkgreve, Dick Baas Bekking, Gay van der Meer, S. A. C. Dudok van Heel, Margaret Clouston, Professor Dr. R. W. Scheller, Peter Schatborn, Mr. and Mrs. Jon Swan, Nigel Konstam, Dr. Alice Clare Carter, J. A. van Alphen, Michiel Jonker, Dr. Katharine Fremantle, Eva Ornstein-van Slooten, P. van Oordt, Benno Groeneveld, C. J. Fox, Cecile van Oosterwijk, Frances L. Apt, Robert Cowley, and, most particularly, Margot Bailey.

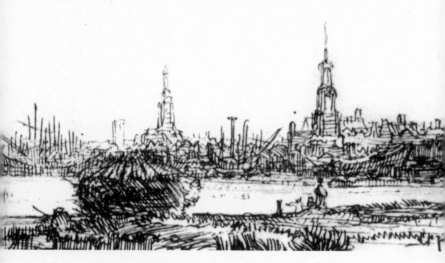

'I delight in a palpable imaginable *visitable* past — in the nearer distances and the clearer mysteries, the marks and signs of a world we may reach over to as by making a long arm we grasp an object at the other end of our own table. The table is the one, the common expanse, and where we lean, so stretching, we find it firm and continuous. That, to my imagination, is the past fragrant of all, or of almost all, the poetry of the thing outlived and lost and gone, and yet in which the precious element of closeness, telling so of connections but tasting so of differences, remains appreciable.'

Henry James: Preface to *The Aspern Papers*

'Besides, this country inspires me. I like these people swarming on the sidewalks, wedged into a little space of houses and canals, hemmed in by fogs, cold lands, and the sea steaming like a wet wash. I like them, for they are double. They are here and elsewhere.'

Albert Camus: *The Fall*

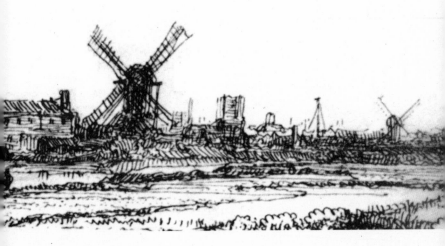

Antecedents

I AM SITTING in the little room that forms the entire ground floor of the back extension of a house in Amsterdam. I have this room for a month. It is, in fact, not on the ground but a few feet above it, with three wooden steps leading up to it from the small courtyard at the rear of the house. The door is made of four vertical planks and three crosspieces holding it together, with the scribbles of an eighteenth-century carpenter just visible on it (upside down, for the door was turned head to tail when it was rehung at some point). Two casement windows, each with twelve panes of glass, some white, some slightly greenish, are set high in the wall. I can look out through them on the courtyard, which is little more than a well among the surrounding buildings. This house was built in 1685 and fronts a canal, with a roadway along each bank, known as the Oude Zijds Voorburgwal. The houses at the back of the courtyard face the Oude Zijds Achterburgwal. The names describe the position of the canals on either side, back and front, of the medieval city wall, an earthen rampart long ago beaten down to form a site for houses. The inner walls of my room are of rough white plaster interrupted by massive woodwork: oak sills, exposed beams and uprights, all painted a glossy reddish-brown. The furniture is simple: bed spanning the width of the room, straw mat, lamp, chair, and table under the window.

The woman who owns this house, a friend of friends, says that the one drawback to the room is noise. A nightclub, casino, and maybe brothel has opened in the building that backs onto the courtyard. Exotic night life, once centered on the Zeedijk, is slithering along this section of the Voorburgwal and Achterburgwal. But last night, although I heard a jazz band playing for an hour or so after midnight, the train and boat journey from England had tired me so that I slept fairly well. If I woke now and then to the bells of the Oude Kerk chiming the hours, halves, and quarters, it was with the feeling of being carried back in time and not just having

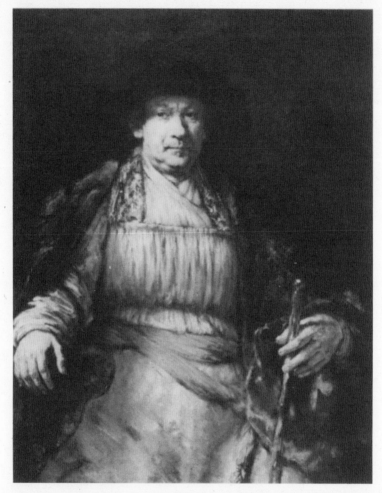

Self-Portrait. *Painting, 1658. The Frick Collection, New York*

the forward motion of time brought to my notice. The bells are a nice sound I shall
get used to, as I presumably also will to the sound of my landlady's wooden-soled
sandals on the floor of her kitchen overhead, and a sort of *flomp*, which may be
one of her cats jumping down from a chair, and a gurgle of waste water running
through the exposed pipes, which are like those in a basement room I once rented
in Morton Street, New York.

I feel fortunate, but a bit queasy too, as one can be when circumstances suddenly make possible a long-brooded-on venture. Twenty years ago, armed – after a brief inquiry in the catalogues – with the information that there was no up-to-date life of Rembrandt for the general reader, I proposed myself to an uptown (from Morton Street, in Greenwich Village) New York publisher as the author of such a work. Why yes, he said, giving me an advance so small it is now clear that, although he would have been pleased to get a book from the arrangement, he wasn't counting on it. But my enthusiasm was large. Perhaps no young Dutchman, crammed with Rembrandt at school the way we in England and America are with Shakespeare, say, or Abraham Lincoln, could have felt the same way. However, living in Manhattan for the first time, walking up and down the avenues, I was in a new world, discovering, as if no one had ever discovered them before, such places as the Frick Collection, at Fifth and Seventy-first, with guards like retainers, few visitors, the sound of water splashing gently in the covered courtyard, and a private, muted comfort, making it a perfect place to get over a hangover from a party or name as a spot to meet a girl.

And there was Rembrandt. Wherever one stood in that long, rectangular room of the Pennsylvania coal baron's mansion, his gaze had to be met. An ornate table stood in the center of the room, roped off with velvet-covered cords and making it difficult to find the right distance for receiving that stare, that resolutely level look with which he had addressed himself in a mirror to one side of his easel. The look now seemed to fall halfway between himself and the spectator – in this case, me, full of blurred ambitions and half-formed ideas, finding it hard to discover the balance between what I thought I ought to be doing and the impression I could make, not always with full conscious control, by words on paper or in speech to the young woman I was standing there with. In that self-portrait, painted in 1658, when he was fifty-two, Rembrandt was evidently a man who had found such a balance: the need to describe himself and the duty to be himself had become one.

I married. I met a girl who was English in a bar on Hudson Street, and took for a good omen the name of the English navigator who had sailed for the Dutch; she also had had a Dutch boyfriend, so I assumed she knew some Dutch. We returned to England for the blessings of family and clergy and then went on a roundabout honeymoon. Getting off the Blue Train in Nice, I left my briefcase in the overhead rack, and off toward Italy went all my notes and a draft of five chapters of my Rembrandt biography. Despite daily forays to the police station and railway station we received no news of it while we were there or, next, in Switzerland, but, courtesy of various European railways, it came unaccompanied from Ventimiglia, on the Franco-Italian border, where it had been found, and joined us in Amsterdam.

We stayed in a small, family hotel in the Beethovenstraat, in the 1930s "new south" section of the city. This was the location offered to us by the municipal hotel bureau at the Central Station, and a twenty-minute tram ride back into the old city, but we stayed there for three rainy, happy weeks. We walked along the canals and watched the wet leaves fall on their own reflections. I talked to people and wrote a piece about the city, then beginning to recover its old spirit twelve years after the end of the war but not forgetting what it had been through. Some evenings at the hotel we played chess, Margot assisted by the proprietor, and I by a gloomy Panhard salesman. Some days we went looking for Rembrandt. We visited the Rembrandt House, where he had lived for twenty-one years, and were, like many who went there, disappointed to find little of the atmosphere of a seventeenth-century house. We sat during many afternoons in the Print Cabinet and Library of the Rijksmuseum, where I read books and articles and Margot copied (it was a labor of love) some of the Dutch documents, *Die Urkunden*, that Hofstede de Groot, a former director of the Rijksprentenkabinet, had published in 1906 – all the written evidence then known to relate to Rembrandt.

Although my wife's knowledge of Dutch turned out to be, like mine, scanty, I hoped that back in the cheerful two-and-a-half-room New York apartment we were to move into, west of Central Park, we would slowly translate them. Unfortunately, it wasn't long before I discovered – what devious or at least snobbish scholars don't tell you in their learned bibliographies, full of Dutch and German titles – that *Die Urkunden* are also in English, as part of Volume 8 of Wilhelm von Bode's *Rembrandt*, translated by Florence Simmons and published in Paris in 1906 – a volume I came across by way of the art room of the New York Public Library. And it wasn't much longer before I decided that my "brief life," three-quarters done, was wooden, stilted, and making use of the last dash and comma of my notes – not, as it ought to, taking off from them. I put the manuscript and notes in a cardboard box and went on to other things.

Yet – while slowly learning how to tackle in writings of various lengths the difficult task of fitting one's chosen theme and enthusiasm to the right form – the early passion never died. We came back several times to the Netherlands, first with two children for a month or so, then with four children for a longer stay. By way of my admiration for its most famous painter, I acquired a fondness for close-packed brick towns, gables and steeples, canals and lakes, high skies and extensive horizons, and for the Dutch scale of things. The country got into many things I wrote: my first, picaresque novel ended in Holland; a poem I began to write because of the Hungarian revolution of 1956 became a poem to do with the maps of Europe that hang on the walls of rooms in several Vermeers. I wrote about a voyage

by sailing boat through Friesland. I wrote a book about crowdedness and planning the tight fit that is modern Holland. I produced to a deadline a "concise history" of the Low Countries, the specifications for which demanded due proportions of Belgium and Luxembourg, and which duly proved more difficult to write than I had expected because previous historians had made a point of treating the Netherlands and Belgium separately, at least from the time of their separation by arms in the late sixteenth century; and indeed one also got the impression that modern Dutch and Belgian historians were talking of quite different places when discussing the earlier period, when their countries had been one, or under one ruler.

In any event, I decided not long ago that it was now or never as far as the Rembrandt book was concerned. The project had never been quite given up; wherever we lived, the cardboard box sat in a corner of my study, and once in a while I would put relevant clippings or notes in it. Wherever I traveled, I dropped into museums and spent longest with the Rembrandts. Whenever I was in New York, I revisited the Frick and repledged my allegiance. Sometimes, taking a breath between other subjects that demanded my attention, I would sit down in a library and read the latest work on Rembrandt. In twenty years, Rembrandt being Rembrandt and I not the only person in the world to be bowled over by his work, numerous books have appeared. Some, like Bob Haak's large and splendidly illustrated *Life, Work and Times*, and Christopher White's more modest but also informative *Rembrandt and His World*, covered much of the ground I had once meant to cover. But in the last few months, reading and adding to my old compost heap of research, I failed to find a book that brought together in one place all I wanted to know about Rembrandt; that put his feet on the ground in his own time and country; and that fitted the facts into a way of looking at and thinking about his work that struck me as invigoratingly just. In some books by brilliant art historians, language and method are such as to make their studies accessible only to other art historians; others fail in the prime task of a historian, which is to evoke the spirit of an age. Reading Johan Huizinga's essay on Spengler and H. G. Wells, "Two Wrestlers with the Angel," I noted his indictment of the German writer: "He is not concerned with men as they live in history. For what he utterly lacks . . . is love. Throughout his book there is not a note of kindness, nothing of piety or devotion, nothing of the still heart, nothing of hope."

I decided to make a personal reconnaissance of Amsterdam, back to Rembrandt's time and particularly to the years surrounding that self-portrait in the Frick. I had my old devotion. I went – who knows whether with a still enough heart? – but I went with hope.

I

Miraculous Country

THE MUSIC from the nightclub comes in waves. Last night it was piano and drums, with a crescendo and final crash around one-thirty. In the morning Renate, my landlady, waters the flowers that are planted in big wooden boxes in the yard, and then a cleaning woman comes with bucket and brush to scrub the paving stones, neither of them at all conscious of the fact that they are doing what mistress and servant do in seventeenth-century Dutch paintings. Pieter de Hooch might be amused by their modern costume, but would find in other respects a remarkable continuity of domestic things.

On my first brief expeditions out into the neighborhood, I am impressed by the patience with which a line of cars waits behind a van unloading at a workshop on the Oude Zijds Voorburgwal. The carriageways are narrow on either side of the canal, with workmen in some places relaying the brick footpaths on sand, and pedestrians squeezing between the stalled cars. The Oude Kerk, under repair, is surrounded by scaffolding, and two bridges being completely rebuilt in traditional style with brick and stone arches attract a small band of spectators, who quietly watch the numbered stones being chiseled and cemented into place. At night, even as twilight falls, the Oude Zijds Voorburgwal perks up. Neon lights in the sex shops and porn emporiums flicker red and pink and purple. Girls appear in the ground-floor windows between the offices and dignified still-residential houses, wearing hot pants, black stockings, and stiletto-heeled shoes – whether staring out, smiling enticingly, demurely reading a magazine, or doing a crossword puzzle, pink-lamplit

from within. The Oude Zijds Voorburgwal at this hour draws solitary men who stroll along looking preoccupied, as if they were going *somewhere*. It is also full of tour parties – bands of smirking and giggling Germans, French, Italians, English, and Americans, who have earlier in the day done the Keukenhof tulip gardens, the Rijksmuseum, and perhaps the Rembrandt House, but have for the moment abandoned their long-distance buses and glass-topped canal boats, and are now being paraded around this naughty section of Amsterdam by efficient-looking girl couriers – a sort of night watch. The girls in the windows look glumly out and the tourist hordes look in. Elderly couples in lederhosen or denims jam into the shops selling dirty films and erotic gadgetry, just browsing. Tourism is surely God's answer to sin – it makes it banal, uninteresting. But when the window-shopping tourists have gone back to their budget-hotel beds and the disco music or click of roulette wheels sounds through the old walls, the girls in the windows seem to recover their confidence, the girls in the doorways decide it isn't a waste of time to utter some soft come-hithers, and a few real customers are taken in. (Renate says the girls also do a steady but inconspicuous trade at midday, during the office lunch hour.)

It is, in any event, a traditional aspect of Dutch life. In 1688 the English consul in Amsterdam was told that brothels in the guise of music halls were tolerated by the city fathers because returning seamen were "so mad for women, that if they had not such houses to bait in, they would force the very citizens' wives and daughters." Much the same reasons are given today if one asks why the burgomasters and councilors allow this porn/pop profusion to spread across the old city. Without it, they say, all the Turkish, Yugoslav, Moroccan, and Surinamese immigrant workers would be roaming the streets and raping the shopgirls and secretaries of Amsterdam. Of course, a few add honestly, now as then it is all trade and turnover for the city, money coming in. And perhaps both the porn shops and the picture-window prostitutes are no more harmful than the forthrightly coarse village romps and tavern orgies that are recorded in seventeenth-century paintings by Adriaen van Ostade and Jan Steen, the men in codpieces, with their hands in women's plackets.

To people arriving here in the mid-seventeenth century, there were plenty of other reasons for thinking the country Rembrandt had the fortune to be born in was a weird and wonderful place. The country itself was scarcely a nation. The group of seven "United Provinces" that had come together in the struggle against Spanish rule was, as Henri of Navarre called it, a "miracle." This tiny country, at the most 150 miles long and 90 wide, and a good deal of that under water, had suddenly emerged as a European power. A few million people, aided by

geography, obstinacy, and courage, had achieved their independence, and now dominated the maritime trade of Europe and managed much of its finance. The country had a form of government that was oligarchical mixed with republican, unique when compared with the surrounding monarchies. The northern provinces attracted people from the south who didn't want to go on living in a Catholic state. The Calvinist supremacy in the north, though in many ways doctrinaire, allowed in practice a toleration of many religions, sects, and types of worship, and particularly in Amsterdam, which had captured much of Antwerp's trade and whose prosperity – its ruling class believed – would be sustained by the continued immigration of merchants and professional men from elsewhere. It was a time of general war and religious persecution in Europe: the oppression of Jews in Spain and Portugal and of the Huguenots in France; the Thirty Years' War in Germany. In Leiden, early in the century, the Pilgrim Fathers Brewster, Bradford, and Robinson, and their followers, found refuge for several years before taking ship to the New World. Royal exiles like Charles II and scholars like the Czech teacher Comenius were taken in. Sir William Temple, English ambassador to the United Provinces from 1668 to 1670, put it well in the *Observations upon the United Provinces* he wrote on his return home:

> The long Civil-Wars, at first of France, then of Germany, and lastly of England, serv'd to encrease the swarm in this country, not only by such as were persecuted at home, but great numbers of peaceable men, who came here to seek for quiet in their lives, and safety in their possessions or trades; like those birds that upon the approach of a rough winter season, leave the countries where they were born and bred, fly away to some kinder and softer climate, and never return till the frosts are past, and the winds are laid at home.

English travelers, with a keen sense of discomfort, were impressed by "communications," as they would now be called, in the Dutch Republic. John Ray, an eminent English naturalist of the time, was fascinated by the locks on the canals – into which water was pumped by windmills, helping to drain the soggy ground, and which also provided a safe way of getting from one place to another. Canal boats called *trekschuiten* carried passengers between the towns of Holland, and after 1630 or thereabout were drawn by horses; it had taken half a dozen men to haul them hitherto. (Sir William Temple was told that a horse could draw on a canal fifty times the load it could pull on land.) Going from his hometown of Leiden to Amsterdam, Rembrandt had a choice of route, traveling by horse and wagon on

the road that wound through the marshes, with a ferry ride across the Brasemer-meer, or by boat across the Haarlemmermeer, whose short choppy waves could, in gusty weather, drench you as well as any sea. John Ray noted in Rotterdam that a *trekschuit* left for Delft every hour during the day, on the ringing of a bell. The voyage took two hours, and a further hour from Delft to The Hague. A *trekschuit* journey could be pleasantly companionable. Song books were provided, and choruses rose as the boat was tugged along, past cows munching grass in the low meadows, windmills turning in the wind that rarely ceased, past isolated farm house, barn, and surrounding clumps of trees, and with views of distant towns, red-brown among all that green, to which one's eye was drawn by a church tower, interrupting the otherwise flat horizon under a great expanse of sky.

Yet the manners of the people took some getting used to; "boorish," a word derived from the Dutch for "farmer," might well be used for them. "The common people of Holland," said Mr. Ray, "especially inn-keepers, waggoners (foremen they call them), boatmen and porters are surly and uncivil . . . the Dutch men and women are almost always eating as they travel . . . the men are for the most part big-boned and gross-bodied." As for Dutch cuisine, "gross" was a term that John Ray used again, as well as "foggy." Meat and drink were relatively dear because of excise taxes. "Milk is the cheapest of all belly-provisions. Their strong beer (thick beer they call it, and well they may) is sold for three stuivers the quart, which is more than three pence English . . . The first dish at ordinaries or entertainment is usually a salade, *sla* they call it, of which they eat abundance in Holland. The meat they commonly stew, and make their Hotchpots of it." Ray missed puddings and wasn't consoled by plenty of boiled spinach with butter or currants in it, by the availability of codfish, called *cabalau*, and pickled herring. In most inns you were served with thin slices of hung beef on buttered bread and a choice of cheeses, including the well-known Edam, cumin-seed cheese, and a green cheese, "said to be so-colour'd with the juice of sheep's dung." Nor was Ray keen on the many chiming bells to be heard in Dutch towns; "troublesome in their frequent jangling," he thought, after a sleepless night.

In most inns a traveler would probably have to share not only a bedroom but the bed. Samuel Pepys, staying in The Hague overnight in 1660 while on the mission to collect Charles II, supped on mutton and *sla* and shared a bed with a judge advocate; he also found a bookshop, where he happily bought three books for "the love of the binding."

The Dutch and the English had a lively, loving and quarreling relationship through a good part of this century, springing partly from the fact that under their dissimilarities they had much in common. They were both beer-drinking, trading,

expanding nations, proud of their ability to handle ships and make money, having Protestant sympathies and joint inclinations to distrust the King of France. In these two countries alone in Europe could be distinguished a mobile, venturesome middle class – and this made for a spontaneity in other fields of endeavor, in science, industrial technology, and art. The United Provinces provided a safe haven for English as well as for other nationalities, whether for Puritan ministers or for a Stuart king (Charles II's family became connected in marriage with the Dutch House of Nassau). Young English gentlemen studied medicine at Leiden University. Nautically minded English youths were sent to sea school and navigation classes in Amsterdam; the charts English ships used were called "wagoners," after the Dutch mapmaker Wagenaer. Packet boats sailed daily between the two countries, and in good weather it was easier to get to Rotterdam from London than it was to many English provincial towns, like Exeter and York. People were constantly traveling back and forth on errands of commerce, politics, religion, and scholarship. The Dutch sent engineers to drain the English fens; their men of science were welcomed as Fellows of the Royal Society. The Dutch taught the English how to starch cloth, to speculate on stock exchanges, to make new kinds of tiles, fabric, and furniture, even how to clip hedges in new ways and how to run a national economy.

Many artists at this time moved between the two countries as their business dictated, or simply for the purpose of seeing what was being done elsewhere. Michael Austin of London, in April 1613, apprenticed his son Nathaniel to the Amsterdam painter Jan Teunissen. Daniel Mijtens, born in The Hague, had the reputation of being the best portraitist in London before the arrival of van Dyck in 1632. Hendrik de Keyser, the Dutch architect, brought back from a trip to London ideas for his Amsterdam Stock Exchange, erected between 1608 and 1611; and then the influence returned: English architects were impressed by Dutch design. Christopher Wren's assistant at Hampton Court was a Dutchman, Willem Talman. The towers of the Zuiderkerk and Westerkerk were echoed in Wren steeples all over London; the sash window seems to have made the trip from Holland to England via Wren; and many English houses went up in Dutch style and often in brick imported from Holland. As for literature, the ties were close. Constantijn Huygens, the diplomat and early patron of Rembrandt, translated John Donne into Dutch (and also received, as many Dutchmen did, a knighthood from the English king). Milton's *Paradise Lost* was not only somewhat influenced by Joost van den Vondel, the Dutch poet and playwright, but similar in its contemporary reaction against Calvinist orthodoxy and the doctrine of predestination. Milton joined Vondel and Hugo Grotius, the great Dutch legal writer, on the side of free will.

There were Anglo-Dutch families as well as Anglo-Dutch wars. Grinling Gibbons, the woodcarver, was born in Rotterdam of English parents. The Amsterdam poet Jan Janszoon Starter and the painter Cornelius Jonson van Ceulen were both born in London. One of the commissions Rembrandt undertook during his first years in Amsterdam was to paint the portraits of Joannes Elison and his wife. Elison was born in England around 1581, studied theology at Leiden University, and in 1604 became minister of the Dutch Reformed Church in the East Anglian town of Norwich. He and his wife were in Amsterdam for more than a year in the 1630s, probably staying with their son Joannes the Younger, who had his parents' portraits painted as vivid keepsakes for himself and Elison descendants.

The effect of Dutch art, bought by English collectors from the king down, and brought to England in person by numerous painters, was longlasting. It impressed not only seventeenth-century English painters but, afterward, Gainsborough and Hogarth, Turner and Constable, Cotman and Crome. Sir Thomas Lawrence and Turner owned in turn a Rembrandt drawing of the banks of the Amstel River (which Edmond de Rothschild bought in Amsterdam in 1913 for the then vast sum of 22,200 guilders and bequeathed to the Louvre).

The Dutch passion for pictures was noted by English visitors – though not, curiously enough, by the otherwise sharp-eyed Sir William Temple. In Dutch paintings of domestic interiors, house walls are often covered with pictures. Peter Mundy, an English traveler, observed in Holland in 1640 that the people were "all in general striving to adorn their houses, especially the outer or street room, with costly pieces." And not just the bourgeoisie. Mundy wrote, "Many times blacksmiths, cobblers etc., will have some picture by their forge and in their stall." John Evelyn, making the Grand Tour, was struck by many pictures for sale at Dutch markets and fairs – pictures that were not expensive, but could be bought by craftsmen and farmers as well as by wealthy merchants. Evelyn thought the Dutch were in those prosperous times buying art for investment, but perhaps it was more generally the case that many people were now aware of beauty, whether in natural or man-altered landscape, in arrangements of flowers, interiors, and the human form, and wanted it seized in paint by their painters.

Certainly Sir William noticed the beauty of Dutch towns, the walks, canals, and public buildings that the citizens were willing to help pay for. Holland was an urban country even then: a majority of the people of the western province lived in the horseshoe ring of towns that ran from Dordrecht to Utrecht. Here the calm of meadows and lakes, of dunes and beaches, was joined by a boisterous and bustling city life, itself nonetheless accompanied by a concern that energy and expansion should not result in a disagreeable fabric. And just as Holland was the province

that provided most of the gusto and revenue to the republic, so Amsterdam was the city that gave most imagination, impetus, funds, and fire. Rembrandt had no say in being born in Leiden on July 15, 1606, but he made a choice twenty-five years later, when he decided to move to Amsterdam.

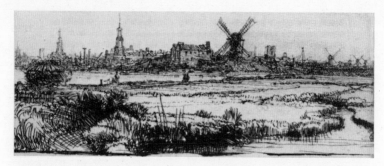

View of Amsterdam. *Etching*, c. *1640. Courtesy of the Trustees of the British Museum*

II

The Golden Swamp

I WALKED this afternoon to the street where he lived for the greater part of his working years. This takes, as it did in the seventeenth century, about fifteen minutes from the Dam, the square in front of the Town Hall in the city center. It is like heading outward from the heart of a tree, crossing the annual rings that in this case are canals. A few minutes beyond the Achterburgwal is the Nieuwmarkt, now an open space overlooked by the Waag – a medieval gatehouse in the then city walls that has been in turn a weigh house for ships' cannon and municipal armaments, a meeting place for professional and artisans' guilds, a furniture warehouse, and (now) a Jewish Historical Museum. The Nieuwmarkt is a flaw in the concentric ring pattern, a knot from which several streets radiate. The chief of these is the Breestraat, "Broad Street," whose first section is still called what it was in Rembrandt's day, St. Anthoniesbreestraat. St. Anthony is the presiding saint in this part of the old city. The Waag had been the St. Anthony's Gate. The St. Antoniesbreestraat ran from the Nieuwmarkt to the St. Anthoniesluis, a bridge and lock at the junction of two canals, the Zwanenburgwal (called Verwersgracht in the seventeenth century) and the Oude Schans, and then out along the St. Anthoniesdijk to what were the outer ramparts of the city in Rembrandt's time. There, at the St. Anthoniespoort, the road followed the dike toward the villages of Diemen, Weesp, and Muiden on the south shore of the Zuider Zee. Between the *sluis* and the *poort* the street was, from the late seventeenth century, called the Jodenbreestraat, because it had by then become the main thoroughfare of the Jewish quarter.

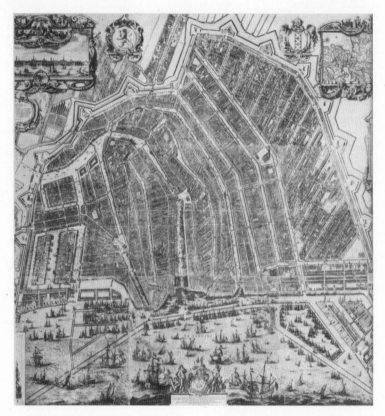

Map of Amsterdam by Balthasar Floriszoon van Berckenrode. 1647.
Amsterdam City Archives

The names of other streets in the city – Zeedijk, Nieuwendijk, Haarlem-
merdijk – describe their location on dikes made to keep the water out. Amsterdam
is a city of islands in a swamp, a medieval fishing hamlet at a dam on the Am-
stel River that, spreading and succeeding, has been formalized into canals and
sandbanks, dikes and building terrain, squares and streets. The form the city has
marvelously managed to retain was established for the most part during Rem-
brandt's childhood. Until the end of the sixteenth century a canal called the Singel,
meaning "girdle," had enclosed the town, but by 1610 it had already been broken
through in the direction of the Breestraat, and the burgomasters – feeling the

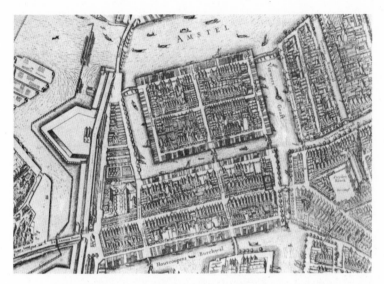

Detail of van Berckenrode's map, showing Rembrandt's neighborhood.
Courtesy of the British Library, London

pressure for more room – produced an expansion plan (perhaps drawn by the municipal carpenter, Hendrik Staets).

The designer certainly deserves a place among the Dutch masters of the seventeenth century. The plan called for three new semicircular canals, one outside the other, to extend and define more regularly the fan shape of the city. The canals were named rather fancily, the Emperor's Canal, the Princes' Canal, and the Gentlemen's Canal, but any airs that Amsterdam gave itself, in this respect, it worked for and deserved. The plan was stuck to over the next half century as the city grew. The canals were dug by hand; mud, silt, and sand piled up onto the banks; new bridges, quays, and city walls built, as the old ones were knocked down, with twenty-six bastions and six gates with gatehouses. On the margins of the old city center the city council, with compulsory powers, purchased old houses, which they demolished to make way for new ones. Fields and vegetable gardens outside the walls were gobbled up for building sites, and new allotments had to be found farther out. On the new semicircular canals were erected the finer houses, and on the streets and lesser canals between rose warehouses and residences less grand. In 1650, work on the three great canals was roughly half-complete; the city's population was more than 150,000, and still rising fast. The expansion of the city

in the generation before midcentury can be seen by comparing the splendid map drawn by Balthasar Floriszoon van Berckenrode in 1625 with the updated edition of twenty-two years later.

Walking through Amsterdam one saw building activity everywhere. The basic material was small, dark red bricks. Blocks of white stone formed the reveals of windows and the door surround. Stone plaques set in the façade gave the name of the house or the date it was built and sometimes depicted a proverb, a scene from the Bible, or illustrated some aspect of the life or occupation of the owner. Sometimes there were mottoes; for example, "I shall be true. I shall not waver." The doors and wooden shutters were generally varnished or painted red and green. The basic effect was friendly (and still is). The bricks were warm. Each of the small panes of glass caught the light. The varnished woodwork shone, and the stone sills and steps showed the bright effect of daily scrubbing.

An Englishman named Bargrave was impressed by the numbers of masons' yards as he wandered around the city in 1653. But the products of these establishments were not only for houses. Hundreds of workmen were hewing stones for the new Town Hall on the Dam. In the yards near the harbor and along the Houtgracht, behind the Breestraat, were stored great quantities of Scandinavian timber brought in by sea for scaffolding and pilings. Together with the sounds of stone being drilled and chiseled and wood being sawn were added the thuds of these piles, "great masts," as John Ray called them, being driven into the ground to provide a safe foundation for new buildings; the Dutch came to call them *juffers*, which is to say "young ladies" – perhaps because of their upright bearing, though they are surely not beautiful. When Caspar Barlaeus, also a Leiden man, moved to Amsterdam in the 1630s to help found the new Athenaeum Illustre (which became the University of Amsterdam in 1877), he made an inaugural address in Latin lauding the city's churches, towers, sluices, markets, bridges, ships, and tolerant spirit (he was a liberal Calvinist who had been forced to leave his job in Leiden), and added, "I consider it no small thing that I have moved to a city that floats amid swamps and marshes, where the burden of so many buildings is held up by forests of wooden pilings, and where decaying pines support the most prosperous mercantile center in Europe." In fact, where the water level of Amsterdam is properly maintained, the piles last. For the foundations of the new Town Hall were driven in 13,659 *juffers* – a number Amsterdam school-children know by heart (and remember easily by taking the days of the year and sandwiching them between a one and a nine) – and when one piling was removed in 1937 for testing (so there are now 13,658), it was found to be in perfect condition.

Because the piles cost money, and it was an expensive business to set up pine tripods with iron-shod oak pile-driving weights hauled aloft by perhaps thirty men to sock the *juffer* again and again another few inches into the ground, and then bridge over the sixteen or twenty piles needed for an average house before construction could begin, land and foundation costs were high; they represented a much larger proportion of house prices than elsewhere. Houses were therefore built that occupied little ground – narrow-fronted, with their elbows well tucked in, but rising high and even leaning forward, so that the upper stories had more floor space than those at the bottom. And few Amsterdam builders worth their salt were satisfied with a simple culmination at the top. There had to be a gable, concealing the roof and made in the shape of a bell, a spout, an inverted funnel, a neck, or like steps of one sort or another. As the century wore on, increasingly decorated types of each species appeared with superimposed carvings, cornucopias, cornices, and balustrades.

Practicality remained, however, in a beam that invariably jutted forth from the gable. A block and tackle was fastened to this beam for lifting or lowering furniture; the staircases within were far too steep, twisting, and narrow. The fact that many houses tilted forward helped the furniture rise or fall without bumping against the façade – though whether the houses were built leaning forward for this reason, for more space at the top, in order to keep rain off the windows (which didn't all have glass in them), or simply for aesthetic reasons, to make it seem from ground level that the house was standing up straight, counteracting the usual impression one has that an upright house is leaning backward – no one is sure. Because piles have decayed from drying out or have sunk, many houses in Amsterdam end up tilting anyway, and have to be kept from going any farther by expensive injections of concrete, by new pilings put in in sections, or by unsightly buttresses of timber jutting out onto the roads and sidewalks.

Rembrandt moved to Amsterdam because it was the best place in the Netherlands to make a successful career, and of course this was why many others came, causing the city to burst at the seams. Country people were even then deciding they would rather live in towns, and preferably in Amsterdam. Modern research in the marriage registers of midcentury has shown that more than 50 percent of bridegrooms married in Amsterdam were born outside the city. With the birth rate and death rate roughly equal, the growth of the city depended on new arrivals. Most immigrants from "abroad" came from the southern Netherlands (some 60,000 Calvinist southern Netherlanders moved north), but others came from Germany, eastern Europe, Huguenot France, and England – like Jonas Harwood, one of the

deacons of the English Church in Amsterdam, who worked as an agent for English firms in hiring and buying ships. Some, like Isaac de Pinto, a Sephardic Jew, arrived already wealthy; some, like Comenius, arrived already famous. New churches were built in new districts for Walloons and Jews, and semisecretly, hidden in ordinary houses, for Catholics. Among the sounds of the city, church tower bells and workshop noise, market cries and clomp of wooden shoes, were the sounds of different languages. Dutch might well be the lingua franca of the Baltic, which was dominated by Dutch shipping, but in Amsterdam, with one resident in four hailing from abroad, all manner of languages contributed to the feeling one had of being at the hub of the universe, or in a melting pot. Some English people who lived in Amsterdam for a long time developed a hybrid way of writing, half-English and half-Dutch, putting two dots over a *y* and spelling "coster" with a *k*.

Amsterdam was thus a cosmopolitan city, to which new arrivals added their skills and energy. It was the center for northern European trade in many commodities, particularly grain. Constantijn Huygens called the city "the golden swamp." The city paid half of Holland's contribution to the revenues of the States General of the United Provinces – and Holland paid 56 percent of the total. The city's wealth came from commerce with the East, for dividends of the East India Company, which brought back the produce of Java, Ceylon, Malacca, and Formosa, generally ran between 25 percent and 40 percent, in a "bad" year sinking to 12.5 percent. The slave trade brought great profits to such Amsterdam families as the Coymanses. The Amsterdam merchants traded even with their enemies, selling weapons and ammunition to the southern Netherlands, Spain, the Dunkirk pirates and Barbary corsairs. Trade created new industries; shipping demanded makers of maps and bakers of sea biscuit. A great bank and a busy Stock Exchange grew to accommodate the demand for money, the desire to invest, and the need for capital. Refugees arrived penniless and found the streets golden. Frans Banning Cocq, the aristocratic-looking fellow who so splendidly leads forth his militia company in Rembrandt's big canvas of 1642, the so-called *Night Watch*, was the son of a German pauper who started his Dutch life begging in Amsterdam but soon made a fortune and a successful marriage. Young Frans put his mother's name in front of his father's, and eventually acquired an English baronetcy.

The city's atmosphere was felt by newcomers as in more than one sense profitable. René Descartes, the Jesuit-educated French gentleman whose private income gave him the freedom to do what he wanted – be a volunteer officer in the Thirty Years' War, dissect animals, or live in Holland working on innovations in geometry and philosophy – wrote to a French friend from Amsterdam in 1631:

If there is pleasure in seeing the fruits of our orchard grow, don't you think there will be just as much in seeing ships arriving here, bringing us in abundance all that the Indies produce and all that is rare in Europe? What other country could one choose where all the conveniences of life and all the exotic things one could desire are to be found as easily? Where else could one enjoy a freedom so complete?

Descartes recommended one particular Amsterdam freedom, a lack of "little neighbors, who [at home] sometimes come to bother you, and whose visits are even more troublesome than would be the case in Paris. Instead, here I am in a great town, where everyone, except me, is in business, so keen are they on making a profit, and I could live here my whole life without ever seeing anyone. I walk daily in a great throng of people . . . "

Rembrandt walked in this throng when he came up to Amsterdam for his first extended stay, in 1624 or 1625, to study for six months with Pieter Lastman. Lastman, a fairly successful painter of historical and Biblical pictures, done in a manner reflecting a stay in Italy, lived in the St. Anthoniesbreestraat, just behind the Zuiderkerk. The tower of the Zuiderkerk is one of the landmarks of this neighborhood; the other, a few hundred yards away up the Oude Schans canal, is the Montelbaan Tower, one of the ornamental towers the architect Hendrik de Keyser was asked to design by the city council, here to improve the looks of a dumpy medieval city wall bastion. (The tower is now the spot from which the city water board keeps an eye on "Amsterdam level," the watermark by which the country decides whether it is going to have to sink or swim.) De Keyser got this commission because the city fathers thought well of the Zuiderkerk tower – a lofty but graceful brick structure, whose elongated wedding-cake upper stories led to an open, lead-encased wooden spire, little more than a cap with a bobble on it; fact becoming fancy with increasing altitude. De Keyser set his tower on the southwest corner of the building, where the people of Amsterdam could see its upper stages and he, living on the Groenburgwal – the little tree-lined canal that runs on the same axis as the nave of the church – could see the whole thing as he stepped out his front door.

The tower's afternoon shadow fell partly on Pieter Lastman's house. The young painter could glimpse from his master's windows the clock face and the date, 1614, of the tower's completion ten years before. The church itself was begun in 1603 and according to some architectural historians shows the uncertainty with which the architect (de Keyser or another) faced the task of designing the city's first,

from-the-start-Protestant edifice. Its three, many-columned aisles still direct the congregation's gaze toward the altar at the far end. In the Reformed Church the pulpit, and the minister speaking from it, was supposed to receive one's attention – although exactly how much attention the minister got is put in doubt by some of the marvelous paintings of seventeenth-century church interiors, done by such painters as Emanuel de Witte and Pieter Saenredam, where people talk with one another while their children play and their dogs prowl around.

While at Lastman's, the apprentice painter got to know a good deal about the city: its narrow streets, where the council tried to introduce one-way schemes and to outlaw private carriages, with varying degrees of success; the hump-backed bridges that formed obstacles for wagons and thus brought about the invention of freight sleds, which needed greased rags in places to make them go and in other places bundles of straw to slow them down. Pedestrians beware! Women with little stoves and giant pans sold hot pancakes. There were the smells of herrings, spices, molasses, beer, whale oil, pitch, and burning peat, in stoves and foot-warmers. There was the Amsterdam face, which had the look, at once watchful but confident, of people who suspected they were living in the right place at the right time. (Although to Caspar Barlaeus the faces often seemed cold and mercantile.)

Of course it wasn't all roses. Some were going down while others were on the way up. Among the new buildings the city was erecting were homes for the elderly poor, additions to the city orphanage, and houses of correction. Profits from the theater, which opened in 1638, went to support such institutions. But Amsterdam charity was by no means spend-thrift. City ordinances banned begging; in the houses of correction inmates were taught useful trades. The out-of-work were directed to jobs, when available, digging canals and erecting new fortifications. James Howell, another English visitor who wonderingly and admiringly walked around Amsterdam, said, "It is a rare thing to meet with a beggar here." Presumably he meant rarer than in England.

The prevailing prosperity rarely reached the war veterans and wounded, those whose work was seasonal or impeded by constant ill health. As a young artist Rembrandt drew beggars and other street characters; they were, in a sense, picturesque, and the French engraver Jacques Callot and the German Hans Sebald Beham had made them a recognized genre. But they were also living demonstrations of the poverty always in wait then for those whose energies faltered and whose luck ran out – walking and limping witnesses, too, of the terrors let loose on common people by warring princes, zealous bishops, and looting soldiery, and by such natural disasters as floods or bad harvests. With long rags wrapped around their feet and ankles in place of shoes, fragments of leather jerkins, and tulip hats

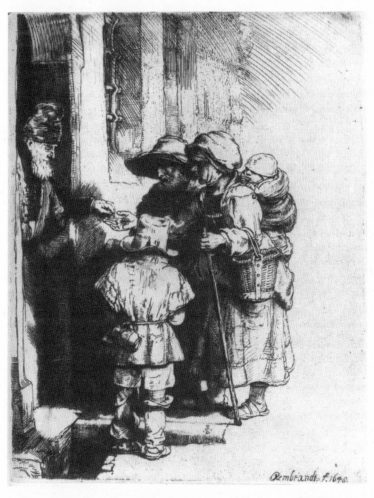

Beggars Receiving Alms. *Etching, second state, 1648. Courtesy of the Trustees of the British Museum*

that gave them a weird kinship with elves and gnomes, they seemed to spring from bad memories, terrible dreams, and to provoke anticipations of anarchy and misery to come. Rembrandt's drawings and etchings of beggars made in Leiden and Amsterdam conveyed this. One of his brothers died destitute. Artists, too, were always going bust. One can see why, with things going well for him, he might want the feeling of relative security given by a big house and many possessions in a wide street in a good part of town.

Walking today to the Jodenbreestraat I found that some of the old density of this neighborhood has gone, it seems, forever. The city council has been talking about the demolition of the ramshackle, run-down Jewish quarter since the 1910s, but even the devastation of the Second World War, when most of the inhabitants disappeared into the maw of Nazi Germany, and the empty houses were stripped for firewood in the last grim hunger winter of 1944–45, left the relics of a community, into which the bargain-hunters and junk-sellers of the Waterlooplein flea market fanned a tawdry flame. But now the Metro has come through. This was needed to bring into town, for jobs and shopping, city people who have been rehoused in a vast new apartment development, or "sleep city," as Amsterdammers call it – the Bijlmermeer – too far out for bicycle or bus commuting. The logical Metro route to the Central Station ran through this part of town; the watery conditions required a cut-and-cover form of construction, the removing of buildings in a wide swath, the constructing of hollow concrete sections, then the pumping away of the mud and sand beneath until the section sank to the right depth, becoming a tunnel for the Metro. East of the Nieuwmarkt the posters and graffiti are still on the walls, announcing demonstrations against the Metro. Students and the remaining residents held meetings and sat in front of bulldozers. But to no avail. The pressure for new services and new institutions is as great as it was in the seventeenth century.

Now there is an extensive view from the St. Anthoniesluis in several directions, a new bridge made wide enough to accommodate an improved road junction, and the Breestraat – *bree* indeed – turned into a four-lane road. The buildings on the north side of the street I had remembered from 1957 had been taken down, and a long, four-story, up-to-date office building, in glass and concrete, a textile-dealers' headquarters, took their place. I stood next to it and looked across the Breestraat to the Rembrandt House: the second building in from the corner by the bridge, whose new, raised approach slightly masks the house. Next door, the shop on the corner sells army surplus equipment and tools; just around the corner, facing the canal, where his former landlord, business partner, art dealer, and relative

by marriage, Hendrik Uylenburgh, lived, is a shop selling hippie gear. The past is rushing away from us at great speed. But the urge I often feel to hug the past round me was now at odds with the moment: the sun had gone in; the wind was chilly; the house, keeping museum hours, would soon be closed. I went back to my room.

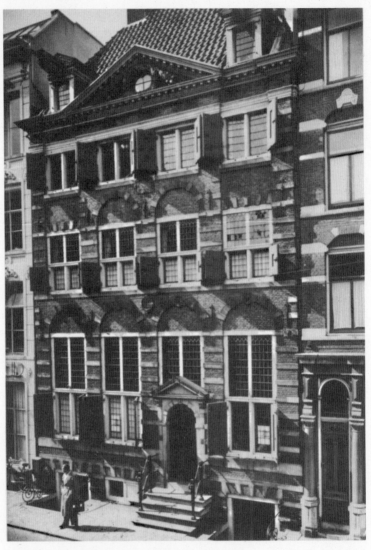

The Rembrandt House. Courtesy of Rembrandthuis, Amsterdam

III

A House in the Breestraat

I F YOU GO to the Rembrandt House today expecting a 1908–1911 museum, with a few late seventeenth-century features, containing a wonderful collection of Rembrandt etchings, you will not be disappointed. If you go hoping to find Rembrandt's house much as he lived in it, with oil paint on the studio floor, grease on the kitchen ceiling, his smock hanging behind a door, and children's toys on a bed, the letdown may be considerable. The floors are well-polished parquet, the walls oak-paneled, and the staircase, of contemporary design, was built a few years ago to take the tread of thousands of visitors. However, those who stand across the street for a few minutes, screening out the surrounding buildings, will see a façade that, although restored at the same time as the interior earlier this century, is much as it was when Rembrandt lived in the building.[*]

Rembrandt and his wife, Saskia, stood there in late 1638 and looked at it because the house was for sale. It was a "double house," roughly half again as wide as most houses on the street; it was a bit grander than the other houses but similar in scale and materials: brick, glass, wood, stone, paint, and tar put together in the way that gave Amsterdam its particular visual character. Steps led down from the footpath to the semibasement, or entresol, the tops of whose doors and windows poked just above ground level. Steps from the footpath led up to the front door, which was set in the lower half of one of four equal-sized window embrasures. These were large because, with party walls adjoining the houses on each side, the windows at

[*] Written in 1976. See p. 233.

front and back had to light the whole house. Casement shutters swung across the lower halves of the windows, while the tops were crammed with small glistening panes of glass set in lead. The four windows of the floor above were slightly smaller but similar. About the arrangement of the next floor up there is some question, but if, as seems likely, the step gable in front of the attic with which the house had been built had been removed a few years before Rembrandt moved in (more of which later), then there was another row of square, shutter-covered casement windows, under a neoclassical fronton, or pediment, giving the house a particularly patrician appearance – right enough for Amsterdam's most successful young painter.

The house, Number 4 Breestraat, had been built in 1606–1607 and was thus roughly the same age as Rembrandt. It was in an area known for publishers and painters. On the corner, at Number 2 Breestraat lived (from 1640), the portrait painter Nicolaes Eliaszoon, and in the house behind him, facing the St. Anthoniesluis, the dealer Hendrik Uylenburgh, with whom Rembrandt had stayed when he moved to Amsterdam in 1631 and through whom he met Saskia. Diagonally across the street was the Jewish scholar and teacher Manasseh ben Israel. At the rear of Number 4 were the premises of a cabinetmaker, while the next house eastward up the Breestraat was owned by Salvador Rodriguez, like Manasseh, a Portuguese Jew. Rembrandt agreed on January 5, 1639 to buy the house. The sellers were the heirs of its original owner, Pieter Beltens, a merchant.

He and Saskia moved into the house on May 1, 1639, and it was to be at the heart of his life for the next twenty years. At a later point he owned two globes – the sort of apparatus that geographers or astronomers pored over in their studies, and on which merchants could trace the voyages of their ships to distant seas. But in that great age of Dutch exploration and overseas initiative, when young Dutch countrymen signed on for journeys to Archangel or Mauritius and brought back to their villages stories of a wider world, Rembrandt was a stay-at-home. After the big jump to Amsterdam he doesn't seem to have returned to Leiden very often; he painted his mother in 1639, but perhaps she came to Amsterdam to visit her son and daughter-in-law in their new house. He had gone up to Friesland, Saskia's province, for their marriage. Some years later he made a short journey to Gelderland. There was a legend that, like so many of his colleagues, he crossed the North Sea. George Vertue, an early eighteenth-century English antiquarian, wrote in one of his notebooks, "Rembrandt van Rhine was in England, liv'd at Hull in Yorkshire about sixteen or eighteen months, where he painted several Gentlemen and sea-faring men's pictures . . . " A few Rembrandt drawings have been identified as English subjects: a view presumed to be of Windsor Castle, and a pair of Old St. Paul's, the cathedral damaged by the great fire of London in 1665

View of London with Old St. Paul's, *seen from the north. Drawing*, c. 1640.
Kupferstichkabinett, Staatliche Museen, Berlin

and replaced by Wren's noble structure. One of the St. Paul's drawings is stilted but the other – as if the first were a warming-up exercise – conveys the feeling of English ground. However, Rembrandt also drew Turkish ruins and Moghul chieftains without suggestions being made that he traveled to Asia Minor and India. It seems likely that, as the art historian Professor Jan van Wessem believes, he borrowed and copied some sketches of Govaert Flinck, a pupil of his who was in England in 1640. The first St. Paul's drawing, at least, was a copy; the second was fluently his own, convincingly *there*.

In Leiden in the 1620s he and his studio partner, Lievens, had been visited by the perceptive Constantijn Huygens, who was then secretary to the Stadholder, Prince Frederick Henry. Huygens was upset that neither of the two still beardless painters would follow his suggestion that they travel to Italy. He wrote, in his unfinished autobiography:

> Oh, if only they could first get thoroughly acquainted with the works of the great masters, such as Raphael of Urbino and Michelangelo Buonarotti . . . and could feast their eyes on the monuments of so many prodigious geniuses, in what short time would these men, born to carry their art to its zenith, if they but knew themselves, be in a position to surpass all, and by doing so oblige the Italians to come to their Holland.

But Rembrandt had said he was too busy to go – and besides, he could see all the Italian art he wanted here in Holland. His teacher Pieter Lastman had passed on to

him (and to Lievens) some of the Italianate fashion, and there were others in town whose work could be seen, influenced by a stay in Italy, by the Italian light, by the classical and the antique, and by the paintings of Caravaggio and Adam Elsheimer, a German who spent the last ten years of his life in Rome. The Grand Tour, as made by John Evelyn or young Jan de Witt, who was to become Holland's leading statesman in the latter part of Rembrandt's life, could be made – as far as the painter was concerned – within walking distance of the Breestraat.

Rembrandt was in correspondence with Huygens at this time of buying the house. Through Huygens he had obtained a commission to paint for Prince Frederick Henry a series on Christ's Passion, and in his letters to the prince's secretary, written in his forceful, absolutely assured script, he tells Huygens how he is getting on, how to hang the pictures, and, at one point, alluding a touch self-consciously to what he was trying to express in a picture, uses a phrase that has caused much scholarly debate – did he mean "natural movement" or "inward emotion"? Talking in artistic terms about his pictures didn't seem to come naturally to him. However, what the letters are really about is money. He nudges Huygens for prompt payment. He suggests a price of 1,000 guilders per picture, but says he will be satisfied with 600 apiece, plus 44 guilders for two ebony frames and crating. What was causing Rembrandt some outward emotion at this point, prompting these remarks, was the necessity to lay his hands on cash to meet the payments for the house. He had agreed to pay some 1,200 guilders of the 13,000-guilder purchase price on May 1, the day he took possession. Another 1,200 guilders was due on November 1, and 850 guilders on May 1, 1640. He could take five or six years to pay the remaining three quarters of the principal, in installments of any size he chose, with 5 percent interest being charged to him on the balance.

But he never got on top of the financial predicament the buying of the Breestraat house landed him in. It was one reason he found himself, seventeen years later, insolvent, and walking around the house with a town official, making an inventory of all his possessions so that they could be auctioned to pay his debts. From the selfish point of view that is ours, in history, his troubles were a matter of good fortune. Without that inventory, perhaps the most essential of the documents collected by Hofstede de Groot in his *Urkunden*, we would find it hard to furnish his house, his temperament, or his mind.

IV

From Room to Room

ON THOSE TWO DAYS in late July 1656 the man from the city's Insolvency Office went from room to room in the Breestraat house. Rembrandt was sometimes with him, as one can tell from some of the descriptions used, which would come only from a painter and a fond owner; and sometimes he must have been called over to explain what something was. There were objects lying on shelves the official hadn't a clue about. The house was crammed with pictures, stacked against and hanging from the walls. There were things that belonged by right to Rembrandt's son, Titus, or to Hendrickje, his companion, and they would have to be called in to vouch for their ownership, with an honest look in their eyes and truth in their voices. But so many things – and what a job to keep one's patience as they were neatly numbered, conscientiously written down.

The inventory-maker started naturally by the front door, in the big, high-ceilinged room the Dutch called the *voorhuis* – the vestibule or hall. Up above, the thick ceiling beams of hewn oak were exposed. There was no fireplace, because the front door would always be opening. This was the room where one greeted friends, patted the dog, said goodbye to one's family, and paused to remember if one had the shopping list. In many houses it was a fine, expensively furnished room, meant to impress visitors and thus kept spotless. Sir William Temple tells of a burgomaster who went to call on a family he knew. The maid, answering the front door, looked at his boots and apparently decided they weren't clean enough. So she picked him up and carried him – no doubt she was a strapping country

wench – and put him down in the next room, where she said, as if this were the normal procedure, "The mistress will receive you now." (The fact that the burgomaster told Sir William this anecdote perhaps indicates that even he thought this was carrying Dutch cleanliness to an extreme.)

In the *voorhuis* the inventory-maker noted down six chairs, one of them on a platform by the front window, raising the person who sat there a little above the ordinary floor level so as to give him or her a better view of the street. Some of the chairs had Russian leather upholstery. Dutch chairs were generally straight-backed and upright, with the leather or cloth covering the back and seat held on with big round-headed brass or copper nails. On the white, plastered walls numerous pictures were hanging – one by Rembrandt's former colleague, Jan Lievens; others by Adriaen Brouwer and Hercules Seghers. He particularly liked Brouwer's violent scenes of people brawling and quarreling in pothouses, and the quite dissimilar but equally intense, moody landscapes of Seghers. A plaster bust and a cabinet – but that was Hendrickje's, full of her things, and not for the inventory – also stood in the vestibule.

A door to the left took them into the side room, or *sael*, the best room, probably with a tiled floor. In many families this high-ceilinged room was little used, but contained their most valued articles of furniture, polished and dusted by maids and cherished by the housewives. It was almost as if part of the house had become sacred when the church ceased to be; the chalices that had been on Catholic altars are transformed into the nautilus-shell goblets displayed on Protestant, patrician dining tables. Here, in Rembrandt's house, was an elegant fireplace; a mirror; a fine walnut table and Tournai tablecloth; seven green velvet-upholstered chairs; a marble cooler; and more paintings – among them another Seghers; another Brouwer; one by Jan Pynas, whom he probably studied with briefly, after Lastman; and a painting by himself, a view of a little outbuilding or *achterhuis*.

The room behind this, lower-ceilinged, and with a view of the back yard, was called the *binnenhaert*, which suggests its central and necessary position in the house. Here household activity went on: together with four simple chairs and four green cushions for them was a linen press, a copper kettle, a small table, a wardrobe, and a clothes horse for airing the family's clothes by the fire. Naturally many more paintings – including more of Seghers's; more of his own. A door led back to a hall with a staircase, twisting tightly so that it used as little space as possible, the result being steep steps, narrow even at their widest part. To the rear, alongside the yard, was the *achterkamer*. Like the *binnenhaert* and possibly the *sael*, this was the living room *and* bedroom. The inventory-maker didn't list the beds of the other rooms because he regarded them either as inalienable or as part of the house itself: they would have been bed-cupboards, which looked as if they were built in. These were

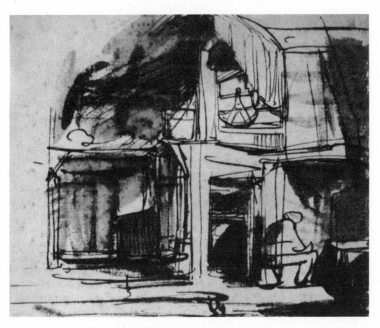

Interior with a Winding Staircase. *Drawing, c. 1633. Kobberstiksamling,*
Royal Museum of Fine Arts, Copenhagen

beds that you climbed into, closing a curtain behind you, and sometimes they had a
drawer underneath for putting a baby in. But this was a room Rembrandt had drawn
often. He had sat there while Saskia lay in bed, not feeling well, about to have a
baby, or later, ill indeed, about to die. He had drawn a servant woman sitting in the
high-backed cane chair the inventory man was noting, as she kept her vigil doing
some needlework by the fire. The ornate fireplace, with caryatids holding aloft the
mantelpiece, appeared in many drawings. He had painted Hendrickje in that bed,
with the blue bed curtains. Feather mattress, eiderdown, bolster, pillows. Copper
warming pan, though in fact between the mattress and the eiderdown, with the
curtains pulled and the warmth of another body alongside, you soon got warm
enough. The chairs in this room had blue coverings, matching the bed curtains.
There was a small cedar cupboard for children's clothes, a cedar clothes press, an
oak table with a woven tablecloth, and a large mirror, whose silvered glass had
reflected his own, Saskia's, Geertje's, and Hendrickje's faces.

Partway upstairs one entered the room over the *binnenhaert* – its low ceiling
allowed two rooms to be squeezed in above it, three thus where two would have

been with ceilings of normal (in other words, considerable) height. These small upper rooms were called "hanging rooms," and they involved ingenious carpentry work, with little flights of steps up and down to them, steps and risers cleverly improvised in shape and height so that one could reach the room without breaking one's neck, and sometimes with windows set in the inner walls to catch the light from an outer room. In many houses one of these would be the *kantoor*, a sort of household office, where domestic or professional accounts and records would be kept. Perhaps because of the painter's nonchalance in this respect, all that the inventory-making noted in the *kleine kantoor* here were "ten pieces of painting, both large and small, by Rembrandt," and one bedstead. This may have been Titus's room.

The upstairs was in any case given over to Rembrandt's work. The rest of the house lived in the shadow, or glory, of what went on up here. The main studio stretched across the front of the house, facing north on the Breestraat. The inventory-maker ignored much of the clutter in here: the Insolvency Office would not put up for sale the tools and materials a worker needed for his craft: easels, mirrors, paints, palettes, brushes, and tables where paints were ground and boards and canvases prepared. But some of the props Rembrandt used in his pictures had to be listed – the costumes for an Indian man and woman, one wooden trumpet, one giant's helmet (how, one wonders, did the inventory-maker know? Or did Rembrandt say, "That's what I've always called it"). There were five cuirasses, and various halberds, swords, and Indian fans. Possibly because the painter did not want the distraction of finished work in such a room, there were only two pictures mentioned here: "Two Moors," by himself, which one presumes is the painting of *Two Negroes* in the Mauritshuis, in The Hague, and "One little child by Michelangelo."

At this point the man making the inventory saw his job suddenly becoming real. Here he may well have taken his jacket off and looked for convenient places to sit while he jotted things down. For in several small rooms – the so-called small painting room and antechamber – and then in the *kunstkamer*, or gallery, was Rembrandt's collection. Most of the Dutch at this time who had a little cash to spare collected not only pictures but small objects, jugs with pewter lids, seashells, silver trays, or pieces of glassware, which one sees in pictures by de Hooch and Vermeer. But in the case of the householder of 4 Breestraat, the collecting trait appears to have become an ungovernable compulsion. In part he collected – as other artists did – bits and pieces that he could use in his works, not just for themselves but as pointers and touchstones. Other artists might own pictures that they borrowed from, within their own fairly limited ambitions, and so did Rembrandt – but his

collection of pictures was huge and diverse. Rembrandt's collection was almost a museum, a collection of the sort that only aristocrats and patricians had hitherto been able to afford, as conspicuous testimony of their wide-ranging taste and interest in the arts and sciences. In his *kunstkamer*, Rembrandt gave himself (and knowledgeable visitors) the sense that he was one of the great collectors of his time.

All this was to go: the two terrestrial globes, the "forty-seven specimens of land and sea creatures, and things of that sort," followed immediately by "twenty-three specimens of sea and land creatures," and a number of heads of Roman emperors, fastidiously arranged in chronological order. There were various kinds of weapons, ancient and modern, European and Asian, thirty-three in one place, and many others scattered elsewhere, including a Malayan kris, iron helmets, crossbows, African spears, more halberds, arrows, a suit of armor, shields, swords, powder horns, and assorted guns, pistols, and a small cannon. There were busts of Homer, Socrates, and Aristotle, and a death mask of Prince Maurice of Orange. Boxes of minerals went on the list, together with seashells (perhaps including the little scallop shell he had used in the etching of *Christ Healing the Sick*, generally known as "The Hundred Guilder Print," and the beautiful shell he had etched on its own in 1650), coral, gourds, and two walking sticks. Several rare cups of Venetian glass, two woven baskets, and an iron gorget. Also a collection of stags' horns. There were all manner of costumes, old lengths of cloth and bright robes, and animal skins – one from a lion, one from a lioness, the inventory-maker wrote. Some objects were in cases, some on shelves, some hanging from the walls. Perhaps the very business of seeing them written down was like having them already sold – they were gone from his arsenal, his bag of tricks. But perhaps he felt he wouldn't need them again. Perhaps he had what he wanted of them in his head.

There were big baskets full of antique heads, nude statues, and anatomical plaster casts, which he ought to have made a case for as part of his professional tools, since they were used in teaching. But they went on the list. Seven stringed instruments were entered too, plus various wind instruments (some made from bamboo), and a harp. Unlike some of his colleagues, he hadn't made frequent use of these items in his pictures, as they often did, as symbols of the easy life; also they often found them handy for serenading a pretty model when they needed a break from painting. He was going to miss the "art books" that formed the longest batch of entries, the portfolios and scrapbooks of sketches, prints, woodcuts, and engravings, many by himself, many by masters he admired – sixty artists of the Netherlands, Germany, and Italy, including Holbein, Breughel, Lucas van Leyden, Schongauer, Raphael, Michelangelo, Titian, Cranach, Rubens. Now and then the

Bust of the emperor Galba, *after an antique sculpture. Drawing, c. 1640–1641.*
Kupferstichkabinett, Staatliche Museen, Berlin

listing conveys Rembrandt's feeling for the object: Item 200, "The precious book
of Andrea Mantegna"; Item 260, a small book "containing outstanding examples
of calligraphy." There was a book illustrating Turkish architecture and life, and
another of erotica. He owned Dürer's book on proportion, but few other printed
texts: an illustrated edition in German of the Roman historian Flavius Josephus on
the Jewish War; a tragedy, *Medea*, by his old friend and patron Jan Six, for which

he had etched the frontispiece; and one old Bible. The art rooms yielded also a number of simple objects, each of which may have had some personal value – a little Chinese figure, a small tin pot, a small inkstand, a tric-trac board. (Tric-trac was a game like backgammon.)

In the attic there was presumably room for students to work. Partitions and stoves used there are mentioned elsewhere, in a document regarding the sale of the house, but they did not concern the inventory-maker on this occasion. He ignored the little courtyard, probably brick-paved, with its few shrubs and plants and a little tree, or vine, growing over the roof of the privy, and a shed for storing buckets and brooms. Nor was he much interested in what he found in the pantry and kitchen, in the entresol under the *achterkamer*. He noted here a few utensils and pieces of furniture, a tin waterpot, various old chairs, nine white cups, two earthenware plates. Hendrickje must have convinced him that the rest belonged to her or to Titus. (Indeed, there is no mention of stoves, fire tools, curtains, and family portraits, which Rembrandt would still own.) But as if to make up for any overgenerosity in that respect he made a point of asking if there were things he hadn't seen, and got an honest answer. So the "Inventory of the Paintings, Furniture and other Effects contained in the house of Rembrandt van Rijn Living in the Breestraat by the St. Anthony Water-Gate" closes with a brief section titled "Linen at the Laundry": "359. Three men's shirts. 360. Six handkerchiefs. 361. Twelve napkins. 362. Three tablecloths. 363. Several collars and cuffs. done and inventoried on the 25th and 26th July, 1656."

V

Growing Up

J UST HOW he got into this predicament may have been as unclear to him as it is
to us, though we have our ideas. He doesn't seem ever to have concentrated
with wholehearted attention on the matter of money. Perhaps because of his first
tremendously profitable fifteen years as a professional painter in Amsterdam, he
thought it would keep pouring in. Then, too, he seemed to develop as time went
on not only a different notion from that of his colleagues and customers as to what
and how he should paint, but an idea of his own as to how an artist should present
himself to the world and how the world should accept him.

He grew up in Leiden. This, the second-largest town in the Netherlands, was
a sometimes congenial, sometimes uneasy mixture: part industrial, part university
town, with a famous botanical garden and great numbers of weaving mills, where
most of its laboring population worked, at least in boom times, though some lived
in great poverty. It was a town of densely packed red-brick houses with red-tile
roofs, and an ancient branch of the Rhine running through it toward the dunes
and the North Sea at Katwijk. Rembrandt's family had been in the grain-milling
business for several generations. His grandmother and her second husband had
bought a windmill for grinding corn in 1575 and dismantled it and moved it from
Noordwijk to Leiden. His father, Harmen, married a baker's daughter, Cornelia
(or Neeltje, as she was called in the family). With his four older brothers and
younger sister Rembrandt grew up in his parents' house in a small street called
the Weddesteeg, near the White Gate of the town, facing the river, close to the

city wall, and next to the family windmill, which was called "de Rijn," the Rhine, and was probably not the same mill as his grandmother's. So early on he knew the smell of newly milled grain, was familiar with the sounds of the big wooden gears and axles turning, the stones grinding, and the swish of the sails going round and round. Windmills were not picturesque for him, but sensible instruments for turning natural energy to human use, and providing his father's livelihood – in his case, making malt for breweries. Yet, later on, he was to draw with loving accuracy the mills and tacked-on cottages that stood on the edge of Amsterdam, and the countryside of flat meadows bounded by ditches and dikes beyond. (Many of the Amsterdam mills were saw-mills, making timber for shipbuilding.)

The name Rembrandt seems to have been slightly old-fashioned even then, the way Egbert or Horatio might be with us. Later, in Amsterdam, a baker named Rembrandt Lubberszoon was to be found living at the corner of the Batewierstraat, and a Rembrandt van Ruynen caused confusion among scholars by being buried in the St. Anthony's burial ground in 1664. Dirck Rembrandtszoon (1640–1683), a Mennonite cobbler in Niedorp, North Holland, had a successful secondary career as a writer of a navigation textbook, which went through fourteen editions. (In the nineteenth century the American painter and museum proprietor Charles Willson Peale named his four sons after four great artists, and like his brothers Raphaelle, Rubens, and Titian, Rembrandt Peale became a painter. A little later, the Italian furniture-designer Carlo Bugatti had two sons, one of whom he wanted to be an artist. He named one Ettore, who became the famous car-builder, and the other Rembrandt, who had achieved a considerable reputation as a sculptor when he died in 1916 at the age of thirty-one.) The name to us sounds similar to other slightly outlandish Dutch names of the time: Rombouts was the name of Hendrik Uylenburgh's brother. Uylenburgh's uncle, and Rembrandt's father-in-law, had the name Rombertus. Rembrandt occasionally forgot to write the *d* in his name, and so did other people, including the clerk who wrote out his banns of marriage in 1634. His grandchild, born in Batavia in the East Indies in 1673, four years after his own death, the son of his and Hendrickje's daughter, was named Rembrandt.

As for the family name, van Rijn, that was obviously derived from the Rijn mill. At that time some families had surnames they didn't bother to use. Rembrandt could have got by in a common fashion by calling himself after his father, Rembrandt Harmenszoon, that is, Harmen's son. Occasionally people picked a surname from a distant relative, the way the painter Claes Moeyaert did, taking the name Moeyaert from his paternal grandmother's family. Thus, taking a surname wasn't necessarily

putting on airs, but was a way of ensuring that you weren't confused with others with similar names.

Rembrandt's family were not poor. They owned a burial place close to the pulpit of St. Peter's Church in Leiden, and his father's handwriting gives the impression that he had had some education. Young Rembrandt had a somewhat coarse, plebeian-looking face, but an evident brightness. His brothers took common jobs (one became a shoemaker before taking over the mill), but Rembrandt's parents decided he was worth an extra effort, and so sent him to the Leiden Latin School. Education there was usually a seven-year process, from the age of seven to fourteen. Here the models were the Bible and antiquity: Christianity framed a study of the classics. School began and ended with prayer; older boys learned to say the Lord's Prayer in the original Greek. Psalms were sung, Latin compositions written, and the Roman historians and poets studied. Here Rembrandt picked up a knowledge of ancient times and a familiarity with the classics, with authors like Homer and Tacitus, that never left him. At home, too, the Bible was much read, if one judges that it was more than a convention that led him, in several early pictures, to show his mother with the Great Book in her hands.

At fourteen he was sent to the university, with the possibility of a career ahead of him in the town administration. Nothing is known of how long the perhaps would-be civil servant stayed in this renowned institution. Rembrandt's matriculation in 1620 was possibly a device frequently used to obtain the privileges of a university student without actually being one: not having to serve in the civic guard, and qualifying for a quota of wine and beer free of excise duties (forty-five gallons of wine per year and half a barrel of beer per month, duty-free, were allowed Leiden professors and students. Incentives to scholarship!).

The university was in fact the pre-eminent center of learning in the Low Countries. It was founded in 1575 as an act of gratitude for the successful defiance of two Spanish sieges (further commemorated by a parade and festival on October 3 every year, which kept the victory over Spain in the memory of Leiden's citizens), and within a short time the university acquired a reputation throughout Europe for its theological, medical, and scientific studies. Famous scholars came, or were lured, from other countries. Many foreign medical students enrolled at Leiden – including Sir Thomas Browne, author of *Urne Buriall* – where they could, among other activities, attend an annual anatomy lesson, watching from theater seats while the corpse of a male criminal was dissected. (Lemuel Gulliver was inscribed by his creator as a Leiden student.) Leiden was also the cockpit of Calvinist controversy. The great debate between liberal and conservative theological views was personified

there by the professors Arminius and Gomarus, leaders of the opposing parties and teachers at the university. This nursery of talent was known as well for its botanical garden. No less an intermediary than René Descartes negotiated for it an exchange of seeds with the French king's royal garden.

But Rembrandt soon enough showed that the pen in his fingers preferred to make other shapes than words. His talent for drawing persuaded his parents to apprentice him to a painter: Jacob van Swanenburgh. Van Swanenburgh was a member of a painting family who were well connected in Leiden: his father had been a burgomaster; a relative was professor of law at the university. Jacob van Swanenburgh specialized in architectural pictures, with a sideline in scenes of hell. While staying in Italy from 1614–1617 he married a girl from Naples and acquired various Mannerist habits then current; judged on his few extant paintings he was not a good painter, but he perhaps provided his pupil with the indispensable technical knowledge. With van Swanenburgh and then perhaps with Joris van Schooten, another Leiden painter, Rembrandt worked, and worked hard – for one was apprenticed to painting as to a trade or craft.

Adriaen van Ostade was one of the painters of the time who now and then recorded the scene: *A Painter's Studio*, with a dog asleep; a boy busily pounding colors on a stone; another boy putting colors on a palette, ready for the master when those he was using ran out; a dust-catching canvas hung over the easel and the painter who worked at it, alongside a window through which the mellow Dutch light came in. As for the boy who worked in such a studio – in an indenture of December 15, 1635, that Dr. W. Martin has printed, Isaac Isaaczoon of Amsterdam agreed to take as a pupil one Adriaen Carmen, aged seventeen. Carmen was required to live in the painter's house, to prepare the colors for the master and himself, stretch canvases, and generally behave himself as an industrious, obedient servant. In return, Isaaczoon undertook to give young Carmen food, drink, and lessons in painting. Carmen's father was to bring the master a yearly gift of a barrel of herrings or cod. Carmen was to be allowed to paint one picture a year for himself on a two-and-a-half-florin panel or on canvas. He was to provide his own bed and bedding.

In between doing the inevitable dirty jobs in the studio, the apprentice learned the ground rules and tricks of the trade. In 1604 the Haarlem painter Karel van Mander published his *Het Schilderboek*, which is mostly a Vasari-like collection of lives of Flemish, Dutch, and German artists, but also contains a long, didactic poem for the benefit of young artists. In this he tells the beginner to seek a master who can teach him how to compose, sketch, shade, and work up neatly, first with charcoal, then with chalk or pen. Again, it is important to learn neatness in *doezelen* – drawing

with stump or pastels. The pupil acquired this neatness and skill first by copying prints and drawings the master kept in his studio, and then by drawing from plaster casts. Eventually Rembrandt himself owned, as the inventory showed, great numbers of these casts: a whole basketful of plaster heads; seventeen arms and legs, molded from life; a large number of hands and faces, similarly molded; and casts of naked children, a sleeping child, a Negro, and various casts from antique Greek sculpture. (Samuel van Hoogstraten, who was a pupil of Rembrandt's in the 1640s, mentions the presence also of plaster eyes, noses, mouths, and ears.) Many artists had on hand so-called flayed plaster casts which were anatomical figures displaying muscles and tendons for the pupil to draw from. So with classical figures – but, although studying the antique was an essential part of this training, the young Dutch artist was able to go on to paint not only nymphs and gods disporting themselves on sylvan slopes but portraits of burghers, seascapes, and still lifes.

But before they produced a "master-piece," so that they could become independent members of the artists' guild and have the right to sell their own work, there were the long years of apprenticeship. The theory of perspective was learned from texts by Hondius, Abraham Bosse, and Dürer. After the apprentice mastered the art of drawing, there was the art of palette and brush, of mixing colors, of finding out which will not mix and how long each color takes to dry. This sometimes involved signing on with another master qualified in this sphere. And here, too, it was a matter of copying and working – in the master's manner – on the same subjects the master painted. If he had ambition, the apprentice tried not to be original but to do better than his teacher in his teacher's style, in the way that Gérard Dou, Rembrandt's first pupil, adopted and intensified the highly detailed technique Rembrandt was using as a young artist in Leiden. All the while grinding the master's colors, preparing his panels and stretching his canvases, and being told over and over, as van Mander tells the aspiring artist: Remember to keep a clean brush and a clean palette so that you achieve a proper finish. And make sure you keep dust off your painting while it is drying. (Gérard Dou sometimes used for this purpose a Japanese umbrella fastened to his easel.)

Throughout this apprenticeship period the pupil's work belonged to the master. Indeed, if the pupil left before serving the time agreed upon in the indenture, it was regarded as a financial loss for the master. When Ferdinand Bol, a pupil of Rembrandt's, became a master in his turn, he demanded 60 guilders compensation for two pictures that a pupil of his was supposed to have painted but, leaving Bol's studio, left unfinished. If up to scratch, the work of pupils was often sold as that of the master and signed with the master's signature. This was particularly the case with portrait painters, for their clients often ordered several copies of the

same portrait, one for themselves and some for relatives. Portraits of celebrities, which might be popular with a wide public, were even kept in stock. Michiel van Mierevelt in Delft had a painting factory, as one is forced to call it, where quantities of smooth, elegant portraits were turned out by his assistants, perhaps touched up where necessary, and then signed by Mierevelt himself. Certain painters became known for, say, tavern scenes or fruit and flower pictures, and, with what they hoped would be a steady demand, produced pictures for future sale.

Hence an established painter was keen to take on a talented youngster as apprentice. Arnold Houbraken, whose gossipy work on Dutch painters was published in 1718–1719, tells (somewhat maliciously) of Frans Hals's recognizing the potential of young Adriaen Brouwer, whose mature work Rembrandt so much liked, and setting him up in a loft to work on his own. Hals made an agreement with Brouwer's mother only to feed him, so there perhaps was a profit in selling Brouwer's paintings. (Brouwer died, aged thirty-three, the year before Rembrandt moved into the Breestraat house.) On the other hand, David Bailly, the Leiden still-life painter, complained that his two pupils Pieter and Harmen van Steenwijck ate so much in his house and were so idle that he made nothing out of them. (One hopes young Brouwer tucked in as much as he could *chez* Hals.)

In Leiden young Rembrandt worked with van Swanenburgh from roughly the age of fifteen to eighteen, that is, from 1621 to 1624. We know this from the first, brief biographical account of him, which was given in 1641 by Jacob Orlers, a burgomaster of Leiden, in the second edition of his *The City of Leiden*. Orlers wrote of such past heroes in his city as Lucas van Leyden and Cornelis Engelbrechtszoon, whose locally famous works, a *Last Judgment* and a triptych respectively, Rembrandt could have seen in Leiden Town Hall, and whose names he may have heard spoken with admiration. The occupation of the painter, then, was something worthwhile. Orlers also wrote, at length, about Rembrandt's contemporary Jan Lievens, whose prodigious talent struck people as even more astonishing than that of the miller's son. And of Rembrandt, wrote Orlers, "His heart being set upon painting and drawing," his parents sent him to van Swanenburgh, and then, "because of his great progress, which astonished those who cherished the arts, so that it became apparent that he would excel as a painter, his father agreed to apprentice him to the celebrated painter, Pieter Lastman, of Amsterdam, to his further instruction."

In Leiden, not much more than six months later, Rembrandt, nineteen, set up as his own master, sharing a studio with Lievens and living still at his parents' house in

the Weedesteeg. Inasmuch as Leiden had a school of painters then, its artists were fond of a form of still life called *vanitas* – an arrangement of familiar or rare objects, books and guitars, pipes, snuffed-out candles, overturned glasses and skulls, to point the moral that life is short, and that even scholars, in that university town, should put away their vanity. Academics and saints, looking scholarly, appear in paintings the young Rembrandt did then; he was not immune to the atmosphere of the place. Although he was still working his way out from the influence of Lastman in Biblical and historical compositions, with strong contrasts of light and shade, and sometimes wild, florid effects, he already struck some visitors as surpassing his teachers. There is an impression that early success might have gone to his head. Arnout van Buchell, a Utrecht legal expert, wrote in his notebook on art in 1628, "The Leiden miller's son is much praised, but before his time." He now had pupils of his own, first Gérard Dou who came to him in February 1628, aged fourteen, and then Isaac de Jouderville, who paid the comparatively high sum of 50 guilders for six months' tuition.

One painting from this time, the little *The Artist in His Studio*, has been thought by some to show young Gérard Dou, perhaps because of the small size of the figure of the artist. It is a picture usually seen in poor reproductions, but in the flesh, in Boston, it gives the feeling of Rembrandt's idiosyncracies, his still clumsy talent, and of the power to come. In the foreground the viewer is presented with the deeply shadowed back of a big easel, dominating a bare room – plaster peeling from the wall, and all the cracks between the sunlit floorboards and joints in the rickety woodwork, the locks and hinges on the door, naïvely rendered. Over in the far left corner, up against the wall, is the timid painter, in his smock, facing the easel, a big black hat tilted on his head, one hand holding the brush he is working with away from his robe, the other clutching all his equipment: more brushes, a mahlstick, a palette. His feet stick out. On the wall next to him, like a coat of arms, hang a pair of palettes, one on top of the other. We are impressed by the feeling of the young artist faced with painting and his future.

He sat up late at night, drawing by candlelight, drawing whichever member of his family was near by. He began etching, as Lievens did too, and after a few erratic attempts got the hang of the craft in such a way that he was soon out ahead of everyone in the country – almost ahead of himself, boldly plunging beyond his own immediate resources in the hope of solving the problems he set himself, but also rapidly achieving an economy of execution that he took longer to find in painting. The earliest dated etchings, from 1628, are of his mother. Houbraken wrote:

The Artist in His Studio. *Painting, c. 1628. Courtesy Museum of Fine Arts, Boston,*
Zoe Oliver Sherman Collection

Rembrandt was on fire with enthusiasm while he was living in his parents'
house, making daily progress in art all by himself. Every now and then he
would be visited by connoisseurs; eventually they recommended that he
visit a certain gentleman in The Hague to show him and offer him a newly
finished painting. Rembrandt carried the painting to The Hague on foot, and
sold it for a hundred guilders.

He therefore didn't have to walk the twelve miles home, but came by passenger
wagon. Houbraken says the horses were changed at a halfway halt, where the
coachman and passengers repaired to an inn for refreshment – all save Rembrandt,
who was still aboard when the new horses bolted and carried him on to Leiden,
sans coachman, a bit faster than scheduled, clutching his 100 guilders.

The "gentleman in The Hague" was probably Constantijn Huygens. It is hard to
think of anyone in Holland then who could better have taken notice of Rembrandt.

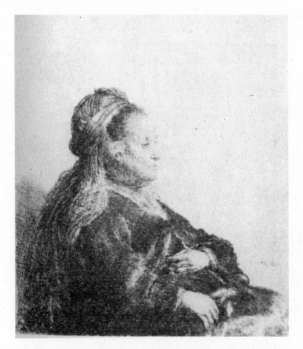

Rembrandt's Mother. *Etching, second state, 1631. Courtesy of the Trustees of the British Museum*

Prince Frederick Henry's secretary was ten years older than Rembrandt and an all-round man: musician, poet, artist, writer, scholar, diplomat, and athlete. He had climbed the spire of Strasbourg Cathedral, and had been knighted by King James I while serving with the Dutch embassy in London. He corresponded with Descartes. He was a true amateur of the arts, a lover of painting. Lievens had painted his portrait in 1626–1627, and it was perhaps through his studio partner that Rembrandt first came to the secretary's attention. (Houbraken's "connoisseurs" may be a slightly muddled memory of how it happened.)

Huygens, in any event, came to visit the two young men in Leiden in 1629, admired their work, and, as we have seen, tried to talk them into traveling to Italy. Huygens was a great admirer of Rubens's work; he particularly liked a *Medusa* Rubens had painted, which was so horrible to look at that it was usually kept behind a curtain. What Huygens liked in Rembrandt was his ability to convey lively

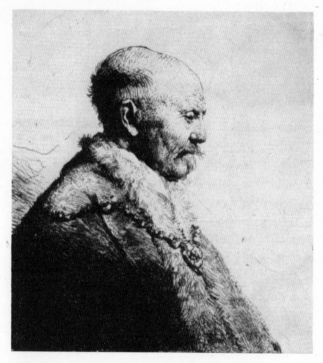

Elderly Man, *perhaps Rembrandt's father. Etching, second state, 1630.*
Courtesy of the Trustees of the British Museum

emotional expression – for example, the melodramatic *Judas Returning the Thirty Pieces of Silver*. (Huygens concluded an ecstatic description of this painting with the words "Bravo, Rembrandt!") And it was probably through Huygens that two paintings by Rembrandt and one by Lievens were acquired, via the Earl of Ancrum, then visiting Holland, for Charles I's collection. The world was swiftly opening up for him.

Meanwhile something of his old life was ending; the family shrank and squeezed him forth. His father – whom he had painted several times in the last few years, asleep by the fire, or under a skullcap, toothless mouth firmly compressed – died, perhaps blind, in August 1630. His brother Gerrit, who had earlier suffered a disabling injury to a hand, died a year later. But if death and illness reduced his

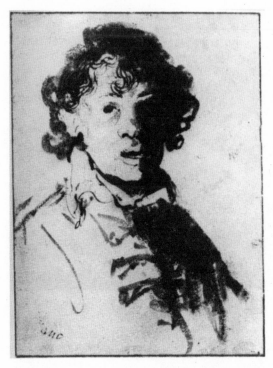

Self-Portrait. *Drawing,* c. *1629. Courtesy of the Trustees
of the British Museum*

stock of family models, he always had, he found, himself. The lifelong obsession
with what he saw in front of a mirror had begun. No other artist has created so
many self-portraits – Rembrandt painted nearly a hundred in the course of his life.
And those he did in Leiden are in some ways a mixture, like those to follow: he
dressed up in exotic clothes, posed in plumed hat with a poodle at his feet; he
experimented with light effects, putting himself against dark walls, and casting a
strong light on one side of his face, while with the wooden tip of his brush he
scored the paint surface to indicate his curly hair; and he painted cool, refined
versions of himself. It is almost a young officer, bound to be a great general, who
stares at us from the splendid 1629 self-portrait in the Mauritshuis. He looked at

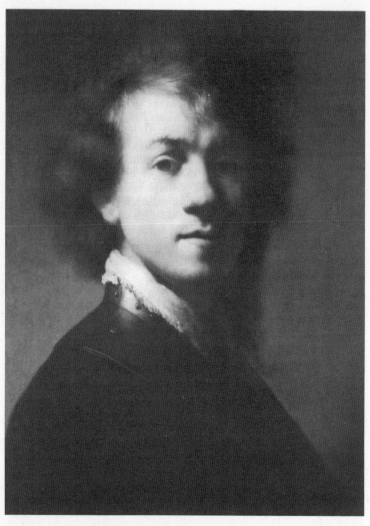

Self-Portrait. *Painting, 1629. Mauritshuis, The Hague*

himself warily and quizzically – he pulled wild faces as he sat with his etching plate under the mirror, frowned, laughed, looked scared or somber. There were two questions at least: Who am I? And, How do I get it down? Finding an answer for the latter was perhaps the best way to answer both.

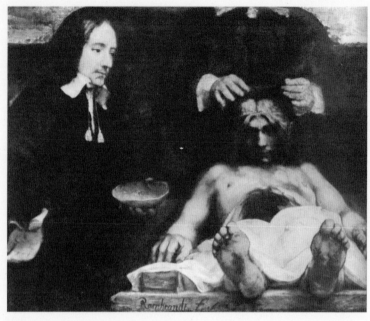

The Anatomy Lesson of Dr. Joan Deyman *(fragment). Painting, 1656.*
Rijksmuseum, Amsterdam

VI

Anatomy Lessons

THERE WERE GOOD REASONS in 1656, at the time of the inventory, for recalling how things had been when he made the move to Amsterdam. He was working through the early months of 1656 on an *Anatomy Lesson*. In 1632 *The Anatomy Lesson of Dr. Nicolaes Tulp* had been part of the attraction – a wonderful commission for a young Leiden painter – that drew him to the bigger city. Although in 1656 his troubles were thickening to a thunderous density, the members of the Amsterdam Surgeons' Guild had not forgotten him. Asking him to paint Dr. Tulp's successor as professor of anatomy, Dr. Joan (which was a form of Johan) Deyman, they made him remember how he had set about the first: his announcement to Amsterdam that he was here.

The surgeons in 1656 had their anatomy theater in St. Margaret's, a former chapel in the Nes, a narrow street south of the Dam, but in the thirties they were in what Rembrandt must have thought of already as his own neighborhood – upstairs in the Waag, the old gatehouse in the Nieuwmarkt, a short walk from his lodgings at Uylenburgh's overlooking the St. Anthoniesluis. There, on the corner of the Breestraat, in the rear half of a big double house, Uylenburgh ran a painting business in which Rembrandt became enmeshed in 1631, as a partner with a stake of 1,000 guilders in the firm. Uylenburgh, on the art dealers' grapevine, may have heard of the *Anatomy Lesson* job and helped Rembrandt acquire it. Or, if an intermediary was needed, it was perhaps Caspar van Baerle, or Barlaeus, as he called himself, in the Latin fashion used by many academics then, and who as noted earlier arrived

in Amsterdam at roughly the same time as Rembrandt. Barlaeus at Leiden had got into trouble because of his liberal religious views, and had been deprived of his post at the university. He was a friend of Huygens's. Coming to the freer air of Amsterdam to be one of the first professors at the Athenaeum Illustre, he became a patient of Dr. Nicolas Tulp. He would have been well placed to comment, "I know just the painter for your anatomy lesson."

Anatomies were performances Rembrandt knew about in Leiden. Twice or three times a year the Leiden Board of Anatomy arranged for the dissection of a corpse in order to demonstrate to medical students and other interested people current knowledge and recent discoveries about the human body and its workings. Since the Middle Ages autopsies and private post-mortems had yielded information, and numerous dissections were quietly carried out by enthusiasts during the Renaissance. Leonardo da Vinci opened up some thirty corpses. With the sixteenth century, public anatomical demonstrations began in such centers of learning as Bologna, Padua, Paris, and Montpellier, and spread to other cities, to Basel, Leiden, and Copenhagen. In Padua, anatomy was taught by Girolamo Fabrizio (*c.* 1537–1619), Galileo's physician. There, too, Vesalius had taught – the southern Netherlander whose *Fabrica*, published in 1543, was for a long time the standard textbook on the subject. As Professor W. S. Heckscher has pointed out in his study of the *Tulp Anatomy*, 1543 also saw the publication of *De Revolutionibus Orbium Coelestium* by Copernicus and the first Latin translation of the Koran. Anatomies were vivid demonstrations of a greater passion for experiment and scientific observation, an aspect of the age well covered by a few words of Spinoza's, an Amsterdam contemporary of Rembrandt's, who opposed to scholasticism "the school of experience." In science as well as painting, the Dutch-Italian link was strong. Galileo perfected in 1610 or thereabout a telescope based on that which the Dutchmen Janssen and Lippershey had invented a few years earlier.

Dissections were generally held in winter because they could usefully go on for four or five days, and in cold weather the corpse lasted longer. The school of experience that provided the body was a hard one: the corpse was that of a criminal who had been executed a day or so before. For Dr. Deyman's anatomy lesson at the end of January 1656 the wherewithal was provided by Joris Fonteijn, known as Black Jan. Originally from the small town of Diest, in Gelderland, he had been in turn a tailor, a soldier for the West India Company, and a vagabond. In Amsterdam he pursued a career of thievery in partnership with one Elsje Otte, whom her associates called the Thunder Whore. Black Jan was spotted robbing a cloth merchant's house on the Nieuwendijk in daylight. He ran and was caught, after knifing one man who tried to stop him. He was hanged on January 27.

Dr. Deyman went to work on him on the twenty-ninth and gave three demonstrations. For Dr. Tulp's anatomy lesson, twenty-four years before, the body was that of Aris Kindt, Arents Kintje or the Kid, aliases of Adriaan Adriaanszoon of Leiden; he was also hanged for robbery with violence.

Since dissections were infrequent and seasonal, the bodies of few criminals were disposed of this way. (Women criminals were apparently not dissected until the eighteenth century.) By this time, moreover, few were left hanging in the city streets, though Rembrandt did a drawing of an executed woman trussed and so suspended, mouth open, and the ax with which she had committed the murder hanging next to her. Most criminal corpses were displayed on gallows set up on a point of land on the north side of Amsterdam harbor, where they attracted birds and deterred, perhaps, a few would-be criminals among the passengers of ferry boats. The instruments of justice were as rough as the times. Confessions were still extracted by torture; a room for the purpose was provided in Amsterdam's new Town Hall. What incriminating words came from the agonized lips of those on the rack, from those who may have been innocent as well as the guilty, is painfully hard to conjecture.

Certainly even the rich and the momentarily mighty were in peril of the same cruel procedures and the blood cry from the people. Cornelis de Witt, brother of the Grand Pensionary Jan de Witt, was tortured in prison during the panic following the French invasion of 1672. Jan, having resigned his office, was visiting Cornelis in prison when an angry mob invaded the place, forced them into the street, killed them, and then terribly mutilated their bodies. The games played in inns or at kermesses and country fairs – for example, grabbing the greased neck of a live goose from a moving wagon or boat; subjecting cats and dogs to bastinado or strappado – speak for a still general, and still easily aroused, barbarity. In balance with it one must put the fact that the Dutch were the first European people to cease persecuting witches; the last trial for witchcraft seems to have been in 1610, when the lawyer for the defense was the popular poet and de Witt's predecessor as pensionary, Jacob Cats. Cats secured an acquittal, but many people went on believing in witches and in such means of avoiding the witches' evil spells as turning their shoes upside down when they took them off at night.

Perhaps a few of those who attended anatomy lessons came for morbid or bloodthirsty reasons. If the 1616 print showing Dr. Tulp's teacher, Dr. Pauw, in action at Leiden is reliable evidence, some small boys would try to sneak in, and dogs were allowed to sit at the feet of their attentive masters. But the dissections were educational "theater," and a solemnity was observed. The ordinances of the Amsterdam Surgeons' Guild forbade talking and laughing, though of course serious

questions were answered. Anyone pocketing the vital organs (heart, kidneys, liver, and gall bladder) as they were passed round for inspection would be fined 6 guilders. Some anatomies were personal celebrations, as Dr. Tulp's may have been, where a group of associates gathered to honor the physician, while others were social events to which foreign visitors would be taken. Over three or four days some 600 people might buy tickets for 6 or 7 stuivers each, and the guild made a good profit. Dr. Deyman's anatomy lesson brought in 187 guilders, 6 stuivers; and the doctor himself was given six silver spoons worth 31 guilders, 9 stuivers for his performance. (Costs included oil for lanterns and a fee for the hangman.)

For *The Anatomy Lesson of Dr. Nicolaes Tulp* in 1632, Rembrandt did a good deal of research beforehand. He presumably talked to other painters encountered at Uylenburgh's and discussed traditional ways of handling group portraits. The Dutch, then as now, seemed to find individual pleasure and prestige in joining associations, guilds, corporations and clubs, militia bands, and groups of regents or trustees, who looked after the running of charitable foundations – and who also wanted their particular association recorded by a painter and the portrait hung in the hall where they met. Each person who was portrayed would pay a share of the picture's cost. Rembrandt consulted the work of his predecessors in this area. He looked at old prints of martyrdoms and dissections, and undoubtedly studied the 1603 *Anatomy of Dr. Sebastian Egbertszoon* by Aert Piertszoon, in which Piertszoon, being paid by the head, crammed in several ranks of surgeons as in a school photograph. He probably saw Nicolaes Eliaszoon's 1625 *Anatomy of Dr. Joan Fonteijn*, Dr. Tulp's predecessor, the attendant surgeons grouped rather woodenly around Dr. Fonteijn and an instructive skull – which also served to put the viewer in mind of the transience of human life. Rembrandt throughout his career used the work of his forerunners, making worthwhile borrowings from it – a figure, a group, a theme – and, churning it up, transformed it on paper, copper plate, or canvas into his own work, and it must already have struck him that it would be more original not to shirk painting the corpse itself, as Piertszoon had shirked it (the corpse barely visible among all the doctors). One of the Miereveld family had done an attention-getting *Anatomy* in Delft in 1617, showing most of the corpse, with cut-open stomach and blindfolded head. Rembrandt wanted to fulfill the conditions of the job – to convey what was happening, to show who was involved – but he wanted to get the necessary facts across in an original and forceful manner.

In 1656, for *The Anatomy Lesson of Dr. Joan Deyman* he painted the corpse frontally, soles of the feet facing the viewer – in whom the picture produces the reverberations of an *Entombment of Christ*. He shows for the first time the dissection of the cerebrum, with the removed skull pan in the hands of the assistant,

Dr. Calkoen, standing, on the left, like an acolyte while Dr. Deyman holds a dissection tool over the brain, accurately colored, and parted to either side like hair.

In 1632 he was still working toward such original simplicity; originality came more readily to him. But even this was not without leg- and wristwork. He had to make studies of each of the participants, the doctors and the recently hanged Kid. The bulging muscles suggest that Rembrandt drew the corpse during the period of rigor mortis, six to thirty-six hours after death. The young artist also must have attended one at least of Dr. Tulp's demonstrations, to get some ideas about the background, the light, and ways of grouping the surgeons. However, when he started painting, he overruled reality in several respects. Anatomical demonstrations invariably dealt last rather than first, as shown by Rembrandt, with arms, legs, and feet; the extremities of the body were less likely to smell if left to the end. Evidently Rembrandt painted the group, doctors and corpse, changing the arrangement here and there as new composition ideas struck him, and then at the end painted in the dissected arm. Light plummets down onto Aris Kindt's huge white chest, seems to bounce around the faces of the spectating physicians, and brings one to a halt at the figure (in darker cloak, alone wearing a hat) of the good Dr. Tulp. With his tweezers, he is pulling up the tendons of the left arm while explaining what happens in the fingertips of Aris Kindt as he does so. That eloquent gesture he makes with his own left hand, bringing together the tips of his left forefinger and thumb, is thus both rhetorical and practical.

According to medically knowledgeable students of the picture, Rembrandt also departed from anatomical facts in painting the muscle Tulp is lifting: the *epicondylus medialis* points upward instead of inward. This, it seems, is because the painter did his anatomical homework in the very book Dr. Tulp has laid open at Aris Kindt's feet. Scholars have identified this hefty volume as *De Fabrica*, by Adriaen van der Spieghel, published in Venice in 1627. The illustrations were by Giulio Casserio, who was probably working with a limb completely severed from the body when he drew the anatomy of the left arm – and thus produced a muscle effect Rembrandt copied but that couldn't have happened with the arm still attached.

Not that the doctors seem to have been worried by this. No doubt they were most interested in how well the artist had captured their living faces. Moreover, Rembrandt had succeeded in making the subject of the picture something more than an anatomy lesson, focused on death; it was rather a celebration of death put to use. Dr. Tulp is a teacher and explorer – a leader of the Dutch age of discovery. It was fitting that he had a role in the discovery of Rembrandt.

Nicolas Tulp was thirteen years older than Rembrandt; at the time of this anatomy lesson he was thirty-nine, and already an eminent man in the city. Born

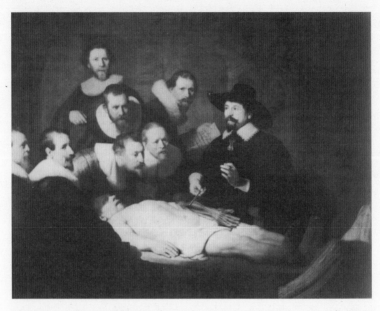

The Anatomy Lesson of Dr. Nicolaes Tulp. *Painting, 1632. Mauritshuis, The Hague*

with the name Claes Pieterszoon, he was the son of a cloth-dealer whose house bore the sign THE BLUE BLANKET. His grandfather was known only as Dirck of Zaandam. Quite how Claes Pieterszoon came by the name Tulp we do not know, except that in 1619 he bought a plot on the Keizersgracht, one of the great new semicircular canals, and commissioned the building of a splendid house for himself with a gable stone, De Tulp. A tulip appeared in the coat of arms on the doors of his carriage, and on one occasion, in appreciation of his work, he was presented with a tulip-shaped silver goblet. But he went on signing his name "Claes Pieterszoon," and he named his son, who was to become an English baronet, after his Zaandam grandfather, Dirck.

Not long after Rembrandt painted him and his anatomy lesson, Dr. Tulp referred to the anatomist as "the true eye of medicine." There were some fifty or sixty doctors in Amsterdam then, and Tulp, who had been a pupil of Dr. Pauw's at Leiden, led them toward a more enlightened practice of their profession. His book on clinical medicine, *Observationes*, went into several printings after being published in Latin in 1641; Tulp himself translated it in his old age into exuberant Dutch. It was a fascinating collection of case histories, most of them beginning

with a sharp, to-the-point description of the patient. In regard to autopsies, he recommended "cut and cut deep, and you will find the source of the problem." He taught special courses for Amsterdam midwives. He cast a cold eye on the medieval apothecary books still in use, full of incomprehensible remedies concocted from rarely obtainable materials; for example, bird droppings gathered at the full moon. Tulp felt that a doctor should encourage natural forces to cure the patient, and his prescriptions were simple. He wrote an economical apothecary book of roughly sixty prescriptions; introduced it, diplomatically, at a meeting of Amsterdam physicians; and, when he had their agreement, set up a commission to inspect apothecary shops to see they abided by the new rules – the first supervision by the authorities of medical practice in the Netherlands. He was the first doctor in Holland to identify a case of beri-beri, which arrived along with much else from the mysterious East. He took up newfangled ideas like visiting his patients in a carriage and drinking tea. Indeed, believing in the leaf's therapeutic properties, he recommended that his patients drink a lot of it daily. (He wasn't alone in this. A contemporary, Dr. Cornelis Decker, also known as Bontekoe, made his patients drink between fifty and two hundred cups of tea per day, which was good for tea importers if not the patient. And the tradition persists. When I was living here a few years ago, I came down with an inexplicable fever, perhaps a symptom of "flat neurosis," or a reaction to overcrowding. My local G.P., Dr. Biederwellen, who was otherwise a normal, practical fellow, doling out Valium to the women in the modern apartment blocks, prescribed for me the drinking of three liters of herb tea every day. I was quickly cured.)

Tulp's practice was large; it included rich and poor, the unknown and the distinguished. He mentions among his case histories a shoemaker who came to him with a swelling and a captain of the guards whom he treated for a wound. He sewed up a man who had been knifed so badly his lungs showed. He dealt with psychosomatic and psychological disorders, like that of Caspar Barlaeus, whom he thought to be "the greatest orator and poet of our age" – but who also for a considerable period didn't dare sit down because he believed his backside was made of glass. He treated the daughter of the painter Nicolaes Eliaszoon when she was ill, and apparently in payment Eliaszoon made the portrait of Tulp now to be seen in the Six Collection, in Amsterdam: a head and shoulders, with Tulp leaning over a stone on which is inscribed his motto, *Aliis inserviendo consumor*, "By looking after other people I consume myself."

Was Rembrandt a patient of Dr. Tulp's? Professor Heckscher, who has studied the background of *The Anatomy Lesson* with great thoroughness, is tempted to see the young genius from Leiden in a case described by the doctor. This was an

artist (*insignis pictor*) who was, Tulp wrote, *arte sua vix ulli secundus* – "in his own art accomplished and second to hardly any." Tulp doesn't mention his name. He says, however, that the painter suffered from (in Heckscher's words) "the somatic delusion that his bones were melting away like wax, so that his limbs seemed to him in constant grave danger of buckling under his weight." This melancholy fellow spent a whole winter, Oblomov-fashion, in bed, but was eventually talked back to work and health by the doctor – and perhaps also by threats of the tea-cure. Constantijn Huygens had expressed a certain anxiety about Rembrandt's sedentary life in Leiden. There was also the curious formal inquiry made about Rembrandt's health in July 1632. An Amsterdam lawyer called at Uylenburgh's and asked a young maidservant who answered the door if Rembrandt was at home. Told yes, the lawyer asked to see him. The lawyer asked Rembrandt how he was, and Rembrandt replied, Thank God, he was in good shape and healthy. This incident might well make one wonder, but has recently been explained by the renowned Dutch archivist Mr. H. J. Wijnman. A year before the lawyer called, two people in Leiden had made a bet whether a hundred people whose names they listed would be alive one year later. Rembrandt's was one of the names picked for their wager, and the lawyer was thus simply checking up to see that he was still alive. As further evidence of his robust condition, one may add that his prolific production of pictures does not seem to have slackened at this time.

Aliis inserviendo consumor. Dr. Tulp's motto perhaps sounds a trifle self-congratulatory to us, but the mid-seventeenth century enjoyed that sort of adage. This particular phrase appears on a burning taper in a *Martyrdom of Saint Sebastian*, painted by Mantegna, and teachers and magistrates often used it in the then-popular emblem books. People kept albums with emblems and devices printed in them, and blank pages in which they asked friends and acquaintances to put autographs, verses, and sketches. It was common to have a motto on the facade of one's house stressing, say, one's commitment to truth or liberty. Dr. Tulp served others, but he did not burn himself out in the process; he thrived on it. His dedication to medicine was matched by his ambition to be one of the oligarchy that ran the city Rembrandt had chosen to live in. In Amsterdam, family connections mattered a great deal, but a new man could break into the ruling circle through the right job, the right marriage, and by accepting the right responsibilities. Tulp's first wife was a respectable, fairly well-off woman who bore him two children. At the age of twenty-nine he became a member of the Vroedschap, the city council. This was a lifetime appointment, and new members were chosen by the council, who thus kept things very much in their own hands. Qualifications included being over

twenty-five and a citizen of the city (which you could be by birth, marriage, or by paying a fee – 50 guilders; a lot of money in 1650). Several councilors were doctors, and others were fascinated by scientific experiment; Tulp was obviously a good person to co-opt. He served on the council for more than fifty years and, at the age of sixty-one, was chosen to be one of the four burgomasters, each of whom served for a year (and sometimes a second term of a year), and took it in turn to be the head – the Lord Mayor, as it were – of the city.

Knowing someone like Tulp, Rembrandt saw the government of the city perhaps as a little less of a closed shop or old-boy net than did most residents of Amsterdam. He later came to know Frans Banning Cocq, whose father, an apothecary in Amsterdam, had arrived penniless from Bremen and been forced to beg in the streets. Frans married Maria Over-lander, the daughter of a city councilor, and four years later found himself on the council too. Rembrandt would know people in the "regent class," who shared among themselves the important jobs and positions, running guilds and institutions. Dr. Tulp received no salary as councilor; as burgomaster he got 500 guilders a year; and his medical practice would hardly account for the fortune of several hundred thousand guilders he left on his death. But eight years after joining the council he married for the second time; his second wife was an extremely wealthy woman from a leading Amsterdam family.

There were many city appointments that allowed one to do some nest-feathering, well within the bounds of Dutch morality or the strictures of seventeenth-century mottoes. Excellent fees were to be earned in such posts as administering the estates of those citizens who died without making a will. Tulp consumed himself in being a governor of the Oude Zijds Latin School and in being city treasurer for eight terms of office. His son was appointed to the board of the East India Company. His daughters were much sought after in the relatively small interconnected world at the top. One had for a suitor Jan de Witt, for twenty years the leading statesman of the United Provinces. One married Arnold Tholinx, inspector of the medical college from 1642 to 1653, whose portrait Rembrandt later etched, and who lived next door to Tulp in the Keizersgracht. One married the patrician Jan Six, who was for a time to Rembrandt both patron and friend.

In the Six Collection in Amsterdam today, in the magnificent house on the Amstel of Jonkheer Six van Hillegom (Jan Six the Ninth, as he is sometimes called), hang half a dozen portraits of Nicolas Tulp, and pictures in which his face appears with others. He was a proud family man from start to finish, and the painters caught this. Nicolaes Eliaszoon painted various family groups – one of Tulp's mother and the children of his first marriage; another, in 1635, of Tulp

A Coach. *Drawing,* c. *1655. Courtesy of the Trustees of the British Museum*

with the children of the first marriage and his second wife and their three children. In 1664 Adriaen Beeldemaecher painted the old doctor, wearing a skullcap, with one of his granddaughters. Among the many painters his true eye fell on was Paul Potter, obsessed with horses and cows. Tulp brought young Potter to Amsterdam from The Hague, bought many of his pictures, and in 1653 commissioned him to paint a life-sized portrait of his son Dirck, on a prancing horse. Tulp also loved poetry; he was a member of the circle of literary-minded people who gathered occasionally at Muiden Castle, six miles east of the city, the home of the historian Pieter Cornelis Hooft. There, on the south shore of the Zuider Zee, one could watch the East Indies or Baltic fleets bringing in wealth to the city, and converse with men and women of letters and of classical inclinations, including Barlaeus, Vondel, and Maria Tesselschade Visscher, daughter of the poet Roemer Visscher. She was named after a shipwreck on the island of Texel in which her father lost a lot of money. Despite her reputation as a bluestocking, she sometimes went swimming in the Amsterdam canals.

Dr. Tulp had a catholic interest in contemporary poetry, painting, medicine, and government, but for all that practiced a remarkably staunch Calvinism. His

fellow councilor Hans Bontemantel admired Tulp's piety but thought he showed himself too much on the side of the orthodox Calvinists in the persecution of the more liberal Remonstrants in the mid-1620s. Dr. Tulp was one of the burgomasters who in 1654 banned performances of Vondel's play *Lucifer*, after complaints from the Reformed Church council about blasphemous language in it. He was annoyed by the new extravagance that seemed to be creeping in after midcentury. In 1655, particularly irritated by the sumptuous wedding feasts that were becoming fashionable, he had a law passed against them – presumably relaxed fifteen years later, when Louis Trip spent 8,300 guilders on his daughter's wedding. Dr. Tulp strongly disapproved of pagan imagery, the naked nymphs and lascivious satyrs who were to be seen cavorting in pictures in the stylishly redecorated houses of the oligarchy. When the young Prince of Orange, William III, came to the city on a state visit in 1660, Dr. Tulp requested – according to Councilor Bontemantel – that "the burgomasters would please not have such heathen gods and goddesses ride on show in triumphal cars as was done when the House of Nassau was entertained the previous year."

Yet it is pleasant to know that a splendid party was given in 1672 to celebrate his fiftieth anniversary on the council. Each guest brought his own servant; specially composed Latin poems were read; toast followed toast; and twelve courses were eaten. The party lasted from 2:00 P.M. to 11:00 P.M., which was late in those days, when most people were up before dawn. It is also good to know that when the council banned the use of private carriages in much of the city center, he was among the few exempted: the carriage with the tulip on the side and the old man looking like a Roman senator within could still be seen in the congested streets and bumping over the bridges. He died in The Hague in 1674, at the ripe age of eighty-one, while serving his city on a delegation to the provincial assembly, the States of Holland.

VII

Making a Splash

LIFE AT HENDRIK UYLENBURGH'S house, where Rembrandt lodged for four years in the early thirties, wasn't at all dull. *"La famosa accademia di Eylenborg,"* the Italian art historian Filippo Baldinucci called it in 1686, after talking to Bernhardt Keil, a Danish artist who studied with Rembrandt in Amsterdam around 1642 to 1644. Just what Rembrandt's relationship or investment of 1,000 guilders involved, we do not know, but possibly he was for a time the master painter – the senior lecturer – in Uylenburgh's establishment. There young artists came to copy pictures, thus training themselves and providing works Uylenburgh could sell. It was a form of art factory and also – before art colleges – a place where art was to be seen and talked about. Uylenburgh imported cargoes of paintings from Italy and Germany. Well-to-do merchants, some of them partners in the art business, came there to look at pictures and also to have their portraits painted. Some came for conversation about other subjects, including religion. For Rembrandt, who found it a useful and thought-provoking home, there was soon an additional pleasure: the presence in the house of Uylenburgh's good-looking young cousin, Saskia.

Uylenburgh was twenty years older than Rembrandt. His father – brother of Saskia's father – had gone from their hometown of Leeuwarden, in Friesland, to Poland, where he worked as the royal cabinetmaker. Hendrik was born in Crackow, lived in Danzig, and, settling in the Breestraat around 1627, brought with him cosmopolitan and slightly dissident connections. Saskia's father had been a member of the Reformed Church. Hendrik's father had been a Mennonite, a

member of a Dutch Anabaptist sect that had been persecuted during the sixteenth century. But by the time of Hendrik's move to Amsterdam, the Mennonites were, like many other religious groups, tolerated as long as they didn't conduct their affairs too conspicuously. The Mennonite community in Amsterdam had a corporate shareholding in Uylenburgh's business. He paid them 5 percent on their 1,000-guilder investment, a fact that perhaps demonstrates that the Amsterdam mercantile spirit affected nearly everybody; the Mennonites were reputed to be opposed to the charging of interest on loans. A number of the individual shareholders in Uylenburgh's firm were Mennonite, and so were many of the merchants and professional men who came, often with their wives, to have their portraits painted. In the Uylenburgh house Rembrandt was therefore among people generally committed to a gentler form of Christianity than the Calvinism that set the prevailing doctrinal tone in the United Provinces in those years – people who were by and large pacifist, believers in adult baptism, outsiders in that they were exempted from bearing arms and, refusing to take oaths, were excluded from public office. They did not believe in predestination. Their only true authority was the Bible; this they constantly read and discussed.

Commissions rained on Rembrandt in his first years in the city. During 1631 and 1632 he completed no less than forty-six portraits, including one of the Stadholder's wife, Princess Amalia van Solms. His own pictures were copied by young painters at Uylenburgh's, for sale in the provinces. And talking with such colleagues as Jacob de Wet, Claes Moeyaert, Simon de Vlieger, and other members of the "academy," he would have picked up information about technique, materials, and buying and selling works at auctions. The painters also probably exchanged work with each other. In 1636, when the craze for speculating in tulips was at its manic peak, Jacob de Wet made a wager with the artist C. Coelenbier, betting him that in the campaign then going on in the resumed war against the Spanish, the Dutch would fail to take a certain entrenchment in the southern Netherlands by June 30. De Wet staked a tulip bulb called the Lyons. Coelenbier put up 24 guilders. De Wet also said that if Coelenbier won, he could keep a print of Dürer's and two prints by Rembrandt that Coelenbier had agreed to buy for 3 guilders, ten stuivers, but not yet paid for. De Wet lost the bet; after a nine months' siege, the Spanish gave up the entrenchment on April 29, 1636.

Like other craftsmen, painters were involved in a guild. This was the Guild of St. Luke, which the painters shared with bookbinders, glaziers, makers of playing cards, and print-sellers (and in Amsterdam, after 1621, compass-makers and luggage-manufacturers). Karel van Mander expressed in his *Schilderboek* pleasure that the medieval status of the painter as the practitioner of an *ambacht*, a fairly

lowly craft or trade, was being replaced by a different, though less certain position. But the guilds retained a practical function as benevolent organizations that helped look after members' widows and orphans. Each member had an ordinary gilt guild medal and also a funeral medal, with his name on it, which would be brought around to him as a reminder before the funeral of a deceased member and which he would hand in at the function itself: this ensured a strong, comradely turnout at the obsequies. (The St. Luke's Guild funeral medal in the late seventeenth century was bronze, cast with a scroll and skull-and-cross-bones decoration around the engraved name of the member.)

Rembrandt's only documented connection with the St. Luke's Guild was in 1634, when he was issued a funeral medal – although he may well have gone to Pieter Lastman's funeral the year before. In the skimpy surviving records of the guild there are no indications of what dues he paid; it appears he was never an alderman of the guild. In Amsterdam the guild's control over its members may have been loosened by the presence in the city of many artists from other places. They did not feel obliged to join it. Moreover, the presence in the guild of all sorts of other craftsmen may have kept at a distance those painters who were beginning to develop a sense of independent importance as artists.

The St. Luke's Guild met at the Waag, along with the Surgeons' and the Bricklayers'; each guild had a room, with a separate entrance to the Nieuwmarkt. Like modern unions, the guilds tried to keep outsiders from taking away their members' business. The historian of art and architecture Nikolaus Pevsner has described the action in The Hague of forty-eight painters (among them Jan Lievens) who in 1655 decided that their Guild of St. Luke, in which they were thrown together with embroiderers, wood-carvers, and sign-painters, was not looking after their interests properly. They set up an association of their own called Pictura. No artist from outside The Hague was allowed to practice there unless he paid a fee to Pictura. Only Pictura members were allowed to sell paintings in The Hague, except at fairs. In Amsterdam nothing so like a closed shop was attempted, but in 1657 the Guild of St. Luke there brought in two new rigorous regulations that may well have affected Rembrandt. Perhaps thinking of the effect of their colleague's mismanagement on their own affairs, they decreed that a member who sold up, presumably after going broke, was to conduct the selling-up without delay. Furthermore, he was no longer to carry on trade in the city, either publicly or from his own home.

The guild's social functions also had their ups and downs. The fashionable portrait painter Bartholomeus van der Helst helped organize the 1653 Saint Luke's Day feast, at which Vondel was honored, but two years later the feast went

uncelebrated – possibly (the art historian Dr. Katharine Fremantle thinks) because of the sour mood Jacob van Campen was in; he had just resigned abruptly from his post as architect of the new Town Hall.

The guild in any case could not hope to provide security for the artist in a time that lacked the stability that had prevailed in the Middle Ages. Dutch painters had a freedom abruptly new in northern Europe. They no longer worked for the church or a king. They were able to pick a genre they enjoyed and to paint within it what they liked – able to be flower painters, sea painters, or interior painters, painters of domestic scenes or views of the sparse, whitewashed naves of churches the Calvinists had taken over from the Catholics. They could arrest the viewer's attention with simple zest or mathematically sophisticated systems of sight and proportion. Because their work would not be hung in churches or – except rarely – in palaces, the painters of this time were limited by the size of canvases that would fit on house walls and by the price a merchant would be prepared to pay to see on those walls his own features and those of his wife and children.

But a painter clearly skillful in a certain line of work could acquire commercial patrons; art dealers began to appear and flourish, providing monthly payments to artists in order to keep them busy at whatever they did best. However, this now and then resulted in overproduction. Although everyone in the United Provinces seemed to be buying pictures, and every burgher's family had to have its portrait and every guild its group portrait (painted often by painters of remarkable talent), the market was fickle; few of the buyers had the education or trained taste of men like Tulp and Huygens. It was possible for an artist to do well and (still painting well) suddenly do very badly. Pevsner tells of one Rotterdam art dealer who left 200 pictures, and the owner of a common "slop shop" who died in possession of 1,500 – caught, as it were, with more on their hands than they knew what to do with.

In these circumstances many artists plumped for security, if it presented itself, or "diversified" into occupations that had fewer ups and downs. A few painters were of fortunate birth in well-to-do or well-connected families. Some were burgomasters of their towns, such as Isaac Claeszoon van Swanenburgh, in Leiden (father of Rembrandt's teacher), Willem Verschuring in Gorkum, and Jacobus Mancadam in Franeker. Jan van de Capelle, painter of high, luminous skies and calm water, and a passionate collector of Rembrandt drawings, had a prosperous family cloth-dyeing business behind him. For a good number, however, painting was the family business, passed down as long as talent persisted: there were generations of Breughels, and many father-and-son partnerships – Cuyps, Vrooms, van der Neers, van de Veldes, van Nieuwlandts among them. But though some painters

when riding high got high prices for their work (Rembrandt on one occasion received 1,600 guilders, and Hendrick Vroom in 1610 was paid 1,800 guilders by the States of Holland for a sea piece they presented to an English prince), many of the works that are now considered to be masterpieces of the age were undoubtedly bought for small sums. Jan Steen, owing 27 guilders' interest on some money he had borrowed, arranged to pay off the interest by painting *three* portraits of his creditor. Emanuel de Witte, splendid painter of church interiors and street scenes, had to indenture himself at about the age of forty to a lawyer, to whom he agreed to give everything he painted in return for lodging, food, and 800 guilders a year. (Ultimately this arrangement didn't help. There was litigation and added debts, and presumed suicide; de Witte's body was found in a canal, after a thaw unfroze it.)

Many painters – including, in the eyes of the future, many of the brightest stars – had second jobs. For Aert van der Neer, Jan Steen, and Jan Vermeer, running a tavern was a solution. Steen, son of a brewer, opened an inn in Leiden in 1672. Vermeer took over his father's tavern and also dealt in pictures, but still died insolvent. Jan van Goyen, whose daughter Steen married, found time to paint his golden land- and seascapes while dealing in houses, pictures, land and tulips, valuing and traveling; he also died insolvent. Cornelis Brizé, the still-life painter, ran a refreshment bar in the Amsterdam theater. So it helped to have solid work. Samuel van Hoogstraten, a Rembrandt pupil, became provost of the Dordrecht mint. Karel van der Pluym was appointed Leiden's municipal plumber. Philips Koninck, another graduate of Rembrandt's atelier, bought a shipping business that handled canal traffic between Amsterdam and Rotterdam. Some painters in time found attractive the idea of not painting at all. Ferdinand Bol, a Rembrandt student, isn't known to have put brush to canvas after marrying a well-off widow in 1669. Meindert Hobbema, the great landscapist, married a girl who worked as a maid in a burgomaster's house, and the burgomaster helped Hobbema get a post in 1668 as a wine-gauger for the Amsterdam excise office; very few pictures came from him after that.

The fact is that despite the prevalence of pictures, despite the protection of the guild and commissions from corporations and wealthy burghers that artists received, it was possible for many people to be alive in Holland then and not bother about art at all. Jan de Witt, who had his portrait done by several artists and regulation busts sculpted, who was an acquaintance of Spinoza and the pre-eminent statesman of the time, went through life seemingly unaware of Rembrandt. Sir William Temple enjoyed living in the Netherlands and wrote his perceptive *Observations upon the United Provinces* without mentioning painting once. There was

hardly a nobility that, in Italian fashion, would patronize artists. The merchant oligarchy believed in looking after itself and thought it should keep the small burgher small – and, with him, craftsmen, artisans, artists, and tradesmen of that kind.

And yet there was the possibility of a different life for an artist, which could be felt even in bourgeois Holland. Something was known of the lives of Renaissance artists, and the works of Raphael, Michelangelo, and Leonardo could be seen in Amsterdam. From them came suggestions of genius, and fame, as constituents of the artistic life. There were opportunities abroad for plumed courtier's hats and flourishes of trumpets, for second jobs not as plumbers or tavern-keepers but as royal ambassadors. These were advantages the Dutch had forgone, along with the Spanish connection and Hapsburg politicking, which was conducted on a far grander style than the States General would consider, even if they did insist on being called their High Mightinesses. But word spread of the careers of Antonio Moro, Anthony van Dyck, and "the prince of painters," Peter Paul Rubens – like van Dyck knighted and at home in English palaces, and living like a great lord in his Antwerp palazzo. One heard that Rubens directed the painters at work on his canvases like a general conducting a battle – that while the painting was going on he dictated his letters! Rembrandt, sitting and writing in his determined script to the secretary of the Prince of Orange at the only court to hand, may well have had in mind for himself a more conspicuous and celebrated life than simply being dean of the Uylenburgh academy and the appointed portrait painter to the burghers of Amsterdam.

There was in many of Rembrandt's pictures done at this time a striving for effect that gives them their strange mixture of attraction and repulsion – virtuosity of technique slightly at odds with theatricality of subject matter. The painting he insisted Huygens accept as a gift from him – showing he could make a munificent gesture in return for Huygens's help – was a horrific *Blinding of Samson*. Perhaps Huygens would hang a curtain across it, as he did with Rubens's *Medusa*. It was designed for that sort of competition. But together with the Rubens-like "goings-on" and a Caravaggio-like stage-lighting went a somewhat uncouth Dutchness or realism. The child peeing as it is lifted aloft by the eagle; the very eyeball exploding as the pike is driven into it. He was compelled to show that he could do as well or better all that a painter had to do: paint velvet, fur, the intricacy of ruffs and the sparkle of jewelry. Sometimes, for all the skill, the result seems forced. And yet in many of the portraits he churned out at this time, brilliantly finished and undoubtedly pleasing to those who commissioned them, there are insights and

intensities, achieved by the way a hand is formed or the eyes deepen, which give them an edge over those painted by his rivals in the portrait business.

One wonders if it was by asking her to sit for him that he got to know the girl he met at Hendrik Uylenburgh's. A painter has a splendid chance to impress and make his undoubtedly flattered subject talk as he puts all the tricks of the oil-painting trade to work, getting on canvas the black-brocaded gown with high waist, the flat lace collar, pearl necklace, hair, nose, and eyes. "What color *are* your eyes?" The question involves going up and looking deep into them. Hendrik Uylenburgh's cousin Saskia was good-looking and well born. Her branch of the family preserved the "van." She was just twenty, six years younger than Rembrandt, the youngest among eight children, four sons and four daughters. Her mother had died when she was six; her father when she was twelve. Rombertus van Uylenburgh had been a burgomaster of Leeuwarden, chief town of Friesland, calmest and greenest of the provinces, a lawyer and public man who had been on hand when William the Silent, leader of the revolt against Spain, was assassinated in 1584, and who had served in the 1587 deputation that offered the sovereignty of the Netherlands to Queen Elizabeth of England. After her father's death, an Amsterdam Calvinist preacher, Jan Cornelis Sylvius, married to a cousin of Saskia's, acted as her guardian. Two of her brothers were lawyers, while a sister, Hendrickje, was married to Friesland's leading portrait painter, Wybrandt de Geest. Saskia had money – but her father's wealth had been divided among eight heirs, and her inheritance was probably nearer 20,000 than the 40,000 guilders it was once estimated at.

Although at the age of twenty-one she showed signs of a double chin, Rembrandt found her pretty, as well as a social catch. He made a lovely sketch of her on some of the best parchment that could be got, writing under the drawing, "this is drawn after my wife, when she was twenty-one years old, the third day after our troth plighting – the 8th of June, 1633." Saskia sat for her intended, looking slightly bemused but happy, wearing her big straw hat with flowers. They were married in Friesland in June 1634.

In Amsterdam Rembrandt and Saskia lived, it seems, first with the Uylenburghs again, then from roughly 1635 to 1638 in a house in the Nieuwe Doelenstraat, close to the guildhall of the civic guard – whose group portrait Rembrandt would soon be asked to paint. Rembrandt paid the high rent of 600 guilders a year for this house. (His landlord was Willem Boreel, a lawyer of the East India Company, who lived next door. Another member of this family, Adam Boreel, had "got" religion, was said to have lived for a time in a hermit's hut, and had spent great sums in alchemical practices, seeking the old magical answer to the world's problems, the

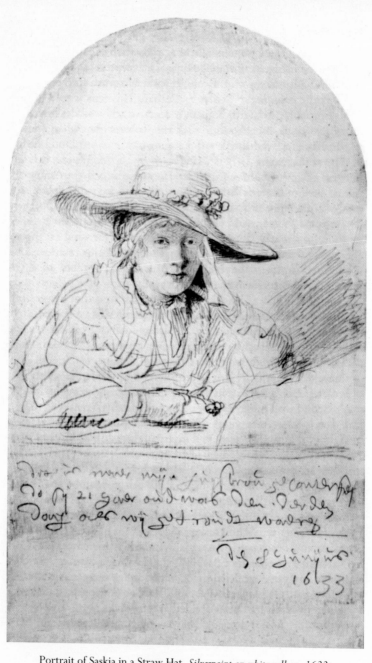

Portrait of Saskia in a Straw Hat. *Silverpoint on white vellum, 1633.*
Kupferstichkabinett, Staatliche Museen, Berlin

philosopher's stone.) After this the young couple lived for a short while on the Binnen Amstel, where the river begins to bend into the inner city. Their house on the quayside would have given them a splendid southerly view back along the river. Here their landlord was a sugar-refiner, Jan van Veldesteyn; the house, known as the Four Sugar Loaves, stood in front of the sugar-making premises. And it was here that they were living when Rembrandt entered into negotiations with Pieter Beltens the Younger and Christoffel Thijs about the house in the Breestraat.

Was the urge to settle down bringing to a close a rootless period of living it up? In the years 1637 and 1638 Rembrandt was involved in a lawsuit in Friesland. Some of Saskia's relatives claimed that he was squandering his wife's fortune in luxury and ostentation. Rembrandt, in rebuttal, declared this was a libel; he was "superabundantly" provided with means. He lost the case. Perhaps, having married an upper-class young woman, he felt the same compulsions as many of his patrician contemporaries: while some were attracted by a Puritan plainness, others acknowledged the pull of display and pomp; some did their own shopping and walked about without footmen while their fellows researched their family trees and took titles. A painting that is sometimes taken for evidence here is the portrait he did of himself dressed up as a cavalier, in plumed hat, sword at his waist, while Saskia sits on his lap, elegantly dressed but looking withdrawn about the whole thing. Ruskin, rather peculiarly, thought that this romp was "on the whole, his greatest picture, so far as I have seen." Ruskin thought it showed Rembrandt and Saskia "in a state of ideal happiness." More recent art historians have speculated as to whether it was a *vanitas*, meant to point a moral about a life of gluttony and jollification, or a prodigal son – but in that case Rembrandt had put aside his usual Biblical realism by setting it in modern dress. Something secretive in Saskia's expression reminds me of the Delilahs he for some reason painted frequently in these years. Rembrandt perhaps had in mind Raphael's portrait of himself with La Fornarina sitting on his knee. Possibly, done tongue in cheek, Rembrandt's painting indicated an awareness of the temptations of good living and high status.

A connection may be noted between two entries written at this time in the album of a visiting artist from Weimar, Burchard Grossman the Younger. (Grossman's father was probably responsible for the commission Rembrandt got to paint the portrait of the German composer Heinrich Schutz.) Visiting the Uylenburgh academy, young Grossman presented his album for the usual epigrams and mottoes. Rembrandt, in addition to making a little sketch of an old man in a cap, wrote, "A pious mind prizes honor above wealth." (Was he partly addressing himself?) And one wonders what prompted Hendrik Uylenburgh to write *Middelmaet hout staet*, "Moderation wears well." However, 1639 was a year in which the tide seemed

to run high for Rembrandt and his country. In the Battle of the Downs Admiral Maarten Tromp trounced the Spanish fleet and ended Spain's history as a naval power. Rembrandt put aside any thought of moderation and agreed to buy the Breestraat house.

VIII

Life with Women and Children

THE KERMESS in the Nieuwmarkt is a post-Lenten fair that now has side-shows, bingo, merry-go-round, bumper cars, and various pieces of machinery for spinning people around and hurtling them up and down. They grin queasily as they rejoin the crowds jostling around the stalls that sell ice cream and candy floss, popcorn and *poffertjes* – the little hollow Dutch pancakes cooked out of doors in huge iron pans and served hot, with confectioner's sugar on them. Much of the amusement apparatus appeared to come from Belgium. Many of the faces in the throng looked to be Chinese or Surinamese. But despite a veneer of the present day, as in the loudly amplified rock music or strobe and neon lights flashing on and off, there was a feeling of something happening there around the Waag, the old St. Anthony's Gate, in much the same way it had happened for hundreds of years. It was an ancient mixture of entertainment and spectacle, the holy day converted into holiday. Indeed, the kermess was once called Saint Kermis, as if the orgy it sometimes became could, thus sanctified, be enjoyed with a clear conscience. The May kermess in The Hague lasted two weeks and attracted everyone in town, high or low. Jan de Witt, the Grand Pensionary, was seen at the kermess in 1654 at a critical moment in the Anglo-Dutch war, talking calmly about affairs of state while standing by a pancake stall. One imagines that Dr. Tulp, wending his way through the crowds during the 1630s to the Surgeons' Guild doorway of the Waag, found the kermess too pagan. On the other hand, Rembrandt – walking up the

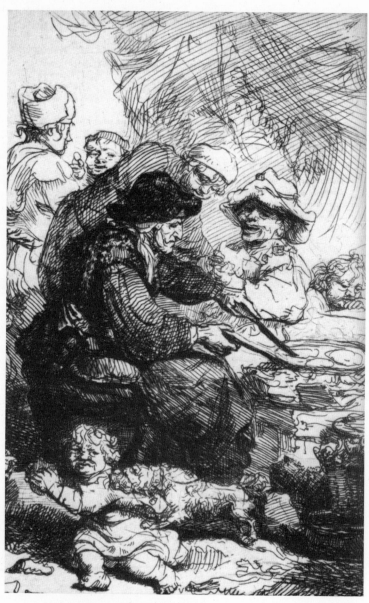

The Pancake Woman. *Etching, second state, 1635. Courtesy of the Trustees of the British Museum.*

Breestraat — would have drawn the hawkers of patent medicine and the pancake women.

Renate and I went late one afternoon and sat in the open air in front of the *poffertje* stand. Many people of the neighborhood whom she knew were there: parents with children; old friends with new friends. She pointed out to me, among those eating *poffertjes* or playing games of chance, several recent rearrangements — a girl who had divorced her husband and was now living with another woman; a woman who was with her son and her lover, who was tolerated by her husband. Renate has been married twice and now lives alone, busy and not unhappy. Our conversation wandered into how, in the last hundred years — which is rather sudden, in historic terms — man has had to get used to lifelong monogamy. Men and women have been bound to the same marriage partners for fifty or sixty years, with all sorts of stresses and strains resulting. In previous centuries men often had two or three or four wives, one after another, as childbirth and consequent complications snatched women away.

In 1656 Rembrandt was legally a widower; he had been so for fourteen years. He had stoutly gone on living in the Breestraat house, which he had bought with Saskia, and which had been their home until she died in 1642. The girl in the flowered hat had awfully soon become a woman in a bed-cap, run-down, listless. Illness seemed to prevail in her family; her mother, some of her brothers and sisters, died young. The first three children she and Rembrandt had, died soon after birth. Only the fourth lived. (A 75 percent infant mortality rate was recorded in London in the early eighteenth-century, and Amsterdam's was presumably not far from this figure.) Rombertus, the first born, named after Saskia's father and baptized in mid-December 1635, lived about two months. It was customary for a son to be named after the father's father — in this case, Harmen; but Rembrandt may have indulged his wife's wish or his own esteem — and this was also perhaps a reason for the fact that Saskia's relatives were invited to be witnesses at the christenings of his children while his own family, it seems, were not. (However, Rembrandt and Saskia may have followed a natural parental instinct and asked well-to-do rather than poorer people to be godparents.) In any event, the next child was named Cornelia, after Rembrandt's mother; baptized July 22, 1638, she lived three weeks. A second Cornelia, born almost exactly two years later in the Breestraat, in the same year Rembrandt's mother died, lived only two weeks.

It ought to be stressed that these were tragedies, though of common occurrence. John Evelyn, that indispensable seventeenth-century Englishman, recorded in his *Diary*, along with so much else, the death of his children — five out of seven. Three died in infancy; one at five; one at eighteen. Evelyn wrote on January 25, 1654;

Saskia Asleep. *Drawing*, c. 1635. *(Signed by a later hand, Renbrant.)*
Ashmolean Museum, Oxford

"Died my son John Standsfield of convulsion fits, buried at Deptford on the East
Corner of the Church, neere his mother's greate Grandfather . . . being a quarter
old, and little more, as lovely a babe as ever I beheld." Small infections could be
fatal. Although smallpox and plague were recognized, and typhoid fever was first
described in England in 1659, there were many dropsies, agues, and poxes for
which we have other names and for which there were then no remedies. Of course
if there was tuberculosis in the van Uylenburgh family, as some scholars suggest,
then Saskia's children were doomed from the start.

Strange fashions of the time didn't always help. Dutch women thought it
advisable to fast after the seventh month of pregnancy, possibly with the hope of
keeping the baby small, but with the effect of weakening both mother and child.
Infants were swaddled tightly, so they were unable to exercise their tiny limbs,
and wrapped in further layers of clothing. Fresh air was to be avoided at all costs.
(England, in these respects, was in advance of Holland; windows were opened
and swaddling abandoned in England in the course of the seventeenth century.)
Despite the Dutch passion for household cleanliness, the sweeping, scrubbing, and

Woman Seated on the Ground Suckling a Baby. *Drawing, c. 1635–1640. (Two sketches on the other side of the paper, showing a woman with a baby and a man in a turban, show through.) Nationalmuseum, Stockholm*

polishing, which Sir William Temple ascribed to the damp and the overcrowding of people, and Johan Huizinga thought sprang from the need for germ-free conditions in cheese-making, there was a notable lack of common-sense hygiene around a childbed. Doctors and midwives didn't wash their hands. There seemed to be no more need for children to be washed and clean than there was for grownups — who might take a bath only on medical advice. There was, perhaps justifiably, a suspicion of water — of drinking water, which in most Amsterdam houses came from a cistern, filled by gutters from rain that fell on the roof. Ground water, pumped up in the yard, might do for household chores. The water in the canals

Woman Carrying a Child Downstairs. *Drawing*, c. *1636.*
By permission of the Trustees of the Pierpont Morgan Library, New York

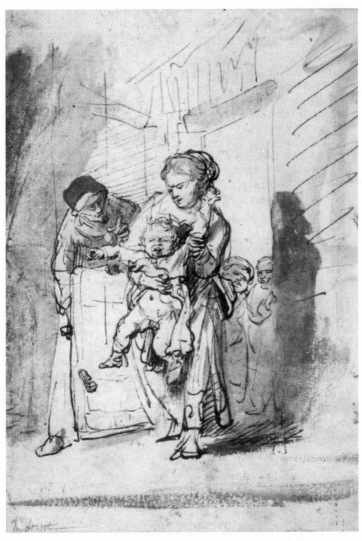

The Naughty Child. *Drawing, c. 1635. (Signed by a later hand, Rembrant.)*
Kupferstichkabinett, Staatliche Museen, Berlin

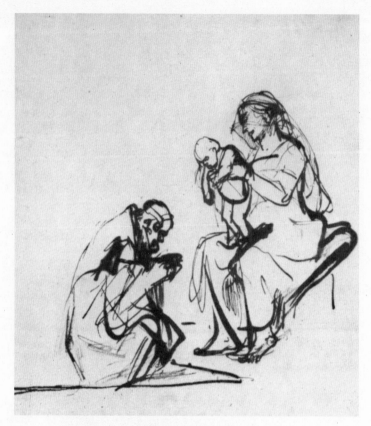

Study for an Adoration of the Magi. *Drawing*, c. *1635.*
Rijksprentenkabinett, Rijksmuseum, Amsterdam.

received many emptied slops and what ran out of primitive drains. There were
stricter controls over food – as, for example, over the ingredients of bread. Cows
were inspected by city officials before slaughtering, and butchers had to sell fresh
meat within twenty-four hours or salt it.

Rembrandt drew the life in his house, the everyday reminders of the necessary
and commonplace, which, would-be patrician or not, he recorded. He drew babies
lying in cradles. A study of *The Holy Family with Angels* deposits the Infant Jesus in a

Portrait of Titia van Uylenburgh. *Drawing, 1639. (Signed by a later hand, Rhimbrand.) Nationalmuseum, Stockholm*

typical Dutch wicker cradle. His children were fed from breast and bottles. Babies were carried, held, and loved. He drew Saskia, or is it a nurse, carrying a child downstairs, the child's heaviness emphasized by the plumb-weight effect of the woman's hanging purse, the little boy's plump arm around her back not supporting his own weight at all; she seems to kiss his cheek, which is pressed against hers. There is a lovely drawing of a mother showing her baby to an elderly kneeling man; the mother's head tilted, the baby flopping forward, its limbs all spaghetti at that age. At other times his children kick and scream. Eventually he was given a model of his own making who survived the first crucial months. Titus, his son, was baptized in the Zuiderkerk in September 1641. He was named after Saskia's sister Titia van Uylenburgh, who had been a frequent visitor at the Breestraat house

Two Women Teaching a Child to Walk. *Drawing*, c. *1640.*
Courtesy of the Trustees of the British Museum

(Rembrandt had drawn her, sewing, head down, wearing pince-nez). Titia had died a few months before Titus's birth.

Rembrandt's drawings demonstrate a parent's pleasure at seeing his child take its first steps, tottering the little way from mother to nurse. Walking was an art learned with the help of various devices: a framework that held the child upright as it moved itself forward; and the *valhoed*, literally a "falling hat," which had a protective cushion round the brim. Learning to walk was also a symbol, in that symbol-conscious age, of self-improvement through practice, so Rembrandt in making these drawings may have killed two birds with one stone: drawing what he wanted to draw while pointing a moral for his students.

The birth of Titus, however, was another stage in Saskia's decline. Rembrandt had often sketched her, head in hand, looking pensive, and now he drew her in bed, sitting up with a hand under her chin or lying on her side, looking at once bored and apprehensive, ignoring the baby, near the back bed curtain, preoccupied with its own hands and feet. Soon she was too weak to sit up; she lay, hands folded or fallen

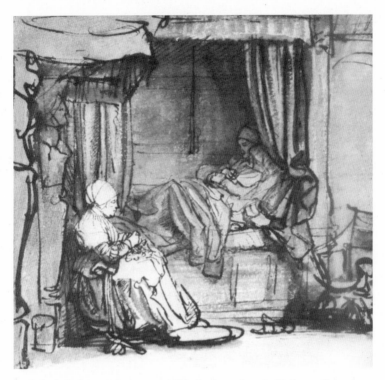

Saskia's Bedroom. *Drawing*, c. *1639*. *Fondation Custodia (Collection F. Lugt),
Institut Néerlandais, Paris*

limply next to one another. She slept, and her white face had almost the pallor
of death. Women sat with her while getting on with the darning or needlework.
Rembrandt sat in the chair we see in various drawings and etchings near the foot
of the bed: a heavy, old-fashioned piece of furniture with carved wooden frame,
leather seat and leather back, unfolding ancestor to a director's chair. He must
have sat there sometimes to give her company; sometimes in vigil. But pen and
paper *had* to be used. With a few lines and squiggles, some dabs of wash, he seized
the last pacific moments.

Titus was nine months old when his mother, not yet thirty, died, on June
14, 1642. Rembrandt purchased a grave in the Oude Kerk, on the Oude Zijds

Voorburgwal, and there she was buried. They had been married eight years, living in the Breestraat house barely three. He had drawn and painted her many times, and found it hard to give up. A posthumous portrait of Saskia is dated 1643; it is painted on an expensive piece of mahogany, as if to increase its chances with time. There is also something of Saskia's features in those of the strange, ghostly little girl who bustles her way through *The Parade of the Civic Guard Led by Captain Frans Banning Cocq* – the big painting commonly called *The Night Watch* – which he finished, along with much other work, in the year Saskia died.

Nothing stopped him from working. Being a widower, with an infant son to look after, didn't appear to slow him down. It was a condition many of his contemporaries could have advised him about. The poet Vondel lost his wife in 1635, and Vondel didn't remarry. Frans Hals was a widower left with two children. Huygens, the Stadholder's secretary, and Barlaeus, the professor, were widowers. Dr. Tulp, his first wife dead, remarried well. But this wasn't necessarily the easiest thing to do for a man who, like Rembrandt, had pretensions, stay-at-home habits, and a child. Moreover, Saskia's will – perhaps cautiously drawn up to ensure that her son didn't lose his rights to his mother's little fortune, given Rembrandt's inclinations to spend freely – made for complications. Rembrandt had the use of the income of her half of their joint estate (with Titus as the heir) as long as he lived and as long as he didn't remarry. Even if a highly marriageable woman had come on the scene, this condition would have given him pause.

Fortunately it was an age in which servants were the rule in families above the working class. However, there were fewer of them in the United Provinces than in other European countries. Jan de Witt was admired by Sir William Temple, accustomed to English ways, for having only one manservant. The government taxed households heavily on the employment of male servants. One or two maids worked in burghers' houses, but the position was not always very subservient. Often a girl in her late teens or early twenties, she was generally treated as a member of the family. She would sleep in a cupboard bed in a commonly used room like the kitchen.

Foreigners raised their eyebrows at the familiarity allowed. Jean-Nicolas Parival, who taught French at Leiden University, thought it was impossible to get properly waited on in Holland. M. de la Barre, a French visitor, was astonished to find in one Edam household that the maid and manservant sat down to a meal with the family and guests. The lady of the house and the maid helped themselves first to the best

portions, and when the master asked the maid to fetch something for him, his wife told him to get it himself – she wanted the servant to rest. Visitors to the country thought it outrageous that you could dismiss a Dutch servant only on grounds of theft, while an aggrieved servant could give notice anytime he or she felt like it. Even if Rembrandt had been a different sort of man – a traveler; a gadabout; a gallant prepared to do some seeking out and courting and not simply get involved with what was close at hand, the way Saskia had been at Cousin Uylenburgh's – even if he had not been a monogamist, as the nineteenth-century French painter and critic Fromentin rightly calls him, with hardly anything of the adventurous libertine about him, the circumstances of the time made possible and almost proper a "working relationship" with one of the women in his house.

One Rembrandt drawing bears the traditional title *The Widower* and gives the impression that the artist may himself have had to look after his small son now and then – as does another drawing of a rather abstracted-looking man taking a little child for a walk. At any rate, he knew, as usual, what it would feel like, what it was to be in that condition. But before Saskia died Titus probably needed a wet nurse, and soon afterward there was someone in the house looking after the boy. One woman who filled this role was Geertje Dircx. Houbraken, getting his information from someone who believed Geertje was Rembrandt's wife, called her "a peasant woman from Raarep or Ransdorp in the district of Waterland, small in figure but well-shaped of face and plump of body." She may be the subject of the portrait in Chicago of a certainly plump and pert girl who stands leaning over the bottom half of a Dutch door, with startled eyes but a willing-to-please expression. She is wearing several necklaces and a pretty, tight-waisted dress with a ruff. The same girl seems to have been the model for the 1647 *Susanna and the Elders*. A woman with a similar plumpness and the same high cheekbones, though apparently older, is in two drawings, which some scholars date around 1636 but others believe to have been done in the early 1640s. The woman is wearing North Holland costume, appropriate for a native of Waterland. On the back of the drawing, which shows the woman from the rear, is an inscription in a seventeenth-century script, *De minne moer van Titus*, "The wet nurse of Titus." Geertje's duties are known to have excluded breastfeeding Titus, but the association of the drawings with Geertje has tradition and possible truth behind it.

Until recently, however, tradition has presented us with the idea that Geertje was quarrelsome, and Rembrandt unwitting and unfortunate in the trouble she let him in for. But in the last few years Geertje has been acquiring defenders. The most notable of these is Mr. H. J. Wijnman, who has studied the sparse number of

documents mentioning Geertje and written some scholarly footnotes for the Dutch edition of Christopher White's book – though chivalry once in a while seems to outride the scholarship. Geertje married a ship's bugler in November 1634, but she was a widow when she joined Rembrandt's household not long after Saskia's death. Geertje was an attractive woman; Rembrandt, in Mr. Wijnman's words, was his customary "fierce" and "passionate" self; and the natural conjunction occurred. It was followed by gifts, including jewelry and clothes that had belonged to Saskia. And Rembrandt made promises, backed up, it may well be, by a munificent gesture. On November 1, 1642, he put up 1,200 guilders toward the ransom of a ship's carpenter, who had been captured by Barbary pirates – a number of whom were in fact Dutchmen using Berber aliases. The unnamed carpenter came from Edam, and was perhaps her brother Pieter. In the document covering the pledge, Rembrandt is referred to as a "merchant of Amsterdam."

We have two further glimpses of the situation: in January 1648 Geertje was ill, and since illness then gave one cause to turn one's thoughts to departing this life for the life to come, she made a will in which she left most of her possessions to Titus. We infer that most of her possessions were obtained from Rembrandt. Indeed, Mr. Wijnman believes that – worrying about Saskia's jewels a little late in the day – Rembrandt may have dictated the terms of the will. Geertje left a portrait of herself, probably by Rembrandt, to a woman friend. Then, roughly a year and a half later, in October 1649, a second notarized document appears. This has the name of another woman in it, who now crops up in the evidence for the first time – Hendrickje Stoffels. She declared that in June that year Rembrandt and Geertje had made "an arrangement" in her presence because Geertje wanted to quit Rembrandt's house.

There is plenty of room here for speculation. Mr. Wijnman suggests that Hendrickje, who was twenty-three, came to work in Rembrandt's house and found favor with the master. He was then told by Geertje, "She goes or I go!" Possibly Hendrickje had been in the house for some time, causing friction between Geertje and Rembrandt, so Geertje began to pawn the jewels Rembrandt had given her. The jewels seem to figure largely in all that follows. The jeweler Jan van Loo, whose daughter married Titus, recalled years later that Rembrandt and Saskia had owned two beautiful pearl necklaces and a pearl bracelet. Geertje perhaps wore these, and a valuable diamond-set rose ring that had been Saskia's. In June 1649 Rembrandt said, "Well, then – go," and Geertje left in a huff.

According to the testimony given by Hendrickje and other witnesses later that year, the "arrangement" was that Rembrandt offered Geertje 60 guilders a year

A Woman Wearing North Holland Costume, *seen from the front. Drawing,* c. *1642. Courtesy of the Trustees of the British Museum*

A Woman Wearing North-Holland Costume, *seen from the rear. Drawing,*
c. 1642. Teylers Museum, Haarlem

for life, the first payment to be in June 1650 together with a down payment of 150 guilders to enable her to get out of hock the jewelry she had pawned. Geertje on her side agreed to stick to her will and leave the jewels to Titus on her death. But this agreement quickly collapsed. In September Geertje started a breach of promise suit against Rembrandt. On September 25, the disputing parties were summoned before the Commissioners of Marital Matters and Injuries, commonly known in the city as the Crack-Throat Court. Rembrandt failed to appear but let it be known that he would improve his offer: he would pay Geertje 160 guilders a year for life if she kept her agreement and made Titus her heir. Geertje went along with this, at any rate until a meeting at the Breestraat house on October 10. This took place in the kitchen, and a notary and witnesses were on hand for the signing of a separation agreement. Here Geertje made a scene. She changed her mind. She wanted more money. This kitchen table at which she sat had in a way been hers. It would soon be winter. To hell with painters!

A second summons came from the Commissioners of Marital Matters and was ignored. The third summons perhaps arrived with a reminder that if he didn't show up this time he could be judged in default. On October 23, both Rembrandt and Geertje appeared at the commissioners' chamber. She put her case: Rembrandt had promised to marry her. The ring he kept going on about had been a gift of betrothal. He had made love to her repeatedly. He must do one thing or the other: either marry her or support her with a proper allowance. On his side Rembrandt flatly denied that he had promised to marry her. As for her allegation about their frequently sleeping together, Geertje ought to prove it. The Solomons of the chamber conferred and decided that (as Mr. Wijnman neatly puts it) it was not right to compel the widowed husband of a Frisian burgomaster's daughter to marry a servant girl. But he was to pay her a yearly "alimony" of 200 guilders and give her a lump sum of 200 guilders at once. Geertje must now keep to her side of the bargain and not revoke her will.

In the course of the next few months, however, Geertje apparently revoked everything else. She rented a room in a shoemaker's house not far from the Breestraat. She led a disreputable life – slept around – got into debt; and pawned her possessions once again. Rembrandt, furious with himself for having given away Saskia's jewels to so unstable a woman, must have concluded that Titus would never inherit them. Mr. Wijnman sees Rembrandt's hand in the action of July 4, 1650, when some of Geertje's neighbors filed a notarized affidavit with the burgomasters of Amsterdam, describing Geertje's uncertain mental state and bad way of life. No doubt he would be relieved to have her placed where she couldn't get up to mischief. Poor Geertje was sentenced to a twelve-year term in the Gouda

workhouse. A member of her family apparently had to agree to this committal and pay the cost of it, and this her seafaring brother Pieter Dircx did – though Rembrandt put up the money, the fairly high sum of 140 guilders. This covered her transportation and admittance, and included payments to sheriffs and the women wardresses.

The Gouda institution was, according to Mr. Wijnman, a model for the time – a former convent. There Geertje had to work, spinning. She had to listen to sermons and religious instruction. Some of her fellow inmates were alcoholics, prostitutes, and half-wits. She had to live with the fact that she had little chance of getting out before the twelve-year term was up. However, Geertje's case seems to have given the Gouda magistrates second thoughts. In 1651 Rembrandt sent a woman to Edam to get from Geertje's relatives there renewed permission for her confinement. The woman was rebuffed. Even so, Geertje stayed locked up, and it was not until another four years had passed that, in 1655, one of her friends, Trijn Jacobsdochter, a fifty-four-year-old widow, traveled up to Amsterdam and told Rembrandt that Geertje's confinement had gone on long enough; she was going to Gouda to get Geertje out of the workhouse. She claimed that Rembrandt told her she wouldn't dare do this. He threatened her with his fist, she said. Then, calming down a little, he said that she ought to wait until Pieter Dircx came back from a voyage to the East.

But Trijn went to Gouda. A number of letters from Rembrandt to the magistrates arrived there, for he didn't want them to pay attention to Trijn in her attempt to convince them Geertje should be let out of the *tuchthuis*. Rembrandt's old animosity against Geertje was no doubt kept alive by the annual payments he had still to make, though they were now to the Gouda magistrates on her behalf. The magistrates made up their own minds. In the resolution book of the Gouda burgomasters was written, on May 31, 1655, "Geertje Dircx is released from the *tuchthuis*." Perhaps she was ill, and Trijn took her back to Edam where she could hope to be taken care of by her friends. Rembrandt failed to pay to her the 200-guilder allowance that year. She was listed among his creditors in the following year, 1656, when he became insolvent. Thereafter her name is dropped from the list of those to whom he owed money, and the assumption is that his obligation ceased because she had died.

Seen in this way, the episode hardly leaves Rembrandt looking much like a gentleman. A further shaft of light fell on the situation on March 2, 1656, when Rembrandt asked that Pieter Dircx be thrown into debtors' prison for not paying back the money Rembrandt had put up for committing Geertje to the workhouse. This would seem to indicate that Rembrandt thought he had been involved in a

Dircx family problem, which he had helped out in. Pieter Dircx was about to sail as ship's carpenter on the ship *De Bever*, and was naturally annoyed. The case was to come up in the court of appeal, and was still going on in May 1656. What happened after that we do not know.

Self-Portrait in Studio Attire. *Drawing, c. 1655. Rembrandthuis, Amsterdam*

IX

Artist at Work

UPSTAIRS much of the house was devoted to Rembrandt's business. He was there most of the day, in the big painting room, in his art gallery, or in the attic workrooms, while down below servants and tradesmen went in and out, the rooms were swept and linen was folded, food was prepared, and in free moments women sat on the bench outside the front door or, in bad weather, on the chairs on the platform just inside, and talked with neighbors and watched the passersby. The large studio faced north, overlooking the Breestraat. The Dutch were out of doors more then than now – and so were the immigrant Jews, who more and more were the inhabitants of this part of town. Looking from his studio window, Rembrandt saw them standing in little groups, discussing business matters or gossiping about family affairs, some even dressed in the old-fashioned central European ghetto costume that harked back to that worn by Semitic tribesmen. He looked out and saw the life of the Bible.

In many houses the lower halves of windows were still unglazed because of the expense, but even those prosperous people who had glass top and bottom tended to leave them wide open in fair weather. The occupants could lean out uninhibitedly and see what was going on in the street. Dutch artists painted girls standing in open windows, as in a frame, not only because it was a pleasant composition but because it was the natural thing people did (and, in old houses, sometimes still do; the modern Dutch picture window is the descendant of the old open casement). This interest and participation in the world without was complemented by an awareness

of the light that fell within. People then lived by the sun – got up early and were asleep by ten – because artificial lighting was expensive. Agricultural hours were kept even in cities. Samuel Pepys, for example, got up at four in summer, five in winter. He worked early and late, but reserved a good deal of the midday and afternoon for society and recreation.

In Rembrandt's studio the north light entered through four windows, each with two bottom shutters that swung back against the outside walls, and an inside shutter, for the top half of the window, that could be hoisted up against the ceiling. This common-enough arrangement gave a painter splendid control over the light. Moving his shutters, Rembrandt could achieve a high, side light. He could bounce the yellow sunlight off the white, plastered walls. He could intensify or alter the angle at which it fell on a model. He could concentrate it on one area and leave the rest in gloom. Mirrors, screens, curtains, and hangings gave him additional ways of reflecting light, absorbing it, of changing the values of brightness and shadows.

Rembrandt also had to control or turn his back on the bustle in the house. Baldinucci wrote, "When Rembrandt was at work, he would not have granted an audience to the first monarch in the world, who would have had to return again and again until he found him no longer engaged." Visitors to the studio were by no means encouraged. According to Houbraken, people who walked over to examine pictures at close range were told by Rembrandt, "The smell of the colors will bother you." But some sitters had to return often, until the portrait he was working on satisfied him. Some pictures went slowly and some fast; some needed correction and alteration, while others came right with an ease that matched the depth of his absorption. At work, he didn't look at all like the gentleman painter who paints the pretty girl holding the trumpet in Vermeer's ideal *Artist's Studio*. Bernhardt Keil, his pupil in the early 1640s, described his master to Baldinucci: "His appearance was careless and his smock was stained with paint, all over, because it was his habit to wipe his brushes on it." He did a drawing of himself in his studio attire, thumbs tucked under the broad sash which held his smock together, wearing a hat, as all self-respecting Dutchmen did, even indoors. There seem to be paint spots on the gown he wears in the 1652 self-portrait.

A lot of his time and energy was involved simply in organizing studio life. One can see why he ignored court summonses and didn't have much chance for reading. Joachim von Sandrart, a writer on art and painter who was much patronized in Amsterdam, said that Rembrandt's house "was crowded with almost innumerable young men who came for instruction and teaching" – and who paid him, for the privilege, 100 guilders a year. His talent and his energy were contagious; he acquired more pupils than any other painter of his time. For a period from

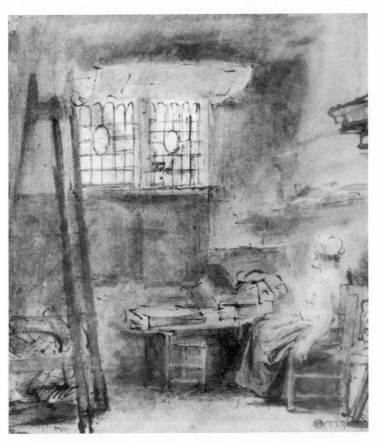

A Model in the Artist's Studio. *Drawing, c. 1655. Ashmolean Museum, Oxford*

about 1637 to 1645 he was in such demand that he rented a warehouse on the Bloemgracht, a canal in the Jordaan, just behind the Westerkerk. Houbraken wrote that in the teaching premises Rembrandt set up there "each of his pupils had a space for himself, separated by paper or canvas, so that they could paint from life without bothering each other." In the late forties and the fifties, with fewer pupils than before, he seems to have made do with teaching quarters at the Breestraat. A clause in the deed of sale of the house says, "The owner will take with him two stoves . . . and various partitions, set up in the attic for his pupils." A drawing, now

in Weimar, by one of his pupils shows Rembrandt conducting a life class – the model standing on a low plinth; the students leaning against the walls or squatting; and Rembrandt, wearing his working beret or tam-o'-shanter, casting an eye on their work. Around 1655 he drew a model naked to the waist, sitting in the big studio room with its fireplace and tall mantelpiece just showing on the right and his easel to the left; she is looking toward the windows, bottom shutters closed, the light falling in on her. The fact that students could draw from life at Rembrandt's would have been an added attraction; the need for bodies, alive or dead, now and then drove artists to extremes. Karel van Mander describes how a painter, Aert Mytens, one night went and cut down a corpse from the gallows and took it home in a sack so that he could work from it.

With his students Rembrandt was immensely generous: ideas for them blossomed from his fingertips; he drew sketches to show them how to resolve certain problems of detail, or to give them compositions for paintings. Some pupils were obviously overwhelmed by him; others were lifted into realms where their talents could thrive. A vital dab of paint from Rembrandt's brush, a suggestion from him that a shadow be moved, a highlight intensified, or a figure taken out – and a picture would be transformed. How much "theory" he taught is uncertain. Samuel van Hoogstraten later wrote a book on art theory, where he related advice that may well have come from his teacher. Hoogstraten recommends half-closing one's eyes so as to omit distracting details. And, "Give the outlines a proper swing, not in one pull which runs like a black wire around the form, but indicate them piece by piece with a light hand." The drawing must breathe! Hoogstraten also said that in his studio Rembrandt and his students often argued about the principles of paintings. But from what we know from Rembrandt's one gawky foray into explication, in the letter to Huygens where he went on about seeking the most natural emotion or movement, he seems more likely to have ducked this sort of discussion. According to van Hoogstraten, he gave one pupil who kept pestering him with unanswerable questions the down-to-earth advice: "If you use properly the knowledge you've already got, you'll find out more rapidly what you don't know."

Houbraken told stories of varying accuracy about life in Rembrandt's studio. He said that on one occasion the pupils painted trompe l'oeil coins on the floor for the pleasure of watching Rembrandt bend to pick them up. (Houbraken took this as evidence for Rembrandt's being avaricious, but it seems more like a demonstration of the changeless capacity of students for practical jokes.) Another time a student took the unclothed female model into his cubicle and, claiming it was very hot, also undressed. His fellow pupils watched through a crack in the partition. Rembrandt arrived at the moment the student was heard saying to the model, "Now we are

naked like Adam and Eve in Paradise." Rembrandt hit the door with his stick and shouted, "Because you are naked you must get out of Paradise!"

Other scenes from the Bible were staged by pupils while Rembrandt and the rest of the students drew. They would "do," say, the discovery of Moses or the dismissal of Hagar, arranging themselves in different poses while Rembrandt indicated, in a few lines, how to get across the essence of the moment, never forgetting that these incidents involved real people, saying goodbye, welcoming someone home. An English sculptor, Nigel Konstam, has recently suggested, by making maquettes, or solid models, of the groups on which these drawings of Rembrandt's are based, that drawings that traditionally have been dated decades apart were in all likelihood done on the same day, within minutes of one another. One drawing is probably from the actual model; the other from the reflection of the model or group as seen in a mirror mounted on the wall or set up on an easel (for example, the two drawings of the woman in North Holland costume, presumed to be Geertje Dircx. One, the back view of the other, shows what appears to be the frame of the wall mirror and a student, paper in front of him, in the act of drawing the woman posed there.) There were obvious advantages gained by using mirrors with many students in one room, "expanding the visible space," as Konstam puts it. The mirrors provided variations, inversions, another way of looking at the subject, and while his students labored, Rembrandt made full use of these, dashing off sketches from life and reflection.

The fact that master and pupils were often at work on the same subject – that Rembrandt, for instance, probably leaned over young Ferdinand Bol's drawing and said, "Why don't you put something in here, like this?" and added a figure; and that, according to Bernhardt Keil, he often generously lent his antiques and curios to fellow painters – has meant occasional confusion among the scholars about the authorship of some pictures. Many students enjoyed the use of his costumes and props, or wanted to follow precisely in his footsteps. In the 1660s Houbraken visited Aert de Gelder, one of his last pupils. De Gelder had returned to his hometown of Dordrecht, where he painted a picture of himself holding an etching by Rembrandt, and where he tried to live *à la* Rembrandt. Houbraken found his place "a rubbish heap of all sorts of clothing, hangings, shooting and stabbing weapons, armor, and so on, including shoes and slippers . . . and the ceiling and walls of his studio are hung with flowery and embroidered lengths of silk cloths and scarves, some of them whole, others tattered . . . From this rich supply he selects the equipment for his pictures." But de Gelder could also rise above the simple flattery of imitation to paint pictures like the lovely *Rest on the Flight into Egypt*, almost an act of homage to the master.

A number of pupils produced portrait work that was easily mistaken for Rembrandt's – his own work was already being copied while he was at Uylenburgh's, and the copies sold to provincial buyers. He undoubtedly touched up some of his students' work, and they presumably did some of the groundwork on many of his portraits. Govaert Flinck, one of his most talented students, painted numerous portraits that were sold as Rembrandt's. Flinck's first-rate portrait of Rembrandt's neighbor in the Breestraat, the rabbi Manasseh ben Israel (now in the Jewish Historical Museum in the Waag) was at one point doctored up, Flinck's signature scraped off, and Rembrandt's painted on instead. But Flinck managed to rise with the times and adjust to the changing demands of the portrait market. Together with other men who trained or worked with Rembrandt, such as Jacob Backer and Ferdinand Bol, he became highly successful, and commissions that once would have come to Rembrandt went to them instead.

Two painters felt Rembrandt's strong influence at close hand and yet developed an individual genius. Philips Koninck, whom Houbraken declared to be one of Rembrandt's pupils, showed the effect of Rembrandt's drawings and his use of light, but went on to make marvelous landscapes, distant panoramas under high skies whose sun and cloud are reflected in the shadow and light below, and which were very much his own vision. Another pupil of the early forties, Carel Fabritius, was the most original of them all. He used some of the same armorial properties and Biblical themes as Rembrandt. On moving to Delft, however, he found a style of his own, full of the daylight that Vermeer was to take over and bathe his works in. Yet unlike Koninck, who lived to sixty-nine and enjoyed an independent income, poor Fabritius, who had begun as a carpenter, had a shortened life. He died at the age of thirty-two in the gunpowder-magazine explosion that devastated a large section of Delft. Nearly ninety thousand pounds of gunpowder blew up at 11:30 on a Monday morning in October 1654 and was heard over much of South Holland. People came from near and far to see the tragic effects. The Queen of Bohemia wrote from The Hague to Sir Edward Nicholas on October 19, "I was at Delft to see the wrack that was made by the blowing up of the powder this day seven-night, it is a sad sight, whole streets quite razed; not one stone upon another, it is not yet known how many persons are lost, there is scarce any house in the town but the tiles are off."

Whether teaching or not, Rembrandt got on with his own work like a man for whom life is too short for getting it all down. He was continually drawing; seizing an odd hour or so to make an etching or carry on with one that was taking him a long time, like that of *Christ Healing the Sick*, which became known as "The Hundred Guilder Print," after the extravagant price possibly he or another collector paid to

acquire a print of it; and painting whatever he felt compelled to paint – a landscape; a slaughtered ox; an old man in a helmet – if he had no immediate commission to complete. A pen, an etching needle, or a brush was always in his hand. Altogether he did some 2,000 drawings, 300 etchings, and 600 paintings that we still have; Professor Jakob Rosenberg, the Rembrandt scholar, estimates that another 200 paintings may have been lost. Twice a year at least he adjusted the mirror near his easel and painted himself, making a record of his own presence unmatched by any other artist. But along with this testimony to his own individuality went frequent acknowledgements to the comradeship in which he moved. Often, looking for a way of handling a certain theme, he would consult the work of other artists he admired – see how Titian or Raphael had done it; check with a print of Lucas van Leyden's or an engraving after a work of Michelangelo's.

The materials that went into a painting were still for the most part made in the painter's workshop. It was the apprentice's job to make brushes, bistre (a brownish ink derived from burned wood), and paint itself: first grinding the raw colors in a mill; then pounding them on a stone and mixing them with oil, for oil paints, and with water for water colors; and then storing the oil colors in bladders and the water colors in shells. Painters kept their supplies in wooden boxes with lots of little drawers and compartments, the fronts and lids often decorated with pastoral scenes. Wooden panels were generally bought from a supplier in certain sizes at certain prices – for example, a ten-stuiver panel, a 2.5-guilder panel, and so on. (Portraits were also priced by size. One commissioned what one could afford: head, half length, three-quarter length, or whole figure.) Like Frans Hals, Rembrandt often used small panels for preliminary oil studies for portrait heads. He sometimes painted in oils on good paper, made from rags, glued to a wood panel or canvas. Large paintings were occasionally done on canvas sewn together in strips to make it wide enough. Three fairly early works he did on copper plates, primed with white lead, and then overlaid with gold leaf as the ground for the paintings. The gold leaf produced an underlying sparkle that showed through. No one, as far as we know, had done this before.

For his drawings he used nearly always a grainy white paper, sometimes tinged with a gray or brown hue before he began to draw. Once in a while he used silky Japanese paper when he wanted to give his drawings an exotic character, as for his copies of Indian miniatures. He drew in red chalk, in black and white chalks, and yellow crayons, and in more elaborate drawings combined the chalks with pen- and brushwork in bistre, India ink, white body color, and even (though rarely) oil color. The liquids were put on with a quill pen, a reed pen, and a brush. For the rapid loops and curves of his work in the 1630s the flexible quill was best suited; in

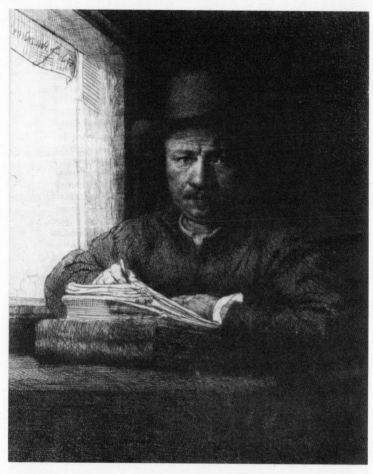

Rembrandt Drawing at a Window. *Etching, second state, 1648. Courtesy of the Trustees of the British Museum*

later years, for the straight, sharp, and broad lines his hand made, the brittleness of the reed pen was appropriate. The reed made an absorbent instrument, and its half-dry strokes gave to his work a vibrancy and expressiveness. He used the brush for filling in with washes between the pen lines, and also as a drawing instrument itself.

He used his fingertips to rub the wet drawing and make the subtlest shadows. He left, with great abandon, apparently, but brilliant skill, large areas of the drawing untouched by line or shadow. As the art historian Otto Benesch exclaims, his great achievement was to make "the uncovered surface of the paper shine forth as if it were a source of light." A high tension is created by the strong control he employed, working so simply and economically, achieving such ease and life.

One technical word must be brought in here, because it is at the center of his work – *chiaroscuro*, Italian for "bright and dark." "In the language of art," Jakob Rosenberg and Seymour Slive, authors of the standard work on Dutch painting in the seventeenth and eighteenth centuries, tell us, "it refers to the contrasting of light and shadow as a principal means of painterly expression." It was the area in which he was unsurpassed. To begin with, there seems to be almost a battle going on in his paintings between the light and the dark; as in the 1629 *Christ at Emmaus*. It is an expression, perhaps, of the unresolved discord between two elements in his own character. But as time went on his figures begin to dwell in the fluid, less black and white border area between the light and shadow. He taught himself how to achieve the most magical and mysterious effects, laying on over a white ground the "friendly" colors of yellow-ochre, brown, or brown-red, which gave an underlying vibrancy to a layer of black placed over them. On these dark backgrounds – of blacks, browns, and grays – into which his figures in dark hats and cloaks seem to merge, he laid on lighter passages and created moments of radiance. A final glaze made for a luminous surface.

His contemporaries were thoroughly aware of his skills in this respect, though it left some of them of two minds, as magic will. Baldinucci thought Rembrandt handled it best in etching, where he invented "a certain most bizarre manner . . . entirely his own, neither used by others nor seen again; with certain scratches of varying strength and irregular and isolated strokes, he produced a deep chiaroscuro of great strength." Hoogstraten wished the master had better understood the theory of the matter! Take, for example, the picture that demonstrated the bravos and buts he attracted in midcareer – *The Night Watch*. This picture, which in fact showed a daytime parade of a militia company, aroused great attention. The amateur soldiers in the cast, who rarely saw action, seemed pleased with it, and Frans Banning Cocq, the captain of the company, had two copies made. Hoogstraten said that it made all its group-portrait rivals look like playing cards. But his reservation that it didn't have quite enough light in it was reinforced by time, which worked to darken it – as did the smoky, peat-burning fireplaces of the Kloveniersdoelen, the hall of the civic guard. In the mid-eighteenth century, it was moved to the war council chamber of the Town Hall, and cut down a little, as

paintings (when moved) were, without dishonor, sometimes cut to fit a new space. Jan van Dijk wrote of it then: "Strong sunlight prevails in the picture. Rembrandt applied his pigments with a vigorous brush, and one can only marvel that such roughness blends into such painstaking care. The trimming of the Lieutenant's doublet is dubbed on so thickly one could almost grate a nutmeg on it."

The legend that *The Night Watch* was a scandal and failure seems to have sprung from late eighteenth-century distaste for the "impurity" and "darkness" of Rembrandt's art, later echoed in Ruskin's comments about Rembrandt's "abysses of obscurity" and "gradations of gloom." It is easier to agree with Fromentin, who thought *The Night Watch* was "without charm." Despite its bustle, its light, its originality, it was a public picture of a public event, demanding attention. It remains so. It is attacked, even physically, as most recently by a deranged man with a knife. It is surrounded by crowds of admirers, who have climbed the Eiffel Tower and stood outside Buckingham Palace and now need to be in the presence of this picture. Its fame makes it less accessible and harder to *see*. One feels that even Rembrandt was put off by it, or felt eventually that that was enough; he had run through his need for display, the marching out for fame and glory. "A pious mind prizes honor above wealth," he had written, but he was later to say, "If I want to divert my mind, I don't seek honor but freedom." Clearly Banning Cocq and his merry men are honor bound.

After he had completed *The Night Watch* and Saskia had died, he wasn't interested in things in quite the same way. He withdrew a little and looked elsewhere. His work no longer called attention to itself by the great excitement in what was going on, but by something, as it were, held back within the picture. What he had aimed for in his pictures for Prince Frederick Henry, to achieve the greatest and most innate emotion, as he told Huygens, came truly within his power when his figures stopped posing and shouting, and found themselves in simpler settings.

In the 1650s, before the inventory and insolvency, he painted, among others, these pictures: c. 1650–1652, *A Man Wearing a Gilt Helmet;* 1652, the year Holland and England went to war, a portrait of Nicolaes Bruyningh; 1653, *Aristotle Contemplating the Bust of Homer*, ordered by the Sicilian nobleman Don Antonio Ruffo; 1654, *Bathsheba at Her Toilet*, a *Woman Bathing*, a portrait of a man presumed to be his brother Adriaen, and the portrait of Jan Six; in that year and the next, three portraits of an old woman, whose face under a headdress seems to have fascinated him as she read or sat, hands folded; in 1655 he painted *The Slaughtered Ox*, a picture of Titus sitting at his desk, and probably, *The Polish Rider;* in 1656, a portrait of Hendrickje, *The Anatomy Lesson of Dr. Deyman* and *Jacob Blessing His Grandchildren*.

There were also, of course, numerous self-portraits and various day-to-day jobs. One such was a commission from a Portuguese-Jewish client, Diego Andrada. Unfortunately, Andrada thought that the resulting portrait of a young girl was not a good likeness, and he asked for alterations. A notary called on Rembrandt to say that if the painter refused to change it, he should keep the picture and repay the deposit of 75 guilders. Rembrandt refused. He said he wouldn't touch the picture again unless Andrada paid the full price or gave a security for the payment. Then he would finish it and submit it to the heads of the St. Luke's Guild for them to decide whether it was a good likeness or not (he would alter it if they said it wasn't). If Andrada didn't agree with this, then Rembrandt would sell the painting at auction. A man of pride!

And possibly a man of sentiment. That, at any rate, seems to be the burden of another anecdote, reported by Houbraken, which also gave the impression that Rembrandt set his own feelings about a picture above his desire to satisfy a client's whim. Houbraken said that one day Rembrandt was at work on a family portrait when he was told of the death of his pet monkey. He asked for the monkey's body to be brought to the studio, and then painted its portrait on the unfinished canvas. Naturally, those who had commissioned the portrait were taken aback and refused to accept it unless the monkey was removed. Rembrandt once again dug his heels in and kept the picture. The story would be improved by the discovery of a picture by Rembrandt with a monkey in it. He painted, etched, and drew horses, donkeys, sheep, cows, ducks, an owl, elephants, dragons, lions, and innumerable cats and dogs, and was undoubtedly fond of animals. Houbraken mentions that this rejected portrait was afterward used as a partition in the studio, so perhaps a student painted a monkey in. (Houbraken was nine years old when Rembrandt died. However, he studied painting under Rembrandt's pupil Samuel van Hoogstraten and knew other Rembrandt students.)

But we do have a picture that Rembrandt made for himself in those mature years that conveys, as no piece of gossip can, what the English art critic Roger Fry called his "power of deciphering and interpreting the data of actual vision." This is his 1655 painting of *Titus at His Desk*. Mr. Fry has (in his essay "Some questions in Esthetics") described this picture so well, and so evoked the painter at work, I step aside for him:

> The boy was at his lessons. Puzzled and bored by them, he looked up from his task; his thoughts wandered, and he sat there day-dreaming, with his cheek propped on his thumb. Rembrandt painted this scene with complete realism, without a thought of anything but the vision before him. He realised

Titus at His Desk. *Painting, 1655. By permission of Museum*
Boymans–van Beuningen, Rotterdam

the modelling in all its solidity and density, but also with all that is infinite,
intangible and elusive in the play of light on its surface. In painting such
a work, in accepting so much of the whole complexity of appearance,
Rembrandt was taking on tremendous odds. To get that density and mass as

he felt it he had to paint with a full brush and model in a rich paste, but he had to get everywhere transitions of tone and color of impalpable subtlety: at every point the drawing had to have the utmost sensitiveness and elasticity. If one looks carefully in the original at the passage where the thumb indents the cheek one can see why such works occur at very rare intervals. If for a moment Rembrandt had thought about his picture he was undone; nothing but complete absorption in his vision could sustain the unconscious certainty and freedom of the gesture. Each touch, then, had to be an inspiration or the rhythm would have broken down.

And Fry continues:

But what is of even more interest for our present inquiry is the painting of the desk. This is a plain flat board of wood, but one that has been scratched, battered and rubbed by schoolboys' rough usage. Realism, in a sense, could go no further than this, but it is handled with such a vivid sense of its density and resistance, it is situated so absolutely in the picture space and plays so emphatically its part in the whole plastic scheme, it reveals so intimately the mysterious play of light upon matter that it becomes the vehicle of a strangely exalted spiritual state, the medium through which we share Rembrandt's deep contemplative mood. It is miraculous that matter can take so exactly the impress of spirit as this pigment does.

X

The New Jerusalem

A NEIGHBOR in the Breestraat was the Jewish scholar Manasseh ben Israel, who lived in a house diagonally across from Rembrandt. The artist had etched a portrait of Manasseh in 1636, before buying the Breestraat house; the etching had given Govaert Flinck a good deal to go on when he painted his oval portrait of Manasseh in the following year, wearing a black coat with a plain, wide white collar and a wide-brimmed black hat, an open, attentive expression on his face, with its rosy cheeks and woolly beard, looking very much a Dutchman.

Manasseh, in fact, was one of the many Portuguese Jews who settled in this part of town. With the opening up of the great semicircular canals, the rich merchants who had built in the Breestraat sold out, as the owners of Rembrandt's house had done, and moved to the newly fashionable parts of the city (and sometimes to country mansions). Their empty houses were snapped up by painters and printers, and particularly, as time went on, by Jewish immigrants with such names as de Castro, Suasso, and de Mattos. Rembrandt's neighbor on the east was Salvador Rodriguez. The house on the corner, between Rembrandt and Uylenburgh, had been bought in 1640 by the painter Nicholas Eliaszoon – whose smooth portraits made him one of the most sought-after artists in the city – and was sold by him in 1645 to a Jewish merchant, Daniel Pinto. In the year Rembrandt and Saskia moved to the Breestraat, the first properly housed Portuguese synagogue was opened on the Houtgracht, the canal – behind the Breestraat – where timber and pilings were unloaded and stacked, and where the Waterlooplein was built in the

Manasseh ben Israel. *Etching, second state, 1636. Courtesy of the Trustees of the British Museum*

mid-nineteenth century. (The philosopher Baruch Spinoza spent his childhood at Number 41 Houtgracht and went to the school attached to the synagogue.) By the end of the seventeenth century the Breestraat neighborhood was mostly Jewish, and the fact was acknowledged by the city fathers' lengthening the name of the Broad Street to Jodenbreestraat.

Like most of his fellow Sephardic Jews from Spain and Portugal, Manasseh was in Amsterdam because of religious persecution in the Iberian Peninsula and economic opportunity and religious tolerance in Holland. In the fifteenth century, Spain had cracked down on Jews who had, in consequence, fled to Portugal. When King Manuel I of Portugal wanted to marry the King of Spain's daughter, one condition set by Spain was that Portugal be "purified" of Jews. They were ordered to become Christian or leave Portugal by October 1497. In Lisbon, where they came to take ship, they were herded into churches for mass baptism. Numbers committed suicide. Many, however, accepted conversion – as many Spanish Jews had – and took the opportunity to become part of Portuguese society. Some of these "New Christians" regretted their Jewish, origin and purchased Christian blood for their families by acquiring, for cash, Christian sons-in-law. Some regretted their conversion and secretly practiced Jewish observances. For others, the conversion was undoubtedly wholehearted. The Inquisition, in any event, put a stop to the assimilation process. Set up in Spain in 1487, and extended to Portugal in 1531, it caused an exodus of the Marranos, or "swine," as the former Jews were derisively nicknamed. Manasseh's father was tortured on three occasions by the Inquisition before he escaped from Lisbon to Madeira, where Manasseh was born in 1604. The family then made its way to La Rochelle, the Protestant free city on the French coast, and thence to Amsterdam. Many other Marrano families came to the Netherlands by way of Antwerp. Most had lost contact with their Jewish past, except perhaps for a memory of an ancestral name, which some readopted in the Low Countries. Many no longer knew about dietary laws or understood Hebrew, and in Antwerp at least gave little impression of feeling a sense of loss.

In Amsterdam, however, in the Breestraat and surrounding streets the Jewish spirit was reborn. This was the New Jerusalem, or simply Mokum, as it came to be called – "The Place." Whole families arriving in the United Provinces wanted to take up the old religion; Jewish services were held in private houses; men were circumcised and gave up their Iberian Christian names. André, Rodrigo, and Inigo de Pinto, for example, took the names Jacob, Moshe, and Aaron de Pinto. Manasseh completed a manuscript of a comprehensive Hebrew grammar when he was seventeen, and a year later became a rabbi and teacher in the Jewish primary school. Obviously the right person to tutor the New Christian "converts"

to Judaism, he lectured on the Talmud at the Sephardic community center known as Neve Salom, "Abode of Peace" (which merged with two other communities to found the Houtgracht synagogue in 1639). Manasseh knew ten languages and wrote in Spanish, Portuguese, Hebrew, Latin, and English. He taught not only new Jews but many Amsterdammers who were infected by the Jewish revival taking place in their midst and wanted to learn Hebrew; one of his pupils, was Gerbrandt Anslo, son of the Mennonite preacher Cornelis Anslo. The fashion was evident in educated circles beyond Amsterdam. When Descartes visited the woman painter and scholar Anna Maria Schuurman in Utrecht he found her reading the Bible in Hebrew. Descartes, however, shocked her by his opinion that this was a trivial occupation. She put in her diary, "God has dismissed this profane man from my heart."

Although Manasseh failed to be appointed chief rabbi at the united synagogue, he led an exceptionally busy life; he taught, preached, wrote, and published. When Queen Henrietta Maria of England visited Amsterdam in 1642 on a trip to present her ten-year-old daughter to the child's betrothed, young William of Orange, it was Manasseh who was asked to preach in the Queen's honor when she came to the synagogue. In 1648, in a letter to a correspondent, he gave lack of time as a reason he couldn't answer at length questions about Biblical chronology. He described his crowded life: "Two hours are spent in the Temple every day; six in the school; one and a half in the public academy and the private one of the Pereyras, in which I hold the office of President; two in proof-reading for my printing press, where everything passes through my hands; from eleven to twelve I have appointments with all those who need assistance in their affairs or pay me visits." That amounted to twelve and a half hours. But he made time for writing, eating, and sleeping.

There were various reasons why Holland took a hand in remaking Jewish history, by thus giving a home to Jews who had lost several earlier homes. Many Dutchmen welcomed the Jews as merchants and traders, with connections in the East and West Indies, and as people bearing an enmity – similar to their own – toward Spain. The writer Pieter de la Court put the liberal and (in regent circles) widely accepted case for free trade, toleration and immigration in his *Interest van Holland* (1662):

Next to the freedom to worship God comes freedom to make one's living for all inhabitants. Here it is very necessary to attract foreigners. And although this is of disadvantage to some old residents who would like to keep the best solely for themselves and pretend that a citizen should have

preferences above a stranger, the truth of the matter is that a state which is not self-sufficient must constantly draw new inhabitants to it or perish.

Andrew Marvell, the English poet, alluded to the financial motives behind Amsterdam tolerance in 1653, when England and Holland were at war:

> Hence *Amsterdam, Turk-Christian-Pagan-Jew*,
> Staple of Sects, and Mint of Schisme grew;
> That *Bank of Conscience*, where not one so strange
> Opinion but finds Credit, and Exchange.

Yet the Jews did not find everything made easy for them. Although the United Provinces were founded on a promise to respect religious freedom, the leadership of the Calvinist Church did not encourage dissent from its own orthodoxy. The elders of the Reformed Church in Amsterdam were infuriated by Jewish worship in public, by the building of Jewish schools, and by "mixed" marriages. The united synagogue particularly bothered them. Even the Remonstrant Calvinists complained about the Jews – as in Barlaeus's address to the Synod of Dordrecht in 1618 – while declaring that they, the Remonstrants, had to put up with harsher policies than the Jews did. The Reformed elders frequently demanded that the burgomasters of Amsterdam maintain restrictions on the Jews: that they not be allowed to employ Christian servants, hold public office, or join a guild. (One reason the Jews became important in the diamond-cutting industry was that it was so small at the time it didn't have a guild.) The guild restrictions remained until 1796, but on July 13, 1657, the States General proclaimed that Dutch Jews were citizens of the Netherlands. In trade or in their travels abroad, they had to be treated in the same manner as Dutch Christians.

At first the Jews were not permitted to use municipal cemeteries and had to carry their dead to a site forty miles north of Amsterdam. In 1618, however, they were allowed to found a cemetery at the village of Ouderkerk, five miles up the Amstel River from the city. John Evelyn made an excursion in 1641 to the Ouderkerk cemetery (which is still in use today). He wrote:

> The Jews have a spacious field assigned to them to bury their dead, full of sepulchres with Hebraic inscriptions, some of them stately and costly. Looking through one of these monuments, where the stones were disjointed, I perceived divers books and prayers lie about a corpse; for it seems, when any learned Rabbi dies, they bury some of his books with him. With the help

of a stick, I raked out several written in the Hebrew characters, but much impaired.

Memento mori, like those precious objects buried with the urns that intrigued the former student at Leiden University, Sir Thomas Browne, ". . . things wherein they excelled, delighted, or which were dear to them, either as farewells unto all pleasure, or vain apprehension that they might use them in the other world . . . "

Among the books Manasseh ben Israel wrote was a tiny volume called *The Glorious Stone, or Nebuchadnezzar's Dream*. The miniature format, roughly five and a half inches by three inches, was then popular. It was written in Spanish and published in 1655, illustrated with four etchings by Rembrandt. Since the artist did not understand Spanish, he presumably had several conversations with the author about his interpretation of the Book of Daniel. Even then, the artist may not have been too clear about Manasseh's ideas, shared with some other Jews of the time, that the coming of the Messiah was at hand. Manasseh thought that the elaborate dream of King Nebuchadnezzar in the Book of Daniel gave evidence of this coming, which would of course bring to an end the long travail of the Jewish people. Although this aspect of Manasseh's work had a reserved reception from most Dutch scholars interested in Hebraic learning, his Messianic notions were encouraged by conversations with the Portuguese Jesuit Antônio Vieria, a friend of the Portuguese king Joao IV. The king wanted the ex-Portuguese Jews and their money to help him reconquer parts of Brazil from the Dutch. Vieria – in Amsterdam on that mission – brought along for support the prophecies of the Portuguese poet, Gonçalo Ares Bandarra, who claimed that a Messiah was on the way, and that the King of Portugal would conquer the world with the help of the Jews and give them Palestine. Then what Bandarra called the "Fifth Empire," a millennium of peace and justice, would occur on earth.

Manasseh's belief was buoyed up by other things. Before the Messiah came, the Jews had to be thoroughly dispersed. As it happened, a traveler named Aaron Levi de Montezinos had recently reached Amsterdam with news of finding the ten lost tribes of Israel in what is now Ecuador. Although this was of great help in the dispersion, there were still places the Jews hadn't yet reached. Moses had said, "And the Lord shall scatter thee among all people, from the one end of the earth even unto the other" (Deuteronomy 28:64). Now, the "end of the earth" in Hebrew was "*ketzeh ha aretz*," and Jewish scholars had for centuries used this term as a sort of ultima Thule to denote England. It was clear, therefore, that the Jews had to return to England (from which they had been expelled in 1290) before the Messiah would come. Manasseh went to England to talk the Lord Protector Cromwell into

the idea. Cromwell, a few years earlier, had considered the unification of the two Protestant republics, but perhaps he now warmed to Manasseh's proposals because he felt the Jews would help England in its rivalry with Holland by furthering English maritime trade, particularly on the Spanish Main. A small community of Jews was established in London in 1657, with no special laws governing their behavior. In personal terms, however, the English trip was a disaster for Manasseh. One of his sons who had accompanied him died, and Manasseh brought the body back for burial in the United Provinces. A few weeks later, the great rabbi died too. He was buried in the Ouderkerk cemetery on November 20, 1657, a few weeks before his neighbor Rembrandt's goods were auctioned off.

Just how well off Rembrandt's Jewish neighbors were is a matter of some conjecture. One authority, Professor Bloom, reckons that of the thousand or so Sephardic Jews living in the city in 1630, only forty-eight were taxed as having an income of more than 1,000 guilders a year. However, wealthy Jews were constantly moving to the city. When the Isaac de Pinto family moved from Rotterdam to Amsterdam in 1653, they exchanged one house for the other and paid an additional 19,000 guilders in cash. The cost of the splendid Portuguese Synagogue, which went up in 1670–1675 on the site of the outer St. Anthony's Gate, at the city-outskirts end of the Breestraat, was 186,000 guilders – a lot of money for a religious community only several thousand strong. One Portuguese Jew indeed became the wealthiest merchant in the country: Antonio Isaac Lopes Suasso loaned 2 million guilders to Prince William III to assist him in setting up as King of England, and was also given an estate in the southern Netherlands and the title of baron by the King of Spain, Charles II, in return for diplomatic services. Yet arriving in the New Jerusalem in these same years were many less prosperous Jews from Germany and central Europe, and it was they, the Ashkenazim, who especially made Amsterdam, within a few generations, the largest Jewish community in western Europe. Their shabby clothes, long cloaks trailing on the ground, and eccentric tall hats gave them the appearance of creatures from another age – as in a sense they were, leaving ghettoes in which they had been segregated for centuries. The Sephardim would come to Rembrandt to have their portraits painted in Dutch burgher cloaks and broad-brimmed Dutch hats, but the artist sought out the poorer Jews in their own haunts.

There were conflicts within the Jewish communities, mirroring the struggle between conservatism and liberalism among the Calvinists. One of several notable Jewish dissidents to the orthodoxy that seemed to arise coeval with the new Jewish security in Amsterdam was one of Manasseh's pupils, Baruch Spinoza. His father was one of the leaders of the Sephardic community and an occasional warden of

the Houtgracht synagogue. Young Spinoza studied Latin with Frans van Enden, a teacher with whom one of Rembrandt's pupils, Leendert van Beyeren, lodged in the 1640s. (Spinoza fell in love with van Enden's daughter, but she married someone else.) In July 1656, while Rembrandt's inventory was being made, Spinoza's career was also at a turning point. In the synagogue on the Houtgracht, Spinoza was given thirty days to retract the views his religious leaders thought to be heretical. He was offered a yearly sum of 1,000 guilders in return for attending services there and refraining from publishing his opinions – blackmail of a kind, but also a generous income for the support of someone recognized as having a brilliant mind. But he didn't retract; he didn't accept the money; and he stayed away from the synagogue on the day of his excommunication. After a similar ordeal some years before, Uriel d'Acosta had committed suicide. Spinoza, however, didn't hear the archaic curses with which he was condemned: ". . . the Lord will destroy his name under the Heavens and the Lord will separate him to his injury from all the Tribes of Israel with the curses of the Firmament which are written in the Book of the Law . . . We ordain that nobody shall communicate with him under the same roof nor within four walls nor read anything which he has composed or written."

Spinoza wasn't moved by this. He stayed on in Amsterdam for the next four years, learning to grind and polish lenses, increasingly needed for telescopes, microscopes, and spectacles. Amsterdam was the European center of this craft, and the skill gave Spinoza an independent living while he thought and wrote. It was curious that these two men, Jewish philosopher and Gentile artist, lived within a few hundred yards of one another, each looking at life intently and originally, each in similar manner slowly isolating himself from the fashions and distractions of daily life. One, the synagogue student, found the Bible an obstacle he could not get over, a fount of doctrine that he could in no way square with logic or science; while the other, the well-known painter, found in the Bible much of the material he needed to illustrate and convey the facts of human nature and truths – *sub specie aeternitatis* – about the human mind and heart.

XI

Through the Needle's Eye

M OST OF THE BIG AMSTERDAM CHURCHES are now locked up during the week. The interior of the Zuiderkerk is slowly being restored, and the view one gets through a slit in the locked door is of ladders, blocks of stone, and builders' gear. The Oude Kerk is surrounded by impenetrable fences from behind which rusty scaffolding rises, like old ivy, around the church. One can enter the Westerkerk on weekdays only by ringing the doorbell of the verger's house next door and asking for permission to go in. The church has a cool and cheerless feeling, with wooden seats that seem right for concerts and are unconducive to prayer; it is rather like a high-ceilinged Dutch *sael* where the family spent little time. The main points of visual interest are four large brass candelabra, which the Dutch call "crowns." A plaque on one wall, one of the few evident memorials, announces the name of the artist who was buried here without much ado in 1669: Rembrandt Harmenszoon van Rijn. The Portuguese Synagogue is open most days and provides a calm haven for anyone who wants to sit for a while under the high, triple barrel-vaulted roof, with tall clear-glass windows and candelabra like those in the Westerkerk, wearing – if you are a man and a Gentile – a borrowed skullcap, and thinking of the well-dressed throng who populated it in Emanuel de Witte's late seventeenth-century portrait of its interior, and of the congregation's descendants, who faced some of the worst horrors of the twentieth century.

Last Sunday morning I walked to the English Reformed Church for the ten-thirty service. In fact a joint congregation of the Church of Scotland and the Dutch

Reformed Church, it is housed in a chapel built in 1392, set in the Begijnhof, an oval-shaped ring of tight-packed houses for old people, with sheltered paths, quiet gardens, and the "English Church" in its midst, a short alley away from the busy pedestrianized shopping street of the Kalverstraat. Services in English have been held in the church since 1607, with interruptions during the Napoleonic and Second World Wars. The church has recently been restored. The rafters are painted robin's-egg blue, the roof panels in the nave are chalky white and, over the side aisle, pale yellow. Through the clear windows I could see the old red-tiled roofs of some of the Begijnhof houses and in return the sunlight coming in and illuminating the walls, the pulpit, and – in the place where one would expect in non-Calvinist churches to see an altar – a small table bearing a vase of red tulips and yellow chrysanthemums. The church was packed and the service simple: hymns, Bible readings, announcements, and a sermon, interspersed with prayers and two short ceremonies – the baptism of a child and the weekly collection. Between times, the organist enthusiastically improvised on several of the hymns. The minister preached, in a stirring Scots accent, on the theme of confidence. A pretty girl in blue jeans and a flowery shirt stood in the pew in front of me. Some of the hymns I remembered from summer camp and schooldays. I sang lustily.

And more than that, somehow. Belief is less difficult on a May Sunday morning in such a place. Sunlight – music – flowers – voices – the human body – minute distillations of talent, beauty, and history; and the mind, my mind, meandering not so much in a state of grace as of gratefulness: all helped submerge for a little while the raft of doubt, skepticism, and, perhaps, reason we cling to as superior creatures (superior but alone). I felt washed momentarily in the tide, if not of faith, of fellowship, of a company that together sets its thoughts on things elsewhere. The minister proposed the Sermon on the Mount as the basis for true confidence. It is a hard code of conduct – turning the other cheek, going the second mile – but briefly it seems not quite so unreachable.

The scale is part of what affects one: a small place filled by light, sound, and people. Another element is the matter of belonging to a group. In the seventeenth century the members of the Amsterdam English church in that respect had pleasures and problems perhaps a little more intense than those of similar Dutch churches. They were surrounded by co-religionists who were not, quite, compatriots. However, though run on the same lines as a Dutch congregation, with its ministers approved by the Calvinist Church council, the English Church didn't have to inhabit either a vast, formerly Catholic church or a great edifice put up to show that the Calvinists could build big as well. As one sees in pictures of the churches of the time, they had ceased to be sacred places. The statues and religious

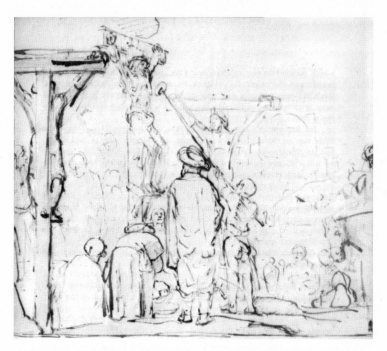

Christ Crucified Between Two Thieves. *Drawing, c. 1650–1655. Cabinet des Dessins, Louvre. Permission of the Réunion des musées nationaux, Paris*

paintings had been removed, and the churches had become meeting places, where sometimes children played and dogs barked at one another and graffiti were scribbled on the columns. John Ray observed: "In the service of God the people seem more delighted and concerned in that part of worship which consists in singing than any other, and they provide more for it." Standing in the pulpit, the minister discussed the Bible and read from it. Over the pulpit hung a big, wide-brimmed lid – like the hats the men wore in church and out – which assisted his words in going out to make their effect.

For Rembrandt, as for almost all Protestants in the Netherlands, the Bible was an element of life, as current and indispensable as food, drink, and air. People were saturated with the Old and New Testaments, the way we are with newspapers and television. It was always on hand and constantly read; it was consulted as a guide to conduct, for lessons, for practical advice, for parable, metaphor, language, and

illustration. It was the Book: it was divine; the Word of God. It provided a rich field for scholars to work, to dispute, and split hairs – and not just for scholars; it was almost a national hobby. It provided, too, the background for what most people still saw as a stark battle between Right and Wrong, God and the Devil, Heaven and Hell.

The Dutch had gone into battle against the Spanish believing that God was on their side. Their national anthem, the "Wilhelmus," is both anthem and psalm, and in it William the Silent, the heroic founder of the republic, gives voice to Biblical comparisons; for example, "Just as David had to flee from Saul the tyrant . . ." In many ways the result of the intermittent war, finally brought to an end by the Treaty of Münster in 1648, must have confirmed the belief of the Dutch that they were the chosen people, predestined to be the victors. They identified themselves with the ancient Jews, the people of the Bible, in the way that many Dutch in the past have identified with the Israelis – a small nation, a people under pressure. The Jews threw off the Egyptian yoke the way the Dutch threw off the Spanish. When it came to decorating the interior of the new Amsterdam Town Hall, among the pictures of the Batavians (who rebelled against Rome) were pictures drawn from the Bible, such as Moses holding the Tablets of the Law. In the marvelously direct self-portrait Rembrandt etched in 1648, sitting by a window, his drawing block rests on a big book I assume is the Bible – the source book close at hand. As a child he saw it often in his mother's hands; he heard it and studied it at school. He may have begun to learn Hebrew at Leiden University – he was able to paint Hebrew written characters.

The Dutch Calvinists in some ways represented a return to the zealous Christianity of the Middle Ages; in others, a success for independent thought. Protestantism made headway where professional men, craftsmen, and artisans could work alongside one another and talk. (In Dokkum, a center of Protestant activity, one still sees boatmen sitting making sails and mending nets and having earnest conversations.) So Dutch Calvinism had a built-in conflict between zeal and liberal thinking. Those who disagreed with the concept of predestination, and they were probably the majority, could have seen in the successful outcome of the battle with Spain a triumph rather of free will: the Dutch had proved they had power over their own destiny; they had succeeded in controlling their own fate by hard fighting on land and sea, by their own efforts.

The Dutch Reformed Church made strenuous attempts to become the state church, but though often supported by declarations from the civil authorities, it never acquired exclusive rights. Its ranks were divided. The separation could be identified with the leaders of the hard-line and moderate factions, Gomarus and

Arminius, both professors of theology at Leiden. The former backed predestination: "an eternal and divine decree has established which men were to be saved, and which damned"; whereas Arminius said more mildly that "those who renounce their sins and place their trust in Christ are granted forgiveness of their sins and life eternal." The division could be recognized in the countrywide split between – on one side – the Orangists, who supported the House of Nassau as semimonarchical leaders in a continuing struggle against Spain, and – on the other side – the party of the regents, the upper-middle-class oligarchy led from 1652 to 1672 by Jan de Witt, which favored peace and free trade. Liberal economics went with moderation in religion. Moreover, it was a split one might be tempted to see as well in Dutch behavior abroad, with extremes of tolerance and authoritarianism, integration and apartheid, present for many years among the Afrikaaners.

Certainly as the seventeenth century wore on, the "fundamentalists" were forced to retreat. In 1651 a delegation from the combined provincial synods came to the Great Assembly of the Reformed Church and denounced "profanation of the holy Sabbath, manslaughter manifold and easy pardons. There are houses of immorality and brothels, schools of dancing, chamber-players, rope-walkers, true baits to all forms of uncleanliness and licentiousness; forbidden, scandalous and incestuous marriages are taking place, there is far-reaching luxury, the wearing of expensive clothes and banqueting to the ruin of many families . . . " These sins, the tirade went on, are "the cause of . . . diseases, unemployment, high floods, general dearness and scarcity."

But the shrieking tone perhaps came from a sense that it was all getting beyond the synod's control. The Amsterdam Athenaeum Illustre gave the Arminians, or Remonstrants, a strong foothold in the city. Sir William Temple, who knew mostly upper-middle-class people, was nevertheless more generally right than wrong in saying, "No man can here complain of pressure in his conscience; of being forced to any public profession of his private faith; of being restrained from his own manner of worship in his house." John Ray, noting the air of freedom, said, "The people say and print what they please, and call it liberty." Another Englishman, Owen Feltham, put it differently. Amsterdam, he wrote, is "a den of several serpents." Here, closer to Hell than elsewhere, "You may be what Devil you will, so you push not the State with your horns."

Although public worship by Roman Catholics was forbidden, they made up roughly a third of the population, and annual payments to town councils helped create an atmosphere in which they could worship privately. There were more semisecret Catholic churches in Amsterdam in midcentury than there were official Calvinist churches. One functioned in a house directly opposite the front door of the

English Reformed Church in the Begijnhof. Another, later named Our Lord in the Attic, was specially built in the upper floors of three interconnected houses on the Oude Zijds Voorburgwal. Pieter de la Court said that most of the "old inhabitants" of Holland – peasants, monied men, and nobles – remained Catholics, while many fishermen, sailors, and tradesmen belonged to such nonofficial Protestant sects as the Mennonites.

The regents set a tolerant example: they allowed shops to stay open on Sundays, ships to be unloaded, and markets held. Jan de Witt, the Grand Pensionary, was known as "a serenely religious man"; he believed that one of the great ties uniting the people of the United Provinces was the bond of "one and the same religion." But in 1660 he took firm action to prevent a fanatical preacher in Medemblik from exhorting people to a new war with Spain. He and his colleagues befriended Spinoza, for whom they arranged an annual pension of 200 guilders. Spinoza, though publishing under an assumed name, recognized how much better things were ordered here than in other countries. In his *Tractatus* of 1670 he wrote, "We have the rare felicity of living in a state where entire freedom of opinion prevails, where all may worship God in their own fashion, and where nothing is held sweeter, nothing more precious than such liberty." Sir William Temple said, "Religion may possibly do more good in other places, but it does less hurt here."

Even within the Reformed Church, the prevailing moderation made itself felt. The Calvinist minister Balthasar Bekker attacked the residual belief in witchcraft. In Amsterdam particularly the desire for normal, getting-on-with-daily-business conditions put "peaceable walking" high on the list of church priorities. The historian Dr. Alice Clare Carter has shown how within the regime of the English Reformed Church in Amsterdam there was latitude for diverse views and compromises to end personal theological conflicts. One of the many people Rembrandt knew who took religion seriously, in various modes, was the husband of Saskia's sister Antje – a Calvinist theologian from Poland, Jan Makowski or Joannes Maccovius, who taught at Franeker University in Friesland. Although a die-hard Calvinist and opponent of the Mennonites, Maccovius was at one stage capable of participating in wild student parties and so offending his colleagues by his goings-on that he was barred from senate meetings; but he eventually became rector of the university.

Yet the Reformed Church was the center of its members' lives. It was an exclusive club, choosy about those who belonged to it, who were, after all, "the elect"; if you belonged, you had to submit to its discipline. Its powers of interfering in its members' lives were considerable. If you expressed heretical views, beat your wife, slandered anyone, or lived in sin, the local church council would take notice (as it did in the case of Rembrandt and Hendrickje). The practice of the

English Church in Amsterdam was to send a delegate to try to talk the offending member out of his misdeed and make him reform. If that failed, the council would condemn the member and expel him from the church. When the Dutch wife of one member, William Best, sold fruit from her shop on Sundays, it was Mr. Best who got into trouble with the minister, John Paget.

The conditions that prevented strict Calvinism from getting its own way – conditions that included prosperity, curiosity, and a general mildness, in climate and character – were also propitious for scientific inquiry. The literary historian Basil Willey called the seventeenth century "the double-faced age . . . half scientific and half magical." It was the age that produced the slide rule, telescope, microscope, thermometer, barometer, and pendulum; many of these were products of the Netherlands. It was the age in which observation and perception were for the first time generally put at the service of understanding, and not made subservient to various given rules or dogma; it was the age of the first museums, botanic gardens, records and collections of plants and creatures. In Delft the great amateur scientist Anthonie van Leeuwenhoek peered through his homemade microscopes and saw bacteria. It was an age in which a world was brought into being that didn't absolutely require miracles or superstition – in which it was understood more widely that natural laws could be discovered to account for what happened. (Though plenty of people went on believing in "phantasms," levitations, and "strange relations" – John Ray's term for some of the things given credit by John Aubrey, English antiquarian and one of the original Fellows of the Royal Society. Aubrey wrote in one of his books, "Dead Men's bones burn't to ashes and putt into drinks doe intoxicate exceedingly.") Spinoza thought the apparent miracles in the Bible were manifestations of the way nature in fact worked; one ought to be able to contemplate God the way one considered a geometry problem.

The increased openness toward science was demonstrated even by Protestant leaders. Luther, for instance, believed that Heaven could not be found in a fixed spot in space. The cosmos might well be infinite, and therefore a proper subject for astronomers to gaze at – as indeed Galileo did at the beginning of the century, with a telescope perfected from one invented by Dutchmen. (The world's largest radiotelescope observatory has recently been established at Westerbork, in the Netherlands, with the capability of penetrating space to the profound depth of nearly 10,000 million light years, and thus perhaps discovering whether the universe is finite or not.)

And yet Heaven, with or without geographical coordinates, was still there, and God remained for almost all seventeenth-century scientists and philosophers the First Cause, "although a Thousand other *Causes* should be supposed to intervene,"

as the physiologist Nehemiah Grew wrote in his *Anatomy of Plants* (London, 1682). "For all Nature is as one Great *Engine*, made by, and held in His Hand." Jan Swammerdam, the Dutch anatomist who first observed red blood corpuscles in 1658, saw in the metamorphosis of the May fly from "a creeping and swimming worm to . . . a flying creature" the lesson that man "should quickly and readily leave the wet and cold waters of this muddy vale and raise himself on the wings of hope and love, which are the two arms of faith, into the air of divine affections." As Basil Willey nicely puts it, "Behind the gauze curtain of science the old supernatural drama was still proceeding as before."

For western Europe, it was perhaps the last intently religious age. The paganism of the Renaissance had waned. Classical images were put to use – as they were in writing by Sir Thomas Browne and Vondel – to bolster Christian morals, and classical architectural forms were used – as Sir Christopher Wren and Jacob van Campen used them – to dignify Christian buildings. Although the Bible was still considered to be of divine inspiration, its historical character was coming to be recognized, too. It was one of Rembrandt's particular strengths that he managed to emphasize its historical and human aspects while conveying – as if he knew what danger it was in of being eroded – its numinous quality.

In Amsterdam, up from Leiden, Rembrandt saw the Jews. He was struck with the fact that here, in real life, at close hand, were the inhabitants of the Bible – people with an inherited foothold in the eternal. Nietzsche called the Old Testament "the book of divine justice . . . Greek and Indian literature have nothing to compare with it . . . I find therein great men, a heroic language, and one of the rarest phenomena in the world, the incomparable naïveté of the strong heart; further still, I find a people." The incomparable naïveté of the strong heart! How well this suits not only the Bible but the seventeenth-century Dutch artist who turned to it. It was with naïveté and a brilliant ability to get things right that he looked at the Jews of his neighborhood and found the people he needed. The Bible furnished the subject matter or a starting point for roughly 160 of his paintings, 80 etchings, and more than 600 drawings.

The Jews came to him with commissions, and he went out to the Jews. The Bible would have been a topic he could have discussed with Manasseh ben Israel or Ephraim Bonus, the Jewish physician, as he made portraits of them. Jews sat for portraits of scholars, prophets, or of themselves, young men and old men. He etched the venerable Askenazim in their synagogue, talking in whispers, wearing strange hats, and with their cloaks touching the ground. Was it due to happenstance or good homework that he etched ten men, the *minyan* (or quorum) needed for a

Jews in a Synagogue. *Etching, 1648. Courtesy of the Trustees of the British Museum*

Jewish service? Once in a while he used a woman close to him – Saskia, Geertje, or Hendrickje – for a Bathsheba or Susannah, and his mother and father and students posed for various paintings and drawings. So there was no rule that his Biblical characters *had* to look Jewish, except for Christ. Rembrandt's Christ was a Jew, and that of course was a revolutionary conception. Furthermore, as time went on Jesus became in Rembrandt's work ever less related to the wondrous creature who figured in most Catholic art, and more and more an antiheroic person whose magnificence is his wisdom and humility.

Certain subjects he went back to throughout his career: Abraham's sacrifice, Samson, the Good Samaritan, Christ at Emmaus, the Flight into Egypt, the Prodigal Son, and so on. Professor Henri van de Waal, the Dutch art historian, has pointed out that many of Rembrandt's works can be put into such categories as "a ruler on his throne" – many of the Saul, David, and Solomon pictures; "a beautiful nude woman in a landscape" – Bathsheba and Susannah; and "angels visiting human beings," who include Hagar, Abraham, Lot, Elijah, Tobias, and Bethlehem shepherds. He enjoyed, apparently, the moment of contact between men and the divine messengers. He also liked "doorway scenes" – meetings, departures, welcomes, and goodbyes, incidents where compassion or forgiveness are shown, and particularly those in which fathers and sons are involved: Jacob and Joseph, David and Absalom, Tobit and Tobias. Since the art he made obviously reflects the person he was, one reads into this the strong affection he felt for his son, Titus – though it is hard to

imagine that pensive boy becoming a troublesome teen-ager or the hairy dropout who is being greeted on his return home in *The Prodigal Son* etching.

The son who was prodigal was perhaps himself. But he showed his concern for his own father in some works that were prompted, it may be, by his father's going blind. In the painting he did of his father in 1629 or 1630, the light falls on the old man's lined forehead and on his blurred and red-rimmed eyes. The Biblical source here was the apocryphal Book of Tobit, which Rembrandt turned to for more than fifty works. (The Book of Tobit was included in the Dutch Bible authorized by the Synod of Dordrecht in 1618, though not in the English King James version, but Dutch readers were warned that the book was untrustworthy, partly because in it an angel lies, telling Tobit that he is Azarias, son of one of Tobit's relatives.) Tobit had gone blind while in exile in Babylon, but had kept to his faith. His son Tobias, while on a journey to collect a debt for his father, was joined by the angel Raphael. Raphael advised Tobias to catch a fish and save the entrails; also to stop at a house of a relative. There Tobias married the daughter, Sarah, and by burning some of the fish guts broke a curse that had killed her first *seven* husbands on their wedding night. Lucky number eight! When they all got back to Tobit's house, Tobias used the remainder of the entrails to cure his father's blindness. This folk tale was natural grist for Rembrandt's mill. He illustrated various aspects of the story. He drew Tobit being operated on for cataracts. He made much of the dog, which accompanies Tobias on the journey and runs ahead to the old man's house when the son returns. In the etching of 1651, Tobit feels his way to the door to greet the returning Tobias – he has knocked over a spinning wheel by the fireplace, and the dog at his feet is trying to nudge him in the right direction. In one drawing of Tobias saying goodbye to his father, that well-known chair of Rembrandt's is one of the props.

Rembrandt was as interested in the apocryphal as he was in the authorized text of the Bible; and always he put the humane before the prophetic. In the same way, he was more concerned with getting across the nub of a situation and the relationship between the characters than in the literal word-by-word account in the Book itself. We realize that his willingness to alter the words was part of his ability to arrive at the heart of the matter – accurate draftsmanship was part of it too. The elements and costumes are what strike *him* as suitable: if necessary, his own tables and chairs; Roman soldiers in Oriental dress or Renaissance headgear. In the Book of Tobit the final disappearance of the angel Raphael is seen only by father and son; Rembrandt, however, often had the family and servants on hand for the occasion. In one of the four small etchings he did for Manasseh ben Israel's *Piedra Gloriosa* is the vague, radiant form of God the Father, contrary to both Calvinist and Jewish

proscriptions against graven images. But these illustrations (which were replaced in the second edition by inferior engravings by another artist, perhaps for theological reasons, perhaps because Rembrandt's plates had worn out) are unusual in that they do not seem to spring from Rembrandt's own impulse, but were done rather as a favor for a friend – whose commission, moreover, was a trifle vague.

His own Biblical work springs strongly from his heart. But, that said, one needs to add that it now and then springs in a way formed by memory or the actual looking-up of a predecessor's work. The scholars tell us that the *Ecce Homo* etching of 1655 has important sources in engravings by Lucas van Leyden, Nicolas de Bruyn, and Callot. The compost out of which *Ecce Homo* matured probably included out-of-doors presentations by the amateur theatrical groups known as Chambers of Rhetoric, popular in most Dutch towns. The archways that appear in later states of the print match those recently found under the Gravenstein courthouse in Leiden, where he no doubt saw them as a young man. The head of the old bearded man who is vaguely to be seen in the seventh state of the etching seems to be one of those plunges into mysterious depths that Rembrandt took from time to time, like the white-faced girl in *The Night Watch* or the strange-hatted horseman in the later version of *The Three Crosses*. Is this ancient bearded fellow Old Adam, as one scholar (E. Winternitz) suggests, freed from limbo by Christ's sufferings; is it a river god; or is it just a doodle Rembrandt found himself making and later tried to erase? Yet the resulting etching, in its various states, full of hints of earlier artists, dramatic pageants, Leiden nostalgia, and possibly race memory, an etching based on Matthew 27:15–26, where Pilate asks the people, "Whom will ye that I release unto you?" and done in his direct, dry-point scratching, could be by no one else. All the borrowings, overtones, and bits of tradition are assembled and transfigured into a work of great power.

It would be audacious to say what religion Rembrandt belonged to. The Baldinucci-Keil description of him as a "Mennist" is not supported by the membership records of the Mennonite Church in Amsterdam. He had, as we have seen, many Mennonite connections through Hendrik Uylenburgh's household, and in 1641 did two portraits, one in paint, one an etching, of the Mennonite preacher Cornelis Anslo, who was famed for his eloquence. (It was at roughly this time that Keil was a student of Rembrandt's and he may well have heard conversations that made him think Rembrandt was especially sympathetic to the Mennonite point of view. Samuel van Hoogstraten, also a Mennonite, joined Rembrandt's studio in January 1641.) Since 1626 the Mennonites had been allowed to worship in public; their unhappy sixteenth-century experiences of persecution and martyrdom were well past. A branch of the Anabaptist movement, the sect took its name in the

Netherlands from Menno Simons (1492–1559), one of its early leaders. The Mennonites believed the church to be a voluntary assembly of like-believing people, any of whom could achieve "active sainthood." They believed baptism should be an adult act of volition; they worshiped with silent prayer and (an act Rembrandt depicted in several works) practiced the humble ritual of washing each other's feet. They believed in the authority of the Bible, and Menno Simons said the Book of Tobit gave lessons in Christian education: Tobit's patience, piety, charity, and morality were all exemplary. Very little in Reformed Calvinism appealed to the Mennonites, and the Dutch Reformed Church continued to fume against them.

Yet Rembrandt's family connection with the Reformed Church was on record: he was married within it; his children were baptized in it; he got into trouble with it for living in an unmarried state with Hendrickje Stofels. He was buried in it, and just before his death stood as a sponsor in the church for his granddaughter's christening, a role permitted only to those who were sound in faith. But he seems to have been less interested in ecclesiastical mechanics than he was in the Bible or, for that matter, in getting on with his work. Orlers, his first "biographer," noted that during the riots in Leiden in the early 1620s between the Remonstrants and Counter-Remonstrants, Lievens and Rembrandt refused to be distracted from their job of copying the then popular prints of Willem Buytewech. Rembrandt was known in Amsterdam as an artist who could cope with just about any religious commission, whether formal portraits of Calvinist dominies or far-out illustrations for the publications of rabbis.

He was an obvious man for the Socinians to turn to. These were the most extreme sect in Holland, named after a Protestant nobleman from Siena, Fausto Sozzini or Faustus Socinus (1539–1604), who spent the latter part of his life in Poland. In the Netherlands, where many of his upper-class, aristocratic followers took refuge, and where they were also known as the Polish Brethren, their radical beliefs stretched Dutch tolerance to the limit. The Reformed Church called for the expulsion and even execution of the Socinians (though the Amsterdam burgomasters as usual managed to ignore such demands as long as the Socinians lay low). A French writer in 1673, in a survey of Dutch religion, said "The Socinians deny the divinity of Jesus Christ, the existence of the Holy Spirit, original sin, the atonement [*satisfaction*] of Christ, the resurrection of the wicked, and the restoration of the same body that the faithful have had during life. Their public meetings are prohibited." To the Socinians Christ was only a man. He had not atoned for man's sins by shedding his blood.

Two of Rembrandt's works have possible ties with the Polish Brethren. (His connection is already established with two former Polish residents, Uylenburgh

"The Hundred Guilder Print." *Etching, c. 1643–1649. Courtesy of the Trustees of the British Museum*

and Maccovius, and Adam Boreel, a member of the family he rented the house from in the Nieus Doelenstraat, was involved in the Socinian movement for a time.) One work is the etching traditionally known as *Dr. Faustus*, done around 1652, showing a man who could have been taken for a savant or alchemist in his study, but in fact gaining its title – some experts now believe – not from Faust who made a pact with the Devil but from Faustus Socinus. Professor van de Waal thinks this etching may have been commissioned by the Socinians as a frontispiece for a book, though quite how their anti-Trinitarian views fit with the monogram of Christ, shown in a sort of holy glow startling the scholar, remains unclear. The letters INRI appear on the mysterious disc, together with an anagram incorporating the letters AGLA. This was a Cabalistic term derived from the name of a Jewish prayer that went on for eight hours, and a term regarded as having special powers by some medieval Christians. (It is to be seen in the Jan van Eyck Ghent altarpiece, on the mosaic floor of *The Singing Angels* section.) But reinforcing the Socinian connection, Mr. Bob Haak points out that unlike most of Rembrandt's etchings, this one is unsigned – "perhaps because of the danger involved."

Not long after this, Rembrandt was painting another work with Polish over-tones. *The Polish Rider*, which now hangs in the Frick on the same wall as the self-portrait of 1658, is a splendid example of the almost deliberate ambiguity Rembrandt could indulge in while producing a masterpiece. The strange Turkish-looking building on the hill, the somewhat spectral horse, whose mission seems to be different from his rider's, the handsome lad with his elbow proudly sticking out – the apparently disparate elements coalesce and are crowned with an evocative title. Is it an equestrian portrait; a soldier of Christ; or a historical figure, per-haps the hard-worked Amsterdam hero Gijsbrecht van Amstel, as the Rembrandt scholar Dr. Valentiner believes? Is it Titus on horseback? There are reminiscences in it of Dürer's *Death and the Devil*, of the Christian soldier going off to fight for Good against Evil. The twisted pose recalls the Verrocchio equestrian monument to the *condottiere* Colleoni. Moreover, a present-day Polish scholar, Jan Białostocki, believes that this really is a Polish rider. The weapons and costume are right, he says. The horse, though not the best, is "a good and genuine example of the light cavalry breed." Moreover, there is the tempting fact that in Amsterdam in 1654 was published an eloquent and controversial pamphlet (*Apologia pro veritate accusata*), supporting toleration and demanding the separation of religious affairs from those of the state. The author, Jonasz Szlichtyng, hid under the nom de plume "Eques Polonus" – *eques* meaning knight or rider; *Polonus* meaning Polish. (When I was last in the Frick, an old lady was standing in front of this picture, murmuring to herself, "Youth – youth – *youth*.")

Look for Rembrandt's religion and you find nothing clear-cut or dogmatic. You find the old-fashioned, the unchanging, and the novel stroke of genius fused in ink, copper, or paint. You find a man who clearly enjoyed hearing the diverse views of people who took their religion seriously, even if he didn't feel the need to profess one in particular; it marks him out again, finely, as the individual he was in that committed age. And you find someone who, along with hard work and domestic ups and downs, *read* the Bible. One work of his that the Bible, or at any rate the New Testament, completely permeates is "The Hundred Guilder Print," which he labored on over a long period and obviously put all his talents into. Although various parts of the Gospels are to be found in it, a specific text might be from Mark 1:32–34: "And at even, when the sun did set, they brought unto him all who were diseased, and them that were possessed with devils. And all the city was gathered together at the door. And he healed many that were sick of divers diseases, and cast out many devils." Christ, the healer and teacher, stands at the apex of a wedge of light thrust through the surrounding dark; he is at the center of a motley crowd.

Around him are the sick, the lame, the well, the rich and the poor; faithful and skeptical, Apostle, and Pharisee, listening, arguing, reverent and contemptuous. The camel that would find it easier to go through the eye of a needle than a rich man would to enter heaven is standing in the gateway at the right. Among the figures on the left Hofstede de Groot thought he identified the features of Socrates in Rembrandt's St. Peter, behind whom stood Erasmus – representatives of ancient and modern wisdom, and also of Rembrandt's uncanny skill in bringing together bits and pieces of past and present, the obviously and less obviously relevant. A small scallop shell lies on the ground near Jesus's feet; it is just there.

There are in this etching no "elite of the elect." No one is damned. Everyone there has a chance to receive the look or touch of grace. Moreover, Rembrandt sees his people of the Bible with a conserving eye, as if hanging on to a way of looking at Christianity that would soon be lost. There is an attribute of innocence and also of finality. Certainly nothing "intellectual" or pompous. (He was capable of drawing St. Jerome with his lion, in one of three drawings he did on this subject, the old saint wearing spectacles, while nearby a bird chirps gaily in a tree.) Van Gogh said, "There is something of Rembrandt in the Gospel, or in the Gospel something of Rembrandt." For him the divine could be human, humanity divine. Through the truthfully perceived he arrived at otherwise imperceptible truths.

XII

Age of Gold, Ink, and Tar

IN THE CENTER of the century an Amsterdammer was sometimes swept by the feeling that this city of his was *the* place to be. Private moments, perhaps, as he walked along one of the great, grandly named canals or the Amstel and admired the fine houses, the red bricks and green leaves of the trees reflected in the calm water; or public occasions, like that on October 28, 1648, when the foundation stone was laid for the new Town Hall by four children, sons and nephews of the burgomasters. Earlier that year the Treaty of Münster had finally brought to an end the long struggle with Spain, which had lasted through the lifetime of most Dutchmen. The treaty confirmed Dutch conquests in the East and West Indies, and kept the River Scheldt closed to shipping, and with it the overseas trade of Antwerp and southern Netherlands firmly under Holland's control.

On the day the peace was proclaimed, bells pealed in all the churches of the city, public plays were performed on the Dam, there were salutes of cannonfire, flags and banners flew, and at night thousands of tar barrels were set alight and fireworks let off. People put on their best clothes and went out into the streets, where they hugged one another in delight. A delegate to the States Assembly of Holland and West Friesland declared, "Holland is beginning, as of old, to grow, to blossom, and the golden age in which our forefathers lived, and which we have longed for for so many years, is setting in." Perhaps the millennium the Jews were expecting was here, already. On one side of the medal struck to commemorate the inauguration of the new Town Hall was to be seen the ship *Argo*, rigged like

a Dutch merchantman, sailing gently into Amsterdam harbor with the Golden Fleece.

This return of an earthly paradise, an age fixed by some in the reign of Augustus or in the dawn of time, among the early gods, was – despite the proper enthusiasm – not altogether rightly named. It was also an age, as Johan Huizinga has written, "of wood and steel, pitch and tar, color and ink, pluck and piety, fire and imagination." It had its ungolden, indeed drossy, passages. During the depression of 1623 a pamphleteer complained of the difficulty of finding employment: "Our land teems with people, and the inhabitants run each other's shoes off looking for work. Wherever there is a penny to be earned, ten hands are at once extended to get it." During the 1638–1640 textile boom in Leiden, 4,000 children were brought in from the poor quarters and workhouses of Liège to work in the cloth factories. The age had its politically tense moments, like that in 1650 when the young Prince of Orange, William II (who wanted to continue fighting Spain and stop the gradual shift of power to the merchant-oligarchs), decided to march his troops into Amsterdam. Fortunately for that assertive city, the prince's men got lost in a fog and the defenses were manned. Then the compromise peace the city fathers agreed to was undone, to their benefit, by the prince's sudden death from smallpox. This left the fortunes of Orange in the hands of his English wife and baby son, born a few days after his death.

For the next twenty years, covering Rembrandt's middle age and old age, the regent class ruled Holland and guided the United Provinces. Their leader, Jan de Witt, whom Sir William Temple called "the perfect Hollander," had first to see his country through a disastrous war forced on it by England's marine and mercantile ambitions. The English claimed Right of the Flag – foreign ships must lower their colors when meeting an English ship – and, by their Navigation Act of October 1651, they insisted that all goods imported into England come either in English ships or in ships of the cargoes' origin, thus striking at the Dutch as common carriers. (Dutch vessels were noted for never carrying ballast; they always negotiated a cargo on both outward and return voyages.) George Monck, the Duke of Albemarle, said in regard to renewed Anglo-Dutch conflict in the sixties, "What matters this or that reason? What we want is more of the trade which the Dutch now have." The quarrel was almost in the family. As a declaration of Elizabeth I's time had pointed out, the Dutch were "the most ancient and familiar neighbours of the English." A marriage, or union, of the two Protestant states was nearly arranged between the regimes of Cromwell and de Witt, and was given flesh by the marriage of William III of Orange with Mary, niece of Charles II.

The first Anglo-Dutch war nearly ruined the United Provinces. They were saved from absolute defeat by a band of courageous sea commanders, and by Cromwell's realization that his interests and those of the Dutch burgher-aristocrats were similar: destroying them would help only the House of Orange and its Stuart relations. But for two years the war had its disastrous effects. During the summer of 1653 the English blockaded the Dutch coast for six weeks. Lieuwe van Aitzema, a Dutch chronicler, wrote twenty years or so later: "The sources of revenue which had always maintained the riches of the State, such as fisheries and commerce, were almost dry. Workshops were closed, work was suspended. The Zuider Zee became a forest of masts. The country was full of beggars. Grass grew in the streets and in Amsterdam fifteen hundred houses were untenanted." Allowing for some exaggeration arising from pro-Orange sympathies, Aitzema's account of the depression was true. Amsterdam's staple business, the Baltic corn trade, was further weakened by bad harvests in the Vistula region and a fall in demand because of depressed conditions in western Europe. Those in charge of construction of the new Town Hall had thoughts of thrifty modifications to the design, topping it off at one story. But the return of peace renewed their confidence.

When the wind was right, the sound of gunfire from ships battling in the North Sea reached the Dutch coast. In Amsterdam the slackened trade, increased taxes, and wounded seamen brought further evidence of maritime war to people who were, after all, born below sea level, almost with one foot in the sea. An English eyewitness to the Battle of Portland, February 18–20, 1653, wrote, "All the men of war who are taken are much dyed with blood, their masts and tackles being moiled with brains, hair, and pieces of skull." In this action the Dutch lost about 5,500 men, killed, wounded, and taken prisoner; the English only a few hundred. In taverns and on city street corners tales of horror and glory were handed on, and the exploits related of the Dutch admirals, the *pikbroek*, or tarpaulin sailors, like Tromp, who had been at sea since the age of nine, and de Ruyter, who never used the "de" but swept out his own cabin and fed his own chickens. Their men fondly called them *bestevaer*, "granddads." Despite the elegant appearance of Frans Banning Cocq's militia company, the patricians were not useless fops; Jan de Witt on one occasion in person took a wind-bound fleet to sea.

The battles were often mêlées, although signals were given by commanders and rudimentary attempts were made at line-ahead formation. Provincial rivalries got in the way – the Hollanders refused to obey the signals of Evertsen, because he was Lieutenant Admiral of Zeeland. Minor captains sometimes used the weather as an excuse for not being where they were supposed to be. In one engagement with the English off the North Foreland in June 1653, Tromp in the *Brederode* fought a

Christ in the Storm on the Sea of Galilee. *Drawing*, c. *1654–1655. Staatliche*
Kunstsammlungen, Dresden

close-quarters combat with the English commander, Penn, in the *James*. Tromp's
men boarded the *James*, were repulsed, and their ship boarded in turn. Tromp as
a last resort threw a burning light into the *Brederode*'s magazine, meaning to blow
up his own ship. Fortunately Dutch parsimony had kept the powder supply low,
and only the upper deck was blown into the air, taking with it the English boarding
party. The *Brederode* was refitted in time to take Tromp to sea again in late July
for the Battle of Scheveningen, destructive to both sides. Tromp was killed, but
the English lifted their blockade. The States General erected a tomb for Tromp
in Delft, his hometown: "He left to posterity a grand example of mastery in naval
warfare, of fidelity to the State, of prudence, of courage, of intrepidity and of
immovable firmness."

Rembrandt's interest in the sea was that of an average Dutchman. He knew it
was there; he knew many people who were involved with it. Many people from
towns and villages in the coastal provinces went to sea – as Pieter Dircx did –
whether on East Indiamen, Norwegian timber boats, warships, or herring busses.
Rembrandt owned half a dozen marine pictures by two of the best sea painters:
four by Jan Porcellis, who specialized in storms, and two by Simon de Vlieger,
painter of calmer waters. His big picture-buying period was apparently over by the

time the States General sent Willem van de Velde the Elder as a war artist to sail in a pinnace behind the Dutch fleet and record the scenes of action. Rembrandt's own pictures of the water are generally drawings of river and harbor scenes. In a lively sketch he made of *Christ in the Storm on the Sea of Galilee*, the Palestinian lake looks much like the Zuider Zee, shallow-water waves buffeting the apple-bowed Dutch fishing boat Christ is sailing in. The boat has well-shortened sail, raised leeboards, and its *wimpel*, or flag, wind-tangled around the mast tip. This drawing of the mid-1650s makes one feel the rocking, lurching motion of a boat in a choppy sea.

Like many people in a time of growth and change, he seemed to want things kept the way they were, or as they had been when he first arrived in the city: old ramparts and towers, sluices and ramshackle buildings. He drew the tower called Swijght Utrecht, next to the Kloveniersdoelen, without its new pointed roof, and the Montelbaantoren without the upper sections Hendrick de Keyser had designed for it and that were added when Rembrandt was a child of three. His preferences in materials came to be for what was old and worn, warm but unfashionable, and he turned his back on some of the grand improvements of the expanding city. On July 7, 1652, the partly demolished medieval town hall burned down; two days later he walked over to the Dam and twice sketched the ruins of it. (There was a problem of where to hang the city bell, rung to summon the citizenry to hear proclamations and sentences. After the fire the burgomasters and council moved their official quarters to a nearby inn, and Hans Bontemantel, a councilor, recorded, "A bell was hung at once out of the highest window.")

Rembrandt did not draw the new Town Hall, the monument to Amsterdam's glory that was rising in neoclassical splendor near the old town hall. Piles for it were brought in by the shipload from Scandinavia in *vlieten*, or fly boats, specially built timber-carrying vessels with sections of topside that swung open for the loading of the long pine trunks. While the new Town Hall was being built, it furnished a constant subject of conversation for Amsterdammers who watched the piles being driven in, the Westphalian stone and Italian marble unloaded from barges, the wooden scaffolding with diagonal braces getting higher, and eventually the cornices and roofs going on, with a cupola meant to be a Tower of the Winds and allegorical bronze figures standing on the pediments: Peace weighed more than 8,000 pounds. The weather vane on the very top was in the shape of a medieval cog, the symbol of the city. The citizens who stood on the Dam watching the construction work also talked about the cost, which finally amounted to 8 million guilders. It was Amsterdam's trade by sea that, despite wars and recessions, largely produced the wealth that brought about the new building. Suitable sea gods, nymphs, and Venus rising from the waves decorated the front pediment.

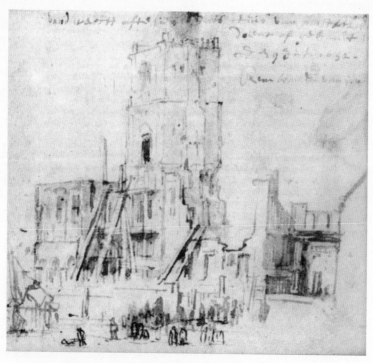

The Old Town Hall, *Amsterdam. Drawing, inscribed by Rembrandt: "As seen from the Weigh House, the Town Hall of Amsterdam after the conflagration of 9 July 1652." Rembrandthuis, Amsterdam*

The new building was not just an extravagant gesture. The city's expansion had stretched municipal administrative resources, and in the new Town Hall were installed the city bank, an ammunition store, the Insolvency Office, prisons and dungeons, a torture chamber, a magistrates' court, council meeting rooms, and the burgomasters' chamber. This overlooked the Chamber of Justice, where prisoners were sentenced, with a window through which the burgomasters could lean to give their approval of the verdict. Condemned prisoners were then led directly out onto a scaffold set up against the side of the building. In the Burgerzaal, the great hall intended apparently as a treat for the taxpayers, mosaic and brass hemispheres were inlaid in the floor: the northern celestial and two terrestrial hemispheres, on

one of which the burghers could see Tasman's discoveries of New Holland, made on his voyage to the coasts of Australia in 1642–1644.

For the first time, the world began to look the way it does to us now. There were a few distortions, such as Brazil bulging overmuch to the east, but otherwise the terra incognita and medieval gap-filling notions of strange continents and islands had gone forever. An educated Dutchman like Rembrandt held in his mind an expanded world, with names like Recife and Nieuw Amsterdam, Bantam and Batavia, Amboina and Japara. There were eastern islands where the Dutch Companies for Far Voyages held sway – Ceylon, Formosa, the Moluccas – not so much for settlement as for trade. In other waters, Hudson and Block sailed the New England coast, Barents the northern seas.

Fighting with the Portuguese and the English for the ripest fruits of the new worlds, the Dutch were not always the most sensitive of newcomers. Jan Pieterszoon Coen, made first Governor General of Java in 1617, slaughtered the natives and controlled overproduction by chopping down spice trees. On Mauritius, a convenient way station between Indonesia and the Cape of Good Hope, the dodo had lived for centuries in wingless security, peacefully laying its one egg upon the ground; it didn't survive the pigs, rats, and hungry sailors who landed from East Indiamen. (A dodo apparently reached Holland, for it is included in a landscape with birds painted by Roelandt Savery in 1628.) The Dutch were not greatly interested in permanent colonies. Native princes were allowed to go on ruling, and were presented with wonders from the tiny waterlogged homeland of these great merchant-venturers. In exchange for a cargo of sandalwood, Prince Crain Patengalo of Macassar asked the East India Company in 1644 for these items: thirty to forty thin bars of iron, twelve pieces of triangular-cut glass through which diverse colors could be seen in the air, a fine large burning glass, a pair of the best telescopes, a *sphaera mundi* made of brass or iron, a large map of the world, and a book or atlas with a description of the entire world.

Much of the new technology was the result of a practical desire to see, navigate, and record more accurately. Glass-grinding and -polishing were crafts that great men by no means thought beneath them. Constantijn Huygens's son Christiaen went from glass-polishing to great discoveries regarding pendulum clocks and the diameter of planets. Leeuwenhoek ground and polished the first short-focus lens, which permitted the manufacture of a simple microscope. Spinoza – as mentioned before – ground and polished lenses for a living. While Galileo's colleague Cremonini refused to look through a telescope for fear of what he would see, Jonathan Swift – who served for a time as Sir William Temple's secretary – wouldn't have written *Gulliver's Travels* if he hadn't looked through a microscope.

Travelers and traders in the Dutch companies needed charts and maps, and the geographers who made these vital objects were shown in symbolic pictures by Rembrandt and others for good reason; they were among the pathfinders of the age.

In Vermeer's elegant rooms, among the mirrors, musical instruments, and draperies, one often sees a map hanging on a white-washed wall, a demonstration of knowledge, a memento of newly found marvels, and possibly a useful guide to places mentioned in accounts brought back of the Indies, the Arctic, and Brazil. And even closer at home: works of both art and practical use are the meticulously detailed cartographic views of Amsterdam done by Balthasar Floriszoon van Berckenrode, which show the timber stacked in piles along the Houtgracht and even the double house at Number 4 Breestraat, wider than the house on the corner. The first edition of Balthasar's map came out in 1625, and a second in 1647, complete with the up-to-date new Town Hall (in fact hardly begun) and showing many of the once-empty sites in the Breestraat area and outside the St. Anthoniespoort filled in with new houses. Many maps of England were engraved and printed in Amsterdam, and when John Evelyn was in town in 1641 he bought several maps and folios from the shop run in partnership by mapmakers Hendrik Hondius and Joan Blaeu.

It was Blaeu who provided many of the items the East India Company gave to Prince Patengalo in return for his sandalwood. Blaeu, following in the great tradition of such Netherlands mapmakers as Mercator and Ortelius and inheriting a successful map business from his father, soon became the leading globe- and mapmaker in the Dutch republic. He had been a student at Leiden University for the three years before Rembrandt's registration there; he served on the Amsterdam City Council from 1651 to 1672. His printing house on the Bloemgracht, where Rembrandt had kept a studio during the 1630s, was the largest in Europe, employing about eighty men at nine presses for letter-press printing and six presses for copper-plate printing, and in the type foundry and the composing and correcting rooms.

Blaeu printed such notable works of the time as P. C. Hooft's *Historien*, Vondel's *Gÿsbrecht van Amstel*, and Hugo Grotius's *Corpus Juris*, a lengthy work with the added fame that it did not have a single printer's error. Blaeu was official printer to the King of Sweden and regularly attended the Frankfurt Book Fair; much of the firm's bread-and-butter work was in producing Catholic prayer books, missals, and devotional literature for a Cologne publisher. He designed a printing press that eliminated the backache printers used to suffer. Like many Amsterdam businessmen, he was involved in the slave trade (the Dutch West India Company gained the largest proportion of its profits from this source). He produced ready-made globes of the

earth and heavens in various standard sizes, but achieved his greatest fame from the *Grand Atlas*, an extremely costly publication with 600 maps, which he brought out in Dutch, French, Latin, Spanish, and German editions. The twelve-volume French edition cost 450 guilders – probably $5000 at today's prices. (French was now taking over from Latin as the international language. Both Christiaen Huygens and Anthonie van Leeuwenhoek wrote some of their treatises in French.) The United Provinces presented the *Grand Atlas* to great personages they wished to impress, including the notorious Barbary corsair Sidi Muhammad. In his copy, a dedication in Dutch and Arabic invoked God's blessing upon him. Joan Blaeu himself was not immune to fortune's slings and arrows. In 1672, the year before his death, a tremendous fire destroyed his printing works and he was thrown off the city council because of his anti-Orange opinions. (The de Witt regime had collapsed and the Prince of Orange had been turned to as the country went into a great panic during the French invasion.)

Printing and publishing gave much to Amsterdam's imaginative and commercial ferment. Many other firms, including the Elzeviers and Janszoons, vied with Blaeu. Philipp von Zesen, a German guidebook writer who had lived in Amsterdam since 1641, reckoned there were forty printing firms in Amsterdam publishing books in all European languages. Many English books appeared first in Amsterdam; for example, John Locke's *A Letter Concerning Toleration*, 1689, which came out in Latin, Dutch, French, and English editions. The Elzevier Press printed many cheap books in English, and numerous works intended as religious propaganda in England and Scotland were printed in Amsterdam and smuggled into those countries. In the Breestraat lived Joseph Athias, who published the Bible in various languages; he claimed that he printed enough Bibles in English that every ploughboy and serving maid in England might own one. The trade in Hebrew books was so profitable that men of other religions were involved in it; a Roman Catholic, Gerrit Huygen Claresteyn, bound and sold Hebrew works. England imported type for its own print shops from Amsterdam. One of the men of the age whom Mr. Wijnman has brought to our notice was the first founder of Hebrew and Greek typefaces in the United Provinces – Jan Theuniszoon, also known as Johannes Antonides and Jan Barbarossius (1568–1638). Theuniszoon demonstrated once again that the Italian Renaissance had no monopoly on *huomo universale*. He was lecturer in Arabic at Leiden University until he lost his post because of academic intrigue. (He had learned the language with the help of the secretary of the Moroccan ambassador.) He became professor of Hebrew at the Amsterdam Academy, run by Samuel Coster, educator and impresario, and also managed a gin distillery and a pub where musical performances took place. In strict Calvinist eyes, such a place

was just about the same as a brothel. Theuniszoon was a Mennonite and wrote many pamphlets in support of that sect.

Printing was the medium through which the knowledge of the age was spread. In the mid-forties there were ten different newspapers in Amsterdam, each appearing roughly three times a week. In 1672 the *Amsterdamse Courant* (the only one to survive to the end of the century) carried news from Prussia, England, Italy, Spain, and France. Dispatches told of the declaration of war by the King of England and reported briefly on the progress of the French army, then marching into the eastern provinces of the Netherlands. The Battle of Sole Bay, May 28, 1672, was announced in the next issue, with numbers of dead and wounded. The paper also carried classified advertisements about forthcoming kermesses, school-openings, things lost and found – someone reported his black greyhound missing. Amsterdam papers were eagerly bought in London for news of continental events. Booklets and pamphlets appeared on all sorts of scientific, religious, political, and financial questions.

Yet few of the now-remembered writers of the age made a living at it. Jan Vos, a popular playwright, got a better income from his glass-making; the playwright Bredero worked as a draftsman; Joost van den Vondel was a hard-working clerk in the Amsterdam Bank, and in 1653 lived in a small and simple house in the unfashionable Jordaan. Vondel, however, met the patrician mood, the need for classical trappings, grandeur, and magnificence, which the new Town Hall was also meant to fulfill. (Mr. Brom, a Dutch writer on the period, says smartly that Vondel couldn't mention a waterfall without first consulting Virgil to discover what a waterfall should look like.) The regents read P. C. Hooft's translations of Tacitus, and felt like Roman senators. They were pleased to hear of an ancient stone, dug up in the Netherlands, on which was inscribed GENS BATAVORUM AMICI ET FRATRES ROM. IMP., for they believed that the Germanic tribe of the Batavians, thus described as friends and allies of the Roman Empire, were their own ancestors. Among the heroic scenes from the past that the Amsterdam burgomasters wanted as decorations in the new Town Hall were eight episodes from the revolt of the Batavians. This had taken place in A.D. 69, and had been led by a chieftain whose Roman name was either Julius or Claudius Civilis. To the regents of the seventeenth century, Civilis was a noble leader, more Roman than the Romans, like William the Silent, who had led the revolt of the United Provinces against Spain.

On the joyful day of inauguration of the new Town Hall, July 29, 1655, the burgomasters sent out barrels of Rhine wine to the ministers of the city's churches. And then the gradual fitting out of offices and chambers proceeded, the completion and lifting into place of statues and carvings, the commission and hanging of the

necessary pictures. But this great centerpiece of the Golden Age was not to be a lucky building for Rembrandt. It was, for one thing, to house the Insolvency Office, where the officials worked who handled his selling-up. On the door of the new office was a relief of the Fall of Icarus. Above Icarus hung a bunch of holly (a suitably prickly plant) and an assortment of smashed locks, empty cash boxes, and bundles of bills that were presumably past due. Alongside the door the improvident citizen coming to sort out his financial affairs was greeted by carvings of purses with no bottoms and, naturally, nothing in them. It might have helped had the burgomasters at this point turned to Rembrandt with some commissions, but they did not. His pupil Govaert Flinck, who was painting in the new, lighter, fashionable manner, was the artist they most favored. It was Flinck who got the greatest commission of the age, the job of painting twelve pictures for the gallery of the Burgerzaal, eight of them to show scenes from the revolt of the Batavians.

Rembrandt's House, as built 1606–1607, and on the right as altered later in the century.
Illustrations from F. Lugt, Rembrandt's Amsterdam, Print Collectors Quarterly, 1915

XIII

Questions about the House

THE TOWN HALL now makes a formal backdrop to the public life that goes on on the Dam in front of it. The people of Amsterdam pass back and forth on their daily errands, and a motley international crowd of tourists and students stands or squats there. The Town Hall was taken over by Louis Napoleon, King of Holland, in 1808, and has remained a royal palace ever since, rarely used by the Dutch royal family, open to the public only in summer, floodlit by night. The seven small doorways symmetrically spaced out at the foot of the central section of the front – either to symbolize the seven United Provinces or to impede a sudden invasion by an antiregent mob – increase one's sense of the building as nonutilitarian, a stage-set for history.

The most recent demonstrations of Amsterdam inhabitants against their council have taken place in the Nieuwmarkt and Waterlooplein area, against the demolition and disruption caused by the building of the new Metro line. But I find that I often pause, as I did today, in a spot that has been created in the wake of the Metro works. This is the rebuilt quay of the St. Anthoniesluis, where the new brickwork, shrubbery, and several benches form an excellent spot to sit and watch the canal traffic pass under the new Breestraat bridge – mostly beamy, glass-roofed *rondvarten*, carrying parties of sightseers around the city, but also the occasional commercial launch, private yacht, or steel skiff noisily rowed by small boys. Ducks paddle under the bridge. The bells of the Zuiderkerk chime through the hum of road traffic. On the other bank, carts of junk arrive at the remains of the open-air

market in the Waterlooplein. My glance passes left, past the caftan-and-denim shop where Uylenburgh lived and the army-surplus shop in the Victorian building on the corner, on the site of the house where Eliaszoon lived, across the Breestraat and the textile-dealers' offices and up the Oude Schans, to the Montelbaantoren. I eat a lunchtime sandwich made from a small French loaf and Edam cheese, and I feel for a moment that history is not a linear progression from A to Z, on which route I somewhere am, but that it is circular, circuitous, and possibly concentric. Rembrandt lives around the corner.

His house in the early 1650s involved him in fresh problems. We know this, but our understanding of his financial problems would probably be greater if we had a precise idea of changes that were made to his house, and their exact timing. When built, in 1606–1607, the house (as I have mentioned earlier) had an entresol, two main floors, and an attic behind a step gable. At a later date the roof was lifted: the attic was enlarged into a room with four square windows overlooking the Breestraat, and the gable above rebuilt in classical style. Until recently, it was assumed that this alteration occurred after Rembrandt left the house. However, the Dutch architectural historian R. Meischke published an article in 1966 suggesting that these improvements were made *before* Rembrandt bought the house. Mr. Meischke proposed a time in 1630 or thereabout. Pieter Beltens, the original owner, had died in 1626, leaving the house to his son Pieter and his daughter Magdalena. In 1627 Magdalena married Anthonie Thijs, a rich merchant with extremely expensive tastes, and they lived in the Breestraat house. Mr. Meischke believes that Thijs did up the house; the attic and façade changes were made at the same time as the lower floors were being enlarged and redecorated, an extension for inner rooms added, and the staircase shifted.

But it wasn't long before Thijs decided to move; he bought and rebuilt a house, called Saxenburg, on the more fashionable Keizersgracht, but died soon after. (His heir, Christoffel Thijs, a cousin or nephew – the Dutch word is the same for both – had a country estate near Haarlem, which he also called Saxenburg; Rembrandt did an etching of it in the early fifties.) In 1628 young Pieter Beltens had built an elegant country house at Maarsen. The builder was his brother-in-law Balthasar Coymans, and Mr. Meischke believes the architect was none other than Jacob van Campen, who did a fair amount of work for Coymans.

Mr. Meischke, now hot on the trail, noted a close likeness between the gable of young Beltens's Maarsen house and that of the Breestraat house. Wouldn't it be likely, he suggests, that Thijs used the same architect for his remodeling as his brother-in-law Pieter Beltens. Jacob van Campen perhaps then provided the Breestraat house with a richly formed wooden fronton to take the place of the old

step gable, possibly the first such to be built in Amsterdam, with details taken from the neoclassical order book, a sort of architectural pattern book, by the Italian architect Vincenzo Scammozi. This was done, Mr. Meischke believes, at the same time as the roof-heightening and the building of new chimneys. The enlarged attic would certainly have provided the space Rembrandt needed for students' studios and a workshop, or *schilderlos*, as mentioned in the 1656 inventory, where painting materials were made up. The house would have looked up to date and "patrician," right for a fashionable and successful painter. It would be slightly ironical if Jacob van Campen was the architect of the renovated Breestraat house; he was, after all, the architect of the new Town Hall, which Rembrandt showed no liking for. But the artist had changed – other elements of his character became dominant – by the mid-fifties.

He was certainly not very sympathetic to the building operations that went on in 1653 next door in the former Eliaszoon house. He and his neighbor, Daniel Pinto, each swore statements before notaries in regard to a dispute about who was going to pay for some lumber, required for alterations being carried on, and which was needed by Rembrandt, Mr. Meischke believes, for defensive purposes: in other words, props and supports were required on Rembrandt's side of the party wall because of what Pinto was doing. This was raising his house (*opgevijzeld*) by three feet and two thumbs – almost precisely the modern meter. The process involved making openings of that height above the floor beams in the brickwork of the side walls so that the beams could be lifted with wooden screw jacks and refixed there. It involved a great deal of interior taking apart and putting back together again of doorways, paneling, and chimneys. On the exterior it required lifting the roof and adjusting features, such as gutters, used in common with neighboring houses; down below it meant rebuilding the front steps, which the two houses had shared.

If there were any more evidence for it – architectural, financial, or in his personality, as we see it in his pictures – one might be tempted to think it was the right time for Rembrandt's house to have received some major alterations too. Perhaps some were inescapable, given what was happening next door. And perhaps other forces were at work. Sixteen fifty-three was the year in which Thijs and Beltens insisted that Rembrandt pay the long-outstanding principal and interest he owed them on the purchase of the house. He thus had to borrow the money elsewhere, and with the help of these loans received the deeds of ownership. Yet one wonders why Thijs and Beltens suddenly decided to get rid of their interest in the Breestraat house. Was it more than impatience with the occupier? Why, in fact, was Pinto raising his house by three feet and two thumbs, half a man's height, and not enough to give him an extra story?

Since no one to my knowledge had asked these questions before, I rang up Mr. Meischke in The Hague, found out when he was next going to be in Amsterdam, and invited him to have a cup of tea with me. He kindly met me in the courtyard cafe of the Amsterdam Historical Museum, which has been formed out of the old city orphanage; the neoclassical courtyard buildings were designed by Jacob van Campen. One compelling reason for raising a house in Amsterdam, Mr. Meischke told me, was that it had settled. In the seventeenth century it was impossible to drive new piles under a house; if it sank, because the pilings had rotted or gone down under the weight, the only thing to do was lift up the house within. I asked if this could have been likely in the case of Pinto's house. Indeed it could have been, said Mr. Meischke. The Breestraat area was notorious, and still is, for poor building conditions. The Breestraat itself ran along a dike, and the houses were built on the sloping sides of this raised bank. In this section of town the stratum of sand to which pilings went down was neither so continuous nor so firm as in other parts; the sand layer below the surface mud and silt sloped downward toward the Amstel River and had been weakened and fragmented by the wandering back and forth of the course of the river over the centuries. It was an area where the level of ground water would have fluctuated considerably, exposing the upper sections of piles to drying out and getting wet again, which brought on rot and collapse, and the uneven sinking of the house above, with consequent sags and cracks. The Rembrandt House had had to be repiled, at great expense, a few years ago. Modern techniques, using hydraulic pile drivers and short sections of concrete locked with steel joints, allow houses to be rescued in this way, as they could not be in time past.

Did Anthonie Thijs know when he moved out that the house was unstable? Did Christoffel Thijs and Pieter Beltens decide to get rid of their remaining interest because they didn't want to be involved in the Pinto problems, or because Rembrandt's house evidently shared the same basic fault? The circumstance that Rembrandt's house was on poor foundations would provide a good reason for the hitherto poorly explained fact that, when put up for sale in 1658, the house fetched a lower price than Rembrandt had paid for it twenty years before. (Mr. Meischke told me that other reasons for this might be that the area had become less fashionable and that Rembrandt, an artist and not a house painter, had let the house get run-down in appearance, in addition to whatever reputation it had at this stage for being on a poor site or with bad foundations.) In any event, Daniel Pinto did not sit back and take the responsibility for the building upheaval entirely on his own shoulders. In his statements to the lawyers, he gave the impression that alterations were being carried out in both houses at the same time. He had

been renting Rembrandt's front cellars to store some of his merchandise, and he brought witnesses to declare that he hadn't been able to get at these cellars for five or six months because of the building operations.

In any event, Rembrandt found it a trifle difficult to go on loving his neighbor during this period. Whatever he had to do to his own house, there was worry about what was happening next door. He could hear hammering and sawing. Would cracks appear in the party wall? Would Pinto make good the joints at the roof? But he went on teaching, etching, drawing, and painting. He stood before his easel, putting brush to canvas to create Aristotle calmly contemplating the bust of Homer, while Daniel Pinto's building contractor was banging away next door.

XIV

Out of Doors

I N WINTER, despite their chimneys, Dutch houses were scarcely heated; small peat fires glimmered in the big fireplaces, or in "stovepots" placed on the hearth. The efficient iron stove as used in Germany wasn't seen in the average Dutch home during the seventeenth century. People bundled up instead. They put on layer on layer of clothing – undershirts, shirts, smocks, fur cloaks – which may account for Rembrandt's portly shape in various self-portraits. They wore coats and dressing gowns in the house, as the artist and most of his sitters did; the habit of keeping a hat on indoors may have sprung from the same good reason of preserving body heat. Women sat with their feet resting on little metal or oaken boxes, containing a piece of slow-burning peat or a brick that had been heated in the fireplace. Sir William Temple found the winds and the frost particularly sharp in Holland. "The spring is much shorter, and less agreeable than with us; the winter much colder . . . "

It was in February – usually the coldest month – that the Blaeu printing works burned down; Jan van der Heyden, eminent both as a painter and an inventor of improved fire-fighting equipment, said the old type of appliances froze and were useless. In November 1650, a terrible winter was inaugurated by one of the great natural disasters of the century. The Rhine rose, with ice floes floating downriver. In several places the dikes were breached, and in the ensuing floods many were drowned, and homes and farms destroyed. In the first few days of the following March, there were northwesterly gales and torrential rain. On March 5 and 6, the coastal dikes were threatened, and on the banks of the Zuider Zee,

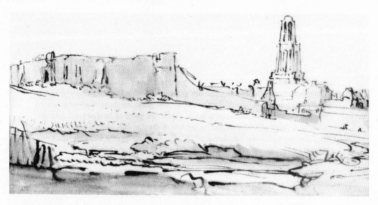

View of Rhenen. *Drawing*, c. 1648. *Collection Haags Gemeentemuseum, The Hague*

the Diemerdijk was breached, just east of Amsterdam. Parts of the city, perhaps including the Breestraat, were flooded, and goods stored in cellars damaged or ruined. In the marshy Amsterdam area there were more fogs than elsewhere, some visitors thought. Descartes complained that the humidity, the prevailing softness of the air, didn't help the workings of the brain. Because Rembrandt was a miller's son, one imagines that he noted, as he walked by, the direction in which the weather vane on the Zuiderkerk tower was pointing.

There were days when he felt the need for fresh air. In the late forties and the fifties he spent more time out of doors than before. He went for walks in the countryside around the city, along the dike roads and the riverbank paths, sketchbook in hand. Did he go for exercise, to get out of a house where there were momentarily domestic troubles, or simply to put on paper what he saw in nature? The Dutch were aware of the attractions of landscape, as perhaps people can be, more readily, when they no longer have to make their living in the rural element. The Dutch were urban even then, mostly living in towns, but spending a lot of time out of doors, in the street or sitting in front of their houses on the bench generally fastened to the wall next to the door. The Dutch child was traditionally thrown out of the house in the early morning and told not to come in till night – an interdiction probably connected with the housewife's desire to maintain a spotless house, and accountable for tales of horror told over the ages by foreign visitors of the behavior of Dutch children, well-mannered in their own houses but known throughout Europe for hurling abuse at strangers in the streets or throwing stones

from canal bridges at passing yachts and barges. (In the late twentieth century, this reputation finally seems to be fading. Perhaps because streets are more dangerous and because of the interior attraction of TV, Dutch children seem to be more often at home, and less well behaved indoors, like children everywhere else.) But in the seventeenth century the Dutch (who were the first people en masse to want their portraits painted) were also the first to realize how beautiful a landscape might be – an extent of meadows, a line of trees by a road, a lake with sails. They went on Sunday afternoon walks in the dunes, taking their dogs. They had picnics on riverbanks, and lovers found private spots behind haystacks or made nests for themselves in the long summer grass.

Many of the Dutch painters mirrored this awareness and liking. A landscape did not need to be a background for a noble couple, a saint praying, or a mythological scene; it could be itself. It could also be a field of human enjoyment and endeavor – a beach with fishing boats; a ferry crossing on a lake, with men fishing; an expanse of woods; a winding lane; distant fields – in which the pleasure lay in the act of seeing. They painted the townspeople out of doors, diverting themselves with such games as *kolf*.

Albert Cuyp, Nicolas Eliaszoon, Jan Steen, and Hendrik Avercamp painted men, women, and children with *kolf* clubs in hand. Rembrandt did an etching in 1654 in which one man seems to be pushing a golf ball in a backhanded way. The clubs were like long hockey sticks, and since the game was also played in winter on the ice, it can be taken for an ancestor of both ice hockey and golf. As with yachting, where many modern words are of Dutch origin, so with golf: the mound on which a player placed his ball was called a *tuitij*; the hole he tried to get it in was the *put;* and he said "*Stuit mij*" – pronounced "stymy" – if anything in his way prevented him from hitting it. The balls were of no particular size; they seemed to vary from the size of a cricket ball or baseball to that of a small football. The best were made of leather stuffed with goose feathers, and the Dutch made such a success of exporting them that King James VI of Scotland forbade their import, because of the drain on Scottish revenues. On the ice – which, the paintings seem to say, formed every year, as if the winters were colder then – the Dutch cut holes to fish, were pulled in box sleds, poled themselves along, and ate and drank at refreshment stands set on the frozen lakes. They sat on upturned boats to pull on their skates. They slithered, fell down, and at last achieved that lovely confidence that let them fly along, one blade driving forward while the other kicked zest-fully back. (I have a skater of Cuyp's in mind, from a painting that seems to express so much of the pleasure of being alive then, on a winter's day.)

View from near the St. Anthoniespoort. *Drawing*, c. 1650.
Courtesy of the Trustees of the British Museum

For Rembrandt it was only a few minutes' walk down the Breestraat to the St. Anthoniespoort in the city wall. Despite the beginnings of development outside, Amsterdam gave the feeling of a city one entered and left, as one enters or leaves a room. (Though it is much more extensive today, the firm dividing line between town and country has been largely preserved.) Having crossed the bridge over the wide canal outside the gate, he would walk out along the dike road toward the village of Diemen, with the reclaimed land of the Over Amstellse Polder on his right hand and eventually the Zuider Zee on his left. He sketched the little farms tucked behind the sea wall, which was strengthened with piles and faced with stone rubble. He looked out over the mouth of the IJ, the body of water that forms Amsterdam harbor, to the village of Schellingwoude on the far shore. He could walk along the sea-dike road or take the southward fork, as he sometimes did, to Diemen. He drew the boats leaning in the breeze and the grass bending in the wind. He stopped on the outskirts of Diemen for a few minutes to sketch a barn, the church, some farmhouses and hay shelters, a little canal, and a man walking toward him with milk buckets suspended from a shoulder yoke. He noted the farmworkers and shepherds, the barges and the drying racks for sails, the effects of cloud and of a shower, about to fall or just fallen. He walked on the western side of the city too, drawing the mills that stood along the ramparts catching the southwesterly wind, or strolled out to the village of Sloten and sometimes as far as the dunes, west of Haarlem. On one of his excursions he came across the tents

Cottage with a White Paling, *perhaps at Diemerdijk. Etching, second state,*
c. 1642. *Courtesy of the Trustees of the British Museum*

of an army camp, perhaps set up in 1650 during William II's attempt to besiege
Amsterdam.

He didn't always manage to avoid associations on these walks. Looking across
the IJ to Schellingwoude he sketched in, to the right, the stubby tower of Ransdorp
church – Ransdorp, Geertje's village. Church towers in that flat countryside
furnished landmarks for travelers by land or water; this one prompted memories.
In 1651 he etched the prospect toward Bloemendaal, near Haarlem, with people
bleaching cloth in the fields and a view of Saxenburg, the manor house of Christoffel
Thijs, to whom he owed so much money. Now and then he stopped at Jan Six's
country house, IJmond, at Joaphannes on the Diemerdijk. Visits there gave rise to
work done within and without; a drawing of a man, perhaps his host, Six, writing
at a window; and an etching called *Six's Bridge*, which in turn prompted a legend.
The story comes to us from Edmé-François Gersaint, the French print-dealer who
catalogued Rembrandt's etchings in 1751. Rembrandt was at IJmond for dinner
one day, said Gersaint, and mustard was needed. Jan Six sent a servant to the
nearby village to get some. Rembrandt made a bet with Six that he could do
an etching before the mustard arrived, and *Six's Bridge* was the result; he won
the bet.

View across the IJ from the Diemerdijk. *Drawing,* c. *1649–1650.*
Devonshire Collection, Chatsworth. Reproduced by permission of the Trustees
of the Chatsworth Settlement

In other work done on these walks he seems to have felt the tug of the past, stopping to draw mills and farm cottages that perhaps reminded him of the family business on the Weddesteeg: for example, the etching of 1641, where grass grows in tufts on the tiled roof of a cottage, next to a windmill, and weeds and flowers sprout from the side of the adjacent shed. But this growth is natural and not desolate. He was either an optimist or a realist out of doors. There is only one drawing that seems to convey the tedium and godforsakenness of the country — what Professor Slive calls the "mood of barren fields," which Van Gogh repeatedly studied — and Professor Benesch is of the opinion that this drawing may be the work of a pupil. His painted landscapes give the impression of being done out of season — imagined back in the studio — hence the storms and the snow. He sometimes added to the Dutch landscape of these studio works hills and ruins, imagined mountains, like the mountains of Hercules Seghers, which seem to derive from the fantastic crags of late medieval art, worn down by several centuries. But Rembrandt made them fit: there is a marvelous print of the mid-1650s in which a countryman walks down a lane between fields with a gun over his shoulder and dogs at heel. Over the spire of the church in the distance rise the steep flanks of hills, by no means Holland, by all means art.

His favorite walk in the late forties and the fifties was up the Amstel River. This meant a slightly longer route through the city before reaching the edge of town. He walked along the Houtgracht, with its yards full of timber. He stopped on the Blauw bridge over the Amstel and, looking upstream, drew the wooden

Six's Bridge. *Etching, second state, 1645. Courtesy of the Trustees of the British Museum*

piers and wharves, the waterside trees and houses, masts of boats, a man rowing, a distant windmill formed by five short pen strokes and some wash, the sky made spacious and the whole drawing made radiant by a simple arched line drawn above, as if to frame it, and a few strokes shading the river in the foreground. (The whiteness of the paper and a few pen strokes were all he needed to convey the feeling of a particular spot, even a below-sea-level, dike-protected sensation, or the extensiveness of a landscape – fling out your arms! – as in the view of the Amstel with a man bathing, Amsterdam in the distance.) No one else achieved this simplicity.

He walked on beside the river as it curved back and forth out of town, stopping at certain spots that became familiar to him over the years. He often halted opposite a spit of land called the Omval, sticking out where the canal that ringed the Diemermeer Polder joined the river, a place where there were summer houses, and people often went to picnic. On various occasions he drew a ruined, fortified riverside house, named Kostverloren, at various distances, sometimes closeup, sometimes behind intervening trees.

The Windmill. *Etching, 1641. Courtesy of the Trustees of the British Museum*

Now and then on these walks he took a friend or colleague along, like Philips Koninck, who wrote on the back of one sketch, done near Kostverloren, "This drawing shows the bank of the Outer Amstel, so well drawn by Master Rembrandt's own hand." He carried with him pen and brush and a bottle of bistre ink. One or two drawings are done entirely with brush. Some of the landscape etchings give the impression that they were "sketched" on the spot, so evidently he sometimes took along a waxed plate too, which he would dip in the acid bath when he got home. He paused often on the Amsteldijk near the Trompenburg estate; and at the little stream called the Bullewijk, which joins the Amstel just before the village of Ouderkerk. There one day he drew a man wearing a broad-brimmed hat gently rowing a boat, with a farmhouse among trees on the far bank and the spire of Ouderkerk in the distance. At Ouderkerk, apart from the church, there was an inn, some houses, and the Jewish cemetery, where Manasseh ben Israel was buried in 1657. (The cemetery figures in a painting by Jacob van Ruysdael, done in 1660 or thereabout, the tombs as they were in fact to be seen, but the ruins, foliage, and melancholy light the products of Ruysdael's imagination.) Ouderkerk was a good place to stop and restore one's strength before setting off on the walk home.

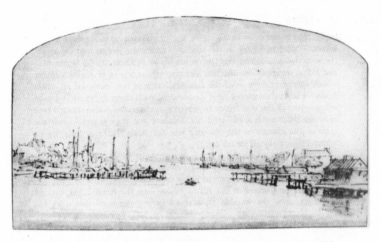

View of the Amstel from the Blauwbrug. *Drawing*, c. 1648–1650.
Rijksprentenkabinet, Rijksmuseum, Amsterdam

Sunday morning: I walked out to Ouderkerk with a stiff northeasterly breeze behind me, tilting me in the gusts, and a bright sun that took some of the chill out of the wind. There is a greater length of urban Amstel now, of course; many of the barges moored along the stone-faced banks within the city are houseboats. The Omval is part of an industrial zone near the Amstel railroad station. Even so, it took me only forty-five minutes to reach the city limits from my *achterhuis* on the Oude Zijds Voorburgwal, first on paved sidewalks, and then on a footpath worn in the grass bank next to the Amstel. The city boundary is marked by a nameplate, AMSTERDAM, and a fifty kilometers per hour speed limit sign, both facing south, to be seen by those approaching the city, and a statue of Rembrandt not far away, looking across the Amstel.

The artist has not had the best of luck among sculptors and painters wanting to portray him (witness the mid-nineteenth-century act of sentimental hero worship in the Rembrandtsplein in Amsterdam) but this Amstel-bank statue by Hans Wezelaar, erected in 1969, 300 years after Rembrandt's death, is a genuine piece of work. It shows the artist down on one knee, the other knee raised as a prop for his sketchbook, looking out over the river to distant concrete works and the giant apartment buildings of the Bijlmermeer. Just past the statue stands a well-restored windmill, cap facing into the wind, vanes revolving quickly and squeakily, passing

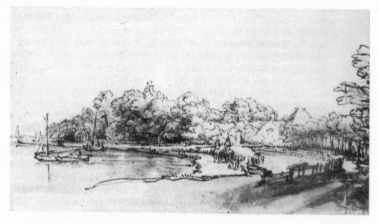

A Bend in the Amstel River near Kostverloren Castle. *Drawing*, c. *1650–1652.*
Devonshire Collection, Chatsworth. Reproduced by permission of the Trustees
of the Chatsworth Settlement

on the downswing with a rush of air within a foot or so of the ground, and raising, at least in my mind, the question: How do you get into the front door of this windmill when the wind is from the northeast?

In Amstelveen, the district immediately outside Amsterdam, the river road soon gives one a view of small farmhouses and the smell of cows. In the fields there were sheep and lambs. The Amstel itself is about fifty yards wide between low grassy banks, and the occasional motorboat or barge went by, sending up a quarter wave that lifted the paddling ducks and divided the waterfront reeds and grasses. Sunday drivers and cyclists passed me on the road. Halfway to Ouderkerk, just beyond a polder pumping station, I saw the seventeenth-century mark of the city's territorial boundary – a stone column on a brick plinth, topped by a copper ball and spike, which was perhaps meant to deflect lightning or birds; the column bore an inscription titled TERMINUS PROSCRIPTIONIS. These posts, reminders that Amsterdam once had a certain independent status, used to stand on all the roads leading out of the city, and marked the extent of its judiciary powers. If you were exiled from the city, this was as close, by law, as you could come to it. Such a boundary marker appears in an etching Rembrandt did in 1650.

I reached Ouderkerk in early afternoon, roughly two hours and fifteen minutes after setting out. The artist, stopping to draw, perhaps took longer. I walked

past the lifting bridge that spans the river and takes the Amsterdam road on the west bank to the main part of the village on the east, and sat for a while in the outdoor riverside café of a small hotel in company with other people out on Sunday afternoon excursions. It was pleasant there. A single oarsman rowed by, much as in a Rembrandt drawing but wearing no hat. A rowing club turned up in an eight, coxed by a girl. The terrace was out of the wind but you could see the wind's effect, shaking the trees on the far bank and driving black cat's-paws fast across the water. Sparrows flew in over the heads of drifting ducks to seize crumbs of biscuit and cake from the wooden bulkhead. I drank a beer and gradually edged my wicker chair out of the shadow and into the sun, which fell on the riverside edge of the terrace and caused it to be crowded. Half in the sunlight, half in the shade, at one end of the terrace, in what could only be called a chiaroscuro, another man sat by himself, drinking a beer: mustache; big wide-spread nose; slightly protruding, observant eyes. The resemblance was uncanny. Was this a hallucination – a tourist-board publicity device – some sort of time warp – or simply the effect of sun, wind, and a single glass of Heineken? Should I go over and ask all those unanswered questions: How long did it take to paint, say, the *Portrait of Jan Six?* How much did you earn in such-and-such a year? Why did you behave to Geertje Dircx in that seemingly most ungallant way? Did he, Rembrandt of the Rhine, feel a tie with the earlier river lord, Gijsbrecht of the Amstel?

But it was too late to find out. The man who looked like Rembrandt was standing up, pulling on a brown anorak, and leaving. From the road outside came the sound of a motorcycle starting up.

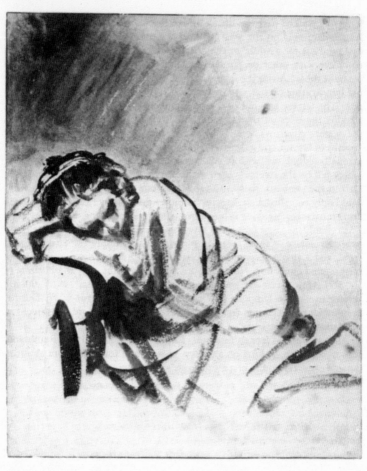

Woman Sleeping. *Drawing, c. 1655. Courtesy of the Trustees of the British Museum*

XV

Acts of Love

HENDRICKJE STOFFELS has this advantage over Geertje Dircx – we definitely know what she looked like. Not that there are any specific portraits of Geertje's successor in Rembrandt's house that are entitled – to give her what seems to have been her full name – *Hendrickje Stoffelsdochter Jager*. But the same girl, painted with love, is the subject of at least half a dozen portraits by Rembrandt from the late forties on; she also sat, dressed up or undressed, for various historical pictures, Biblical paintings, and life drawings, standing next to a door or window frame, leaning out of bed, and lying on her side in a chair, asleep. She posed as Bathsheba having her feet washed, and for the *Woman Bathing*, in the London National Gallery, in which she holds her smock up out of the water. The woman in some of these pictures is not invariably painted or drawn with the same facial features, but exudes the same serene spirit from the same warm flesh. We can hear the artist shouting downstairs, "Hendrickje, come and sit for a while." She was a willing model, a good companion.

Her father had been an army sergeant who served in the garrison town of Bredevoort, near Winterswijk, in Gelderland. When she came to work in the Breestraat house she was in her early twenties; she was twenty-three in 1649, when her name first crops up in the documents as a witness to the notarized "arrangement" between Rembrandt and Geertje. There was need for another woman to help; she got the job. Soon enough she was indispensable. She became Rembrandt's housekeeper, mistress, and in all save the marriage ceremony, his wife. Their liaison remained unblessed by the church, in part, perhaps, because of

the terms in Saskia's will by which he would lose the income from her dowry, held in trust for Titus, if he remarried.

This helped bring about a further problem in 1654 – though as usual with Rembrandt's problems, one suspects that a good deal of his attention remained apart, safely concentrated on his work. Word of the illicit relationship reached the local Reformed Church council, which summoned Rembrandt and Hendrickje to appear before it. They ignored the joint summons, and other summonses, directed at Hendrickje alone, followed. (The fact that Rembrandt is mentioned in the first and not the following summonses has been taken for negative evidence that the Calvinists realized he wasn't a member of their church at that time, and therefore something else – perhaps a Mennonite.) After her second failure to appear, the brethren of her district resolved in their consistory "that she be visited and exhorted." This was part of the Calvinist procedure, which tried to deal privately with offenders before taking them before a church body in what amounted to a trial, strictly run by the consistory president, with no speaking out of turn, an examination in front of witnesses, and with a final sentence and a follow-up process for the reclamation of declared sinners. It must have been a disturbing experience for a young woman who was six months pregnant. The church court declared, "Hendrickje Jaghers, having appeared before the sitting, confesses that she has engaged in fornication with Rembrandt the painter, is therefore severely reprimanded, admonished to repent, and forbidden to take part in the Lord's Supper." The child was born at the end of October, and named Cornelia. Unlike the two daughters he and Saskia had had, this namesake of his mother's lived.

There are few other documents regarding Hendrickje, but his pictures of her speak so affectingly that one knows she provided throughout the dramatic ups and downs of his life in these years something certain, calm, and affectionate. She seems to have had the right temperament for living with a genius. (The difference a really good model can make to an artist's work is immense; witness Modigliani, Picasso, Matisse. Many artists have had to marry their models to keep them.) She looked much less complicated than Saskia; her serenity must have seemed wonderful, in the tumultuous wake of Geertje. Hendrickje always retained a childlike chubbiness. The simple girl looks out through the woman, trustingly, selflessly, whatever the fine clothes and jewelry he has dressed her in. Although she had none of Saskia's upper-class connections, and could be said to be one of "the common people" writers like Houbraken accused Rembrandt of consorting with at this stage of his life, there was nothing coarse or cheap about her. It is important to distinguish between low life and love life.

The Dutch have always been forthright about sex, and foreigners haven't always judged them properly on this score. John Ray remarked that "the common sort

of women (not to say all) seem more fond of and delighted with lascivious and obscene talk than either the English or the French." The presence of brothels and so-called music halls then, as of porn shops, sex shows, and "casinos" now, led visitors to assume a fairly prevalent lewdness. (Dutch artists found clients even in the brothels: prostitutes commonly hung on the doors of their rooms portraits of themselves, and the customer's first reaction on entering was no doubt one of a critic who decided whether it was a good likeness or not.) But Sir William Temple thought the Dutch were essentially "temperate" in their emotions. "In general, all appetites and passions seem to run lower and cooler here . . . Avarice may be excepted." He claimed, "One meets pleasant young gallants, but no mad lovers." And of Dutchwomen, "They live with very general good fame, a certain sort of chastity being hereditary and habitual among them." John Ray admitted, "Once married, none more chaste and true to their husbands," though he also noted, pleasurably, that you could kiss them in greeting on short acquaintance. Many women soon became matronly, in manners and looks; they ran their households, suffered the pains of childbirth, and often looked older than their husbands.

Yet an ideal of feminine beauty persisted, particularly among writers on art, and Rembrandt's view of woman was found wanting. He drew his early models as he saw them, not glamorizing them; in fact, making a point almost of rolls of fat and manifold wrinkles. Rubens and Jordaens had gone in for "realistic" nudes too, and the German artist Wenzel Hollar demonstrated a contemporary interest in such work by copying Rembrandt's etching of a *Nude Woman seated on a Mound*. But it was women like this, and the Eve in his *Adam and Eve* etching of 1638, who antagonized the cognoscenti soon after his death.

The amateur artist Jan de Bisschop published a handbook on ancient and Italian art in 1671 and therein deplored the nudes done by some of his compatriots: "Yes, even if Leda or Danaë were to be portrayed . . . [they would] make her a female nude with a fat and swollen belly, drooping breasts, garter stripes on her legs, and many more such malformations." The artist he clearly had in mind was criticized (and named) by Joachim von Sandrart, the fashionable German painter and art historian, in his work *Teutsche Academie* (Nuremberg, 1675–1679). Sandrart was upset because he, Rembrandt, "did not hesitate to oppose and contradict our rules of art, such as anatomy and the proportions of the human body, perspective and the usefulness of Classical statues." Jan de Bisschop's complaints were echoed by Rembrandt's former pupil Hoogstraten in 1678, and combined with Sandrart's in a poem by Andries Pels, "The Use and Abuse of the Stage," 1681. Rembrandt's "wash-girls" and "turf-treaders" were hardly appropriate models for Venus, Pels thought, with their

flabby breasts,
Ill-shaped hands, nay, the marks of the lacings
Of corsets on the stomach and of garters on the legs,
[Which] must be visible if Nature was to get her due:
That is *his* Nature, which would stand no rules,
No principles of proportion in the human body.

Arnold Houbraken summed it up in 1718: "As far as his nude women are concerned, that most beautiful subject in art, into which of old every master has put all his industry, they are too awful (as the saying goes) to make a song about . . . Usually the pictures make one sick and it is incredible that such an ingenious man should be so wilful in his choice."

Yet if there had been any desire to shock, it had left him by the 1650s, when he found himself drawing, etching, and painting the female form more frequently than before. His knowledge of anatomy was "massive and accurate," to quote Robert Hale, who for many years taught life drawing at the Art Students League in New York. In regard to the back view of a seated nude woman, Mr. Hale writes, "At first it is difficult to realize what a staggering amount of knowledge is in restrained display in this somewhat simple figure." The women in many of these works of the fifties are indeed beautiful. They have the beauty of solid form, of line made flesh. Fat-bottomed Dutch girls, perhaps, yet given such life one feels one should be able to rub the muscles in their backs. But it is more than flesh. There are etchings and paintings of this period that one feels almost beholden to, for having established for all time something essential about female nature. In the *Bathsheba*, with what understatement he gets across a complicated mixture of the woman's physical and emotional yearning to set off, in answer to the letter she holds from King David (who has seen her bathing); and at the same time her diffidence and her foreboding. It is so much more than simply a magnificent painter's view of an unclothed woman, served up for the spectator's delight. Some of the etchings of this time show how, through a truthful rendering of the surface, he could let us glimpse the animating force within; for example, the so-called *Negress Lying Down*, of 1658, probably a dark print of a woman in the deep shadow of a bed; the woman seated on a bench with a man's hat beside her, also of 1658; and the traditionally mistitled *Woman with an Arrow*, of 1661. She is, in fact, not. holding an arrow, which would be a strange thing to have in bed, even for Diana or Cleopatra or whomever a classically minded connoisseur would put there. She is holding the bed curtains together; the "arrow" is a slit of light between the draperies; in the gloom behind, one can just make out the face of a man, waiting for her.

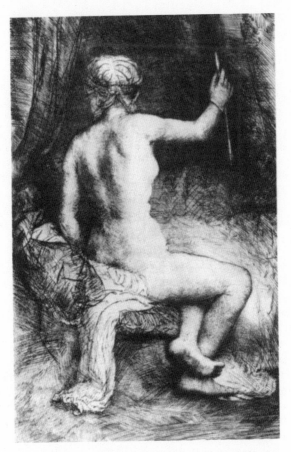

Woman with an Arrow. *Etching, second state, 1661.*
Courtesy of the Trustees of the British Museum

Often the bed used in these works is that from the downstairs back room in his house – an ornate bedstead rather than a cupboard bed, but with canopy and curtains creating some of the same roomlike privacy. You had to climb up into it, and then, pulling the hangings closed behind you, what sensations of security and comfort. How *gezellig!* There was a thick feather mattress, and big pillows and bolsters, plump and undulating. There was the occasional pleasure of clean sheets and in winter a warming pan popped in before bedtime to take the chill off them. Foreign visitors sometimes found these Dutch beds too hot and stuffy.

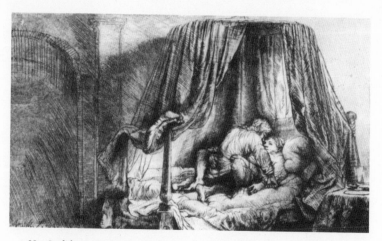

Het Ledekant. Etching, 1646. *Courtesy of the Trustees of the British Museum*

Rembrandt made two etchings of a man and a woman making love. One bears the title *Het Ledekant*, "The Bedstead," though an earlier age also called it, with a slight snigger, *Le Lit à la Française*, as if it were only the French who went in for this sort of thing. It shows a man, mostly clothed, lying between the upraised knees of a woman in the well-known bed. In the other etching, the scene is out of doors, in the corner of a hayfield – she again with her knees up, dress pulled up to reveal rather powerful legs; he kneeling over her, in what some have taken for a monk's habit but may merely be a farmworker's smock. She has her shoes off. His are still on. In the background a man with a scythe goes on working, the way the men go on ploughing while the boy falls from the sky in Breughel's *Icarus*, and the earth turns. In both cases the woman has one leg over the man's left leg. In *Het Ledekant* the woman has three arms: one right and two left. One of these left arms is lying flat on the bed, the other on the man's back, as if Rembrandt hadn't made up his mind where finally he wanted to place it.

The fact that he didn't in the end decide and therefore finish the etching makes it even less a commercial work and more in every sense an act of love. There is nothing meretricious, coarse, or pornographic about either of these etchings. They are "vulgar" only in the sense that this is what people commonly do. They are erotic in their acknowledgement of bodily love. *Het Ledekant* particularly has a natural intimacy that is moving. I take it for an expression of the sensuousness and affection re-aroused in Rembrandt by Hendrickje's presence in his house.

XVI

Money Troubles

I N THE SPRING OF 1656 he was no longer a wealthy painter; his long-standing money troubles had reached a point where something had to be done to keep him from outright bankruptcy and debtors' prison. A petition was sent on his behalf to the High Court in The Hague, asking for *cessio bonorum*, "a surrender of goods." This was a form of liquidation granted to individuals who had been unlucky in their financial affairs (as opposed to the fraudulent and unscrupulous). The petition for Rembrandt described his problems as having come about "through losses suffered in business, as well as damages and losses by sea . . . " The cession was quickly granted through the Amsterdam Court of Insolvency. As a result, Rembrandt had to hand over to his creditors his estate or the proceeds of selling it up. Thus the inventory was drawn up of all the goods to be auctioned off.

Just why he went broke remains uncertain. Clearly more money went out than came in. "Neither a borrower nor a lender be" is old advice – though that wording of it was recent – and Rembrandt was both borrower and lender. He lived it up, and in good times seemed to put nothing by, unless into the buying of art objects. There was the war with England, the economic depression, the complications of Saskia's will, and the Pinto house trouble. It would help to know exactly what his income was. Sandrart reckoned that Rembrandt's receipts from his pupils' tuition and their work were between 2,000 and 2,500 guilders a year, an estimate that seems high but may well be accurate for several of his most popular years. He got generally high prices for his pictures. The Stadholder paid him 2,400 guilders for

two paintings in 1646. That this was a fair payment for "a Rembrandt" is indicated by the evaluation of 1,500 guilders set by an expert in 1657 on his 1644 painting *Christ and the Adultress*. Don Antonio Ruffo was happy to pay 500 guilders for the 1653 *Aristotle Contemplating the Bust of Homer*, but said it was roughly eight times what he would have paid for an equivalent picture by an Italian artist. Five hundred guilders would seem to have been his price for an important three-quarter-length portrait, which would make a picture as large and detailed as *The Night Watch* a bargain at 1,600 guilders.

Of course he didn't always get his price: we have seen Huygens talking him down, and the burgomaster Andries de Graeff argued with him about the cost of a portrait. There were also earnings from the sale of his prints and the occasional book illustration. There were windfalls, like the 2,500 guilders or so he received from his mother's estate, and the income from Saskia's dowry. He was undoubtedly among a small group of Amsterdam artists who were well-to-do, and for a short while he was probably the richest. But it didn't last. The times changed, and gradually he seemed out of step with the presiding taste. By midcentury many of the regent class had retired from the daily activity of trade and business and were beginning to live on their investments. They beautified and enlarged their houses and paid attention to French fashions. Even the petty burghers felt the same temptations. Professor Boxer, an authority on the seventeenth century, quotes a pamphleteer of 1662 who complains that small shopkeepers, tailors, cobblers, publicans, "and their respective wives" now dressed in velvet and silk so that you couldn't distinguish them from their social superiors. The painters who fitted in with the new mode were practitioners of a smoother, lighter style, like his former pupils Govaert Flinck, Jacob Backer, and Ferdinand Bol, and Bartolomeus van der Helst, who had studied with Nicolaes Eliaszoon but also learned much from studying Rembrandt's work. Houbraken said: "Before Rembrandt's death, the world had its eyes opened by true connoisseurs to imported Italian painting, and bright, clear painting came into fashion again."

Yet he was never out of work, and the sort of money he made would have provided plenty to live on for most professional people. A municipal physician then earned roughly 1,500 guilders a year, and a university professor something similar. (The co-rector of the Amsterdam Athenaeum Illustre got 1,500 guilders and free housing in 1652.) The Amsterdam Jewish community's offer to Spinoza of an annuity of 1,000 guilders was certainly enough for a comfortable existence for a single scholar. A skilled worker at this period in Amsterdam could expect a daily wage of about 1 guilder; a ship's carpenter might make 500 guilders a year in the best of times. The yearly budget of a Dutch Reformed minister and his wife

(first printed by Dr. Enno van Gelder of the Nederland Penningkabinet) came to a little more than this amount, but they also enjoyed a rent-free house. The figures are interesting, though possibly a touch inflated if they originally were drawn up to support a request for a raise in the minister's salary: 36 guilders a year for bread; 70 guilders for meat and fish; 50 guilders for wine and beer; 40 guilders for wood and peat; roughly 25 guilders for cleaning materials; 10 guilders for doctor and apothecary; 25 guilders for books, paper, and newspapers; 45 guilders for linen; and 10 guilders for charity. One could spend a mere 8 guilders on yearly fees for the Latin school or 1,000 guilders for an elegant cupboard, or *kast*. Some weddings in regent circles cost 4,000 guilders or more.

Most Dutch merchant and professional families kept careful household accounts in the small room called the *kantoor*. But we don't know whether Rembrandt followed this practice. The only reckoning of his that exists is scribbled on the back of a drawing. Among a citizen's expenditures were numerous taxes, for the Dutch were on that score the most heavily burdened people in Europe. Most domestic necessities bore taxes, as did all sorts of commercial transactions, such as the sale of property or of animals. Sir William Temple wrote: "I have heard it observed at Amsterdam, that when in a tavern a certain dish of fish is eaten with the usual sauce, about thirty several Excises are paid, for what is necessary to that small service." There were duties on wines and tolls on locks and bridges. If you entered or left the city gates after dark you had to pay a stuiver for the privilege. (The guilder, or florin, was usually divided into 20 stuivers or 16 penningen, each of which had 8 duits; the silver florin contained 28 stuivers. In 1658 you could buy a pair of shoes for 1 silver florin, a pint of milk for a silver stuiver, and an egg for 1 copper duit. Dutch coins were still minted in various towns and valued by their content; a shopkeeper might ask you for a stuiver or two more if the silver coin you proffered him was worn.)

The English consul in Amsterdam noted at this time that householders had to pay an annual poll tax on every servant they had over eight years of age (not telling us, however, how often there were servants under this age). The owner of a house was also charged a levy, based on the size of his property, to help pay for the night watch and for street lighting (a recent introduction). Yet most citizens, though shaking their heads over the cost of such improvements as the new Town Hall, which required the compulsory purchase and demolition of surrounding property in the same way the Metro has now, felt they got value for their contributions to the municipality. Dutch house-pride carried over into pride in the city.

When he was in funds, Rembrandt was free with them. He placed 1,000 guilders in Uylenburgh's art business and advanced 1,200 guilders for the ransom

of the ship's carpenter from Edam, perhaps Geertje's brother, in 1642. In the early fifties he may have helped out members of his own family – his sister, Lijsbeth, had money troubles in 1652, and his brother Adriaen died the same year, laden with debts. It is worth noting that in the document recording the ransom advance Rembrandt is called a "merchant of Amsterdam," and possibly the "losses by sea" his lawyer claimed for him in the insolvency petition were more than the usual good excuse for getting lenient treatment from the authorities. He may well, like many of his compatriots at the time, have thrown a lot of money into merchant-venturing.

Despite the impression they – with the aid of their portrait painters – give of being sober, clear-headed, down-to-earth businessmen, the Dutch often indulged in the wildest speculations. One form of it was *windhandel*, "trading in the wind"; that is, buying and selling "futures" in all sorts of commodities, from brandy to butter. The most sensational and widespread instance of this "new way of trade," as the Englishman John Cary called it, brought on the tulip fever, which seized the country in the 1630s. When the mania was at its most intense, from 1634 to '37, trading in tulip bulbs was going on in inns, and in clubs set up for the purpose, all over Holland. The flower grew well in the coarse sandy soil behind the coastal dunes, and captured Dutch fancy soon after its introduction from Asia Minor. Albums of tulip portraits were painted, for instance by Frans Hals's student Judith Leyster. Soon vast prices were being given for bulbs that produced new color formations. For one Viceroy bulb the buyer gave two loads of wheat, four loads of rye, four fat oxen, eight fat pigs, twelve fat sheep, two hogsheads of wine, four barrels of 8-florin beer, two barrels of butter, a thousand pounds of cheese, a complete bed, a suit of clothes, and a silver beaker – all in all valued at 2,500 guilders. Nearly twice this amount, plus a carriage and pair of horses, was given for one Semper Augustus bulb. A brewer offered his brewery for a single bulb. Guilds speculated in tulips, thieves stole tulips, and citizens guarded their gardens with trip wires and alarm bells. Bulbs were often bought, like other commodities, "on margin," frequently without being seen or handled, and never actually changed hands. A speculator would agree on a certain price to be paid for a bulb, at, say, planting time; if the bulb could be sold for more at that time, he claimed the profit; if it fetched less, he paid the loss. Tulip mania did not infect everyone – the tulip-crazed were called "hooded ones" by those who kept their heads, an allusion to the hoods worn by madmen. The painter Jan Breughel the Younger painted some tulips being worshiped by a pack of monkeys. Edward Forstius, professor of botany at Leiden, was unable to look at a tulip without getting furious and attacking it with his stick.

The crash in the tulip market came in February 1637. The craze had passed. More people were selling than buying, and suddenly the market was flooded. Attempts were made to organize the chaos that followed – the chains of debt, the flood of lawsuits. People needed to be paid so that they could pay their debts. Many were ruined, including the painter Jan van Goyen.

Similar hopes of untold (and unworked-for) riches involved the Dutch in foreign voyages and overseas trade. They could invest in ventures of strictly and less strictly commercial intent. Everyone held in the backs of his mind the great coup of Admiral Piet Hein and his squadron in capturing the Spanish silver fleet off Matanzas in 1628. The haul was huge: 66 pounds of gold, 117,000 pounds of silver, and other valuable goods, with a total worth of 12 million guilders. The West India Company, for which Hein was sailing, paid off its outstanding debts and divided out the rest. Shareholders and the ruling circles took most, but some was prudently put aside to finance future expeditions. Piet Hein got a share of 0.1 percent, and each member of his squadron got a "tip."

The West India Company customarily made much of its profits in the slave trade, though if a slave had the good fortune to reach Dutch soil, where slavery was forbidden, he was free. A good investment was shares in the East India Company, which Jean-Nicolas Parival in midcentury said were returning an average 300 percent. Investors could join syndicates that financed whaling expeditions in the northern seas. But the risks were commensurate with the profits: shipwreck, capture, and disease were common. A fleet arrived with more of a commodity than was needed, and the price collapsed. Temple encountered a Dutch sailor, just back from the East, on a passenger barge between Delft and Leiden, and was told of nutmeg trees being chopped down in the Moluccas, and piles of nutmegs as high as a small church being burned. The Dutch astonished our good observer Temple: "Never any country traded so much, and consumed so little: they buy infinitely, but 'tis to sell again, either upon improvement of the commodity, or at a better market. They are the great masters of the Indian spices, and of the Persian silks: but wear plain woollen, and feed upon their own fish and roots." The willingness of the Dutch to invest meant Dutch merchants could borrow capital on long loans at surprisingly low interest; this fueled Dutch expansion and prosperity. But it didn't prevent many investors from losing their shirts.

We shall probably never know exactly what were Rembrandt's "losses by sea"; it was obviously a phrase the insolvency commissioners heard often. We gather that his financial problems were conspicuous as far back as 1647, because in that year Saskia's relatives attempted to make sure that Titus's share of his mother's estate was properly safeguarded. In 1653, Christoffel Thijs presented the bill for

the sum outstanding on the house: 8,470 guilders, 16 stuivers, which included the principal owing, the interest due on it, and three years' back taxes paid by Thijs. Rembrandt was forced to scurry around to find new backing. But he found it. He received 4,180 guilders on a year's loan, interest free, from Cornelis Witsen, who had become a burgomaster in February of that year. Witsen was a member of the Kloveniersdoelen, and perhaps met Rembrandt during the painting of *The Night Watch;* he seems to have held Rembrandt in high regard, although for his own portrait he went to Rembrandt's "rival," Bartolomeus van der Helst. A thousand guilders came from Jan Six, who had recently retired from active business, though still in young middle age. Rembrandt was to paint his portrait, superbly, the following year. Perhaps they were friends, but Six demanded a separate guarantee for his loan from someone else who knew Rembrandt well, Lodewijk van Ludick, an antiquary and painter of Italianate landscapes. A further 4,000 was borrowed at 5 percent interest from a man named Isaac van Hersbeecq, who lived in the Singel but whose other achievements are unknown.

For a little while at this point Rembrandt had hopes of scraping out of his predicament with perhaps just a little retrenchment. He had the deeds finally for the Breestraat house. Toward the close of 1654 he negotiated to buy a house for 7,000 guilders in the Nieuwe Hoogstraat, where property was relatively cheap. The house had been lived in by a portrait painter named Hercules Sanders. Rembrandt apparently hoped to buy it by means of a mortgage and promise of paintings and etchings, one to be an etched portrait of the house's owner, Otto van Cattenborch, done to the same standard as Rembrandt's 1647 portrait etching of Jan Six. Otto van Cattenborch was the brother of an art dealer, Dirck van Cattenborch, and retained an interest in Rembrandt, ordering a picture from him a few months before Rembrandt's death. The Hoogstraat deal was witnessed by van Ludick and Abraham Francen, an apothecary and passionate print collector; but it seems to have fallen through. The move to a cheaper house didn't take place. In May 1656, in a final thrash for the receding shore, Rembrandt tried to transfer the title of the Breestraat house to his son, Titus, while himself remaining responsible for his own debts. But this didn't work out either.

When he became insolvent in 1656 his creditors were named as Cornelis Witsen, Isaac van Hersbeecq, Daniel Francen, Gerbrandt Ornia, Hiskia van Uylenburgh, Geertje Dircx, and Gerrit Boelissen; there were also unnamed "others," perhaps in case anyone stepped forward with a claim at the last moment. Daniel Francen was the brother of Abraham Francen, and Rembrandt had borrowed 3,000 guilders from him earlier in 1656, with a promise to pay him in paintings if he couldn't pay him in cash. Clearly a number of people still felt that their loans to

the artist were well covered if they could eventually get some work out of him. Ornia had taken over, perhaps at a discount, the promissory note to Jan Six, and was soon to demand that van Ludick, the guarantor, pay up, as he had pledged to if Rembrandt failed to repay the loan. Hiskia, Saskia's sister, disappears from the list of creditors hereafter and perhaps was mistakenly included in the first place. (Saskia had named her as heir to half of the joint estate, reserved in the first place for Titus but to be returned to her family if Rembrandt remarried.) Geertje's claim was for the annual "alimony" payment promised to her, and now in arrears. Boelissen was owed 800 guilders by Rembrandt, but like van Hersbeecq is otherwise unknown. There are, in other words, people whose immortality resides in the fact that they lent money to Rembrandt and were not paid back.

Going broke, even in the semidignified fashion in which Rembrandt did, wasn't pleasant. There were deeds, quittances, agreements, and injunctions. It meant being pestered by lawyers, syndics, and magistrates, making petitions and appearing before examining boards, telling of past success and present difficulty. It was important to show that his wealth had been great at one period before this financial collapse, in order to increase Titus's share of the selling-up. Thus Rembrandt had to ask various friends and colleagues – for example, Philips Koninck – to testify to his ability to buy expensive jewelry for Saskia and works of art for his own collection. The cloth merchants Jan Pieterszoon and Nicolas van Cruysbergen, who had appeared in *The Night Watch* as members of the militia company, gave evidence to the officials of the Insolvency Office that Rembrandt was paid 1,600 guilders for the work. Two experts said that Rembrandt's rarities, engravings, drawings, and paintings were worth more than 17,000 guilders in 1650. Jan van Loo, the jeweler and silversmith whose daughter Titus married in 1668, came with his wife to testify that they had seen in Rembrandt's house pearl necklaces, diamond earrings, a ring set with a large diamond, a prayer book with golden corner pieces, great silver platters, and a silver ewer.

The insolvency process had stigmas attached, though not so dire as those attached to complete bankruptcy. The Mennonites threw out any member who actually went bankrupt. Jacob Cats, lawyer, popular poet, and pensionary, decided not to pursue his romance with a Middelburg girl when he found that her father was bankrupt; it would have harmed his career. Vondel's son went bankrupt in November of this same year, 1656, and Vondel as an old man dutifully went on paying off his son's obligations out of his bank clerk's salary and then his retirement pay. One of the commissioners of the court that heard Rembrandt's petition for *cessio bonorum* was the son of his old patron Nicolas Tulp. It was a small city; small enough so that a person of stature and talent was never really dropped, or

dropped out of sight, but small enough, too, that the word quickly went round: "Oh, Rembrandt – hopeless in money matters."

A few nights ago I went to the first part of the auction of a notable Dutch art collection. This took place in the course of two evenings and an intervening afternoon in the Round Lutheran Church on the Singel. The church is a fine piece of late seventeenth-century Dutch Baroque architecture that has been restored as a conference center. Dealers from England and Germany queued with a large number of Amsterdammers who wanted to see what promised to be a spectacular event. The collection had been formed over a lifetime by Mr. B. de Geus van den Heuvel, a land-reclamation engineer whose works included the barrier dike across the Zuider Zee. The collection ranged over four centuries of Low Countries' art, and although there were a number of mediocre pieces among the 382 that one by one were spot-lit on an easel to the left of the auctioneer, there were also some splendid works from the seventeenth-century. Painters represented, among others, were Emanuel de Witte, Adriaen van de Velde, Roelandt Savery, Adriaen van Ostade, Jan van Goyen, and (in the form of three etchings) Rembrandt van Rijn. Because of the crowd, assistant auctioneers were stationed in the gallery and upper gallery, where I was, to catch the auctioneer's eye with the aid of a flashlight if there were bids from up there in the "gods." The sound of guilders in thousands and hundreds of thousands rattling off the auctioneer's tongue had an almost hypnotic effect, and it may well have been possible to come there as for a theatrical or social occasion and be caught up in the outpouring of money–money–money, to find oneself sticking a hand up, scratching the top of one's head with a ballpoint pen, pulling an ear lobe, or even shouting out a bid. There were a few bargains – naturally most evident in retrospect – when a skillful buyer could and perhaps did pounce. There were works which finally sold for vast sums that brought gasps of wonder from us all. No doubt elements of gambling, investment, and love of art were all present. One of the Rembrandt etchings fetched 29,000 guilders; the others 8,000 guilders each. Previous auction records of many other artists tumbled. Something like 20 million guilders was taken in.

One way Rembrandt went through a lot of money was by attending auctions – buying for the Uylenburgh firm, for his own art-dealing purposes, for studio props and for his *kunstkamer* collection. Baldinucci wrote:

> He often went to public sales by auction, and here he acquired clothes that were old-fashioned and disused as long as they struck him as bizarre and picturesque, and those – even though at times they were downright

dirty – he hung on the walls of his studio among the beautiful curiosities he also took pleasure in possessing, such as every kind of old and modern arms . . . and innumerable quantities of drawings, engravings and medals and every other thing which he thought a painter might ever need . . . [At auctions] Rembrandt bid so high at the outset that no one else came forward to bid; and he said that he did this in order to emphasize the prestige of his profession.

On February 9, 1638, he went to the auction of the Gommer Sprange collection. He spent 224 guilders buying numerous drawings and prints by such artists as Lucas van Leyden, Dürer, and Hendrick Goltzius. The Dürer prints included eight sets of a woodcut series on the life of the Virgin, which suggests that he bought most of them to sell again. But he seemed to lack the temperament and the wholehearted interest to make a successful art dealer. Although he knew many dealers, including Uylenburgh, Clement de Jonghe, and Pieter de la Tombe, who was listed as half-owner of some of the works in the Breestraat collection, he does not seem to have had the necessary professional caution. In 1637 he bought a Rubens for 424 guilders and sold it in 1644 for 530 guilders, but it would appear that, more commonly, he bought high and sold for what he could get.

Going to an auction with the idea of upholding the honor of the painter's profession was to set off on the wrong foot if one was also buying as a dealer. The risks of that trade are sufficiently considerable in any event, dealing as it does in areas of changing taste, heavy capital investment, and confidence – not least in the work's authenticity. (Hendrik Uylenburgh's prosperous art business was taken over on his death in 1661 by his son Gerrit and fell apart eleven years later when thirteen paintings Gerrit had offered the Great Elector of Brandenburg were declared to be fakes. Jan Vermeer of Delft, brought in as an expert, said they were rubbish. Other experts defended the pictures, and Gerrit Uylenburgh paid Vondel to write a poem in praise of his art business. Uylenburgh was declared insolvent in 1675 and went to England.)

At an auction Rembrandt's feelings for a work of art completely took over. He wanted what he felt to be wonderful, and didn't mind what he paid for it. He was impressively reckless. Johann Ulrich Mayr, a pupil of Rembrandt's from Augsburg, told Sandrart he had seen Rembrandt spend 1,400 guilders at an auction on fourteen of Lucas van Leyden's best prints. Kenneth Clark has suggested that the busts of Roman emperors he collected were not casts but the original marbles, much in demand for fashionable collections and as such very costly. He appears to have been moved in a manner we may now find hard to grasp by these images of

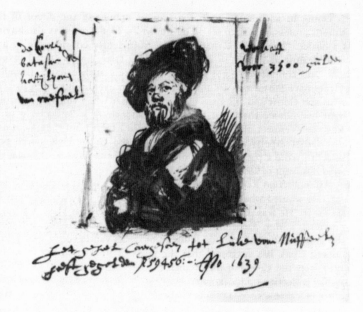

Baldassare Castiglione, after Raphael's portrait. Drawing, 1639. Albertina, Vienna

great men of times past, and especially by Homer, who created art out of ancient history in the way he, Rembrandt, was often trying to, and who was, unlike himself, without sight. Sometimes he attended the first days of an auction, as he did at the sale of the Jan Basse collection, which went on for three weeks in March 1637, and then sent a deputy – on this occasion his seventeen-year-old pupil, Leendert van Beyeren. (Rembrandt bought some Lucas van Leyden prints and drawings for 607 guilders there.)

Yet he didn't always buy. At the April 9, 1639, sale of the Lucas van Uffelen collection, he watched the auction of a Raphael portrait of Baldassare Castiglione. Joachim von Sandrart was in the bidding for this work, but lost it to Alphonso Lopez, a Sephardic Jew who was Amsterdam agent for King Louis XIII and Cardinal Richelieu of France, and a dealer in paintings, diamonds, and armaments. (He lived on the Singel in a house called De Zon, now auction rooms; Lopez had sold one of Rembrandt's early pictures, *The Ass of Balaam*, to a Paris buyer.) Rembrandt contented himself with making a sketch of the Raphael portrait and scribbling down the details, as people do in auction catalogues – the previous owner's name,

which he misspelled "Nuffeelen," and the price, 3,500 guilders. The influence of the Castiglione portrait was reflected in a self-portrait Rembrandt etched in 1639 and another he painted the following year, looking like a rich courtier.

It isn't likely that he stayed away from the auctions of his own possessions that took place in 1657 and 1658. He made a portrait print at this time of Thomas Haringh, warden of the Town Hall and bailiff of the Court of Insolvency; De Desolate Boedelskamer is the formidable Dutch name. Thomas Haringh had assembled statements of all the outstanding debts and called a meeting by letters and posters at which Rembrandt would have been given an opportunity to satisfy his creditors. When that failed, the selling-up had to take place, and Haringh presided over the sales as auction master. Rembrandt, turning to use all his ups and downs, painted a portrait in 1658 of a young man, known as *The Auctioneer*. The first sale of household effects and paintings took place in December 1657 at the Keizerskroon Inn in the Kalverstraat; it was the oldest hostelry in Amsterdam, the favored place for sales, and a room there was billed to Rembrandt, presumably for exhibiting the items to be sold. He had been allowed to keep his working equipment and day-to-day clothes. Hendrickje retained her linen and jewelry and her big oak chest from the Breestraat vestibule. One by one the auctioneer called out the household goods and paintings listed in the inventory. The total realized was not great: 3,094 guilders and 10 stuivers.

There was quite a long gap between this sale and the second, the following September, devoted to what the auction poster called "paper art" – the etchings and drawings by "outstanding Italian, French, German, and Netherlandish artists," including Rembrandt himself. The delay appears to have irritated Rembrandt's professional body, the Guild of St. Luke, which on August 31, 1658, promulgated an ordinance requiring any artist selling up to do so without procrastinating. Perhaps his fellow artists feared the damage that might be done to the art market by so great a quantity of good art suddenly released onto it; perhaps they thought dealers would otherwise hang around, not buying as usual, while waiting to see what bargains they could pick up at the insolvency sale; perhaps they were simply expressing their resentment toward Rembrandt for his behavior at auctions, bidding high prices, boosting his own work, and in their eyes "upsetting the market." (Rembrandt, we know, believed his *Christ Healing the Sick* print was worth 100 guilders, and he valued the portrait etching he planned to do for Otto van Cattenborch at 400 guilders. But his friends van Ludick and Francen on one occasion valued two lots of his etchings, numbers unknown, at 160 guilders and 103 guilders, and his old partner Hendrick Uylenburgh in 1647 estimated a print of Rembrandt's *Ecce Homo* as worth 6 guilders – a pretty basic dealer's price!)

Whatever the motives of the guild, the second sale took place in September very soon after the new ordinance was passed. Beforehand, Rembrandt got out his prized Moghul miniatures and made drawings based on them on appropriate India paper. But the bills and posters announcing the sale gave little advance notice. Foreign dealers and connoisseurs in Paris and Vienna were perhaps unable to attend. If Rembrandt had hoped for rescue now – for someone to buy for the prestige of the profession, to splash out for the glory of art – his hopes were dashed. Every low bid must have been a blow; the few barely reasonable sums called out, for things he had chosen, felt strongly about, done himself, and *valued*, were simply straws to grasp at, quickly gone. The proceeds of the second sale were a dismal 596 guilders, 19 stuivers.

The house itself took two years to sell. Various prospective purchasers came and went, but it was December 1660 before the sale was completed. A merchant named S. Geirinx, in partnership with his brother-in-law Lieven Simonszoon and Daniel Fortijn, bought Rembrandt's house for 11,218 guilders. Some scholars believe this to have been a good price for the times, but when one considers that it was nearly 2,000 guilders less than Rembrandt paid for it, twenty years before, it would suggest that house or neighborhood had become run down, that Amsterdam was perhaps experiencing for the moment the effects of overbuilding, and that there was little or no inflation in mid-seventeenth-century Holland.

In the sharing out of Rembrandt's assets and the proceeds of the sales, some lenders were more fortunate than others. Gerrit Boelissen received his 800 guilders plus 48 guilders' interest in September 1656, paid out of the cash in hand Rembrandt had been forced to give over to the Boedelskamer. The heirs of Christoffel Thijs, who apparently had died meanwhile, were paid 1168 guilders' interest still outstanding on the house in 1658. Burgomaster Witsen – whose loan of 4,180 guilders, interest free, dated from January 1653 – was paid back in February 1658. In December of that year Isaac van Hersbeecq heard that he was getting back his 4,000 guilders, together with the interest that had accrued on it since March 1653; but he was due to be disappointed, because Titus's guardian, Louis Crayers, went to bat for his charge and obtained a decision from the Amsterdam magistrates in May 1660 that Titus – as heir to his mother's half of the now rather diminished joint estate – had a prior right. Quite why he hadn't a right prior to Witsen and the others was not explained. Poor Hersbeecq fought this judgment. He went to the Court of Holland in The Hague, and when they rejected his case he appealed to the High Court. At one point he was briefly named a joint guardian of Titus, which looked like a chance for him, but the High Court dismissed his appeal in May 1665. Titus finally got the money in June 1665; his share of the estate amounted

to 6,952 guilders. When Hersbeecq died three years later, Rembrandt's debt was still in his accounts, though listed as "hopeless."

A few small creditors squeaked through. Isaac Vrancx was paid 116 guilders, 25 stuivers by the Boedelskamer on January 28, 1659. Rembrandt's friend van Ludick, who had bravely guaranteed the loan from Six and had been forced to pay up, seems to have sold his lien on Rembrandt to the wealthy merchant Harmen Becker. Becker lent further sums to Rembrandt in the ensuing years – 537 guilders in 1662 and 450 guilders in 1663. He was in some ways typical of the self-made immigrant to Amsterdam: born in Riga, a servant to a Dutch merchant till the age of twenty-four, and then a rapid success in various businesses including jewelry, floor tiles, linen, and licorice. He admired Rembrandt's work, was happy to be paid in pictures, and clearly realized that lending Rembrandt money was one way of getting work out of him. On one occasion he made Rembrandt finish a pledged painting of the goddess Juno before letting him pay off a debt. On another occasion a debt to him was paid in cash, soon after Titus came into his inheritance. (Titus didn't seem to consider that he had any personal, particular rights to the money, but was happy to help out his father.) Among the other small charges resulting from the insolvency were those of the Boedelskamer for payments to notaries, syndics, and the inventory-maker – in this case probably Frans Bruyningh, secretary of the Boedelslcamer, whose annual stipend of 300 guilders was supplemented by a levy of 5 percent on the sale of goods, and a fee of 8 guilders a day for making the inventory.

Despite the constant worry and juggling with money, Rembrandt went on working. He went on taking his country outings and making sketches along the way. Although, as far as the Insolvency Office was concerned, he was allowed to take commissions, sell new work, and teach pupils, the Guild of St. Luke once again threw a spoke in his wheel. This time they insisted that insolvent artists not be allowed to sell their work in Amsterdam. Fortunately there was a way around this: three days before the completion of the sale of the Breestraat house, in December 1660, which was going to force them at last to move, Hendrickje and Titus set up a business partnership. Rembrandt was called an employee of this firm. He had to hand over all his work to them. Moreover, all the stock in trade belonged to the partnership, so it couldn't be seized to pay off the artist's old debts. The contract says, ingeniously, that "since the partners are badly in need of expert advice, they can think of no one better able to act in that capacity than Rembrandt van Rijn."

One work from these years has tempted many scholars to look in it for symbols and meanings. This is his etching of 1658 called *The Phoenix*, or *The Statue Overthrown*. A very lifelike statue lies toppled on the ground, clutching its head, while angels

with trumpets herald the rebirth of a most scrawny-looking phoenix, flapping its wings as it rises from its own ashes on the pedestal. One scholar (J. P. F. Kok) thinks the snake wound around the arm of the statue identifies it as Envy, overthrown. Another (J. Emmens) believes the print is related to the quarrel between the House of Orange and Jan de Witt's regent party. The phoenix was often shown on medals then to represent the resurgent Orange cause led by young William III. Professor Adriaan Barnouw, the Dutch historian, was of the opinion that the phoenix was inspired by three recent Jewish deaths in autos-da-fé in Spain; the "statue" was the martyrs' executioner falling backward in terror. Whatever the intended message of this allegorical curiosity, it could also be taken for an announcement on the part of the artist that he wasn't defeated.

XVII

Domestic and Public Scenes

LARGE AS THEY LOOM NOW, these troubles of the 1650s lay mostly in the background, and life in the Breestraat house ran on nevertheless. The inhabitants were preoccupied with common pleasures and problems and the daily necessities of living. While he got on with his work, there was marketing to be done and household chores undertaken. In July 1656, when the inventory was made, there were two children in the house: Titus, fourteen, and little Cornelia, not yet two.

Houbraken stressed Rembrandt's simple tastes in food, saying that he was content to make a meal out of bread and cheese or a pickled herring. But even if this frugality wasn't a matter of necessity, it was a habit general to many of his compatriots. Most families cooked only once a week; on the other days they either ate cold fare or reheated the leftovers. "Cold potato eaters" is a Dutch term, still used, describing those who manage their lives in a thrifty way. In many households a big iron pot was kept in the hearth, ready to be swung over the fire, and new ingredients added as the contents were consumed: beans, peas, parsnips, cabbage, and hunks of bacon or meat when they could be afforded, resulting in a *hutspot*, or watery sort of stew. Not the least of the problems caused by the first Anglo-Dutch war was a severe herring shortage; the Dutch fishing boats were kept in port while the English navy dominated the Netherlands coast. But perhaps Hendrickje the housewife had a good stock of pickled herrings put by.

When Hendrickje or the maid went shopping, Amsterdam provided – if one did a little walking – a convenient choice of things close by. Peat for winter fires could be bought in the Rokin, where there was also a market for freshwater fish.

A meat market was in the Nes, a fruit market on the Singel, and a daily sea-fish market on the Dam, where there also took place a weekly market for butter and cheese. A vegetable market was held in front of the Oude Kerk, close by the spot, on the Oude Zijds Voorburgwal, where barges unloaded beer from Rotterdam and Delft. Women drank as much as men – and foreign visitors were astonished by how much the Dutch drank. "The qualities in their air may incline them to drinking," wrote Sir William Temple. "It may be necessary to thaw and move the frozen and inactive spirits of the brain."

Milk-sellers went around the streets early each morning – the common breakfast was bread, butter, and milk. Women from all classes and walks of life were to be seen out shopping. Mrs. de Ruyter, the admiral's wife, went to market with a shopping basket on her arm. She also did her own laundry; the day after her husband's death, she was unable to receive an envoy of the Prince of Orange, bringing condolences, because she had slipped and hurt herself while hanging out the wash. Most things could be bought from stalls, barrows, or simply sites on the cobbles of a public square, with the sellers crying the virtues of their goods; but there were also many shops: poulterers, tailors, wine merchants, tobacconists, and so on. Some streets were known for certain items, as the Warmoesstraat was for herbs and spices. The apothecary shops had competition from the quacksalvers, or patent medicine salesmen, who caught Rembrandt's eye and were captured by his pen as they hawked their curative salves and love potions in the market places.

Just how clean the city was kept was a matter of opinion. Foreign observers tended to be impressed. Town officials watched over the sale of perishable foods, and householders were supposed to wash down the roadway in front of their houses, clean out the gutters and make sure the planks that covered them were in sound condition, and sweep the footpaths, which they sometimes then sprinkled with sand. However, a lot of rubbish was dumped in the canals, despite regulations like those which prohibited midwives from disposing of the afterbirth in the nearest *gracht*. The canals smelt strong in summer (and Amsterdam retained into this century a reputation for mosquitoes). Possibly the urban crowdedness and proximity of dirty water made the Dutch more conscious of cleanliness than other people, though it was an ideal they did not always realize. *Schoon*, the old Dutch word for "beautiful," came to be used for "clean" (it has retained both meanings in Flemish). Delft had the reputation for being the cleanest town, where the canals were regularly cleaned and their water renewed, and Vermeer was clearly at home there: *schoon* in both senses his pictures are. In Dokkum I noticed a few years ago that rose bushes had been planted in profusion along the banks of the vilest-smelling canal.

It was in Delft that Anthonie van Leeuwenhoek, the draper and amateur scientist, was just finding out that there were bacteria and microbes in water. Looking

through his simple microscope, he first saw what he called his "animalcules." He corresponded about his discoveries with Henry Oldenburg, secretary of the recently formed Royal Society in London, and in his letter of October 9, 1676, gave an account of his first microscopic observation of rainwater a year before. There he had seen "living creatures in rain, which had stood but a few days in a new tub, that was painted blue within . . . more than ten thousand times smaller than the animalcule which Swammerdam [a Dutch contemporary] has portrayed, and called by the name Water-flea, or Water-louse, which you can see alive and moving in water with the bare eye."

If he was like most Dutchmen, Rembrandt drank buttermilk and thin beer, but if he wanted a glass of water, he most likely drank rainwater, caught in the gutters on his roof and brought down via pipes to a cistern in the cellar. Amsterdam ground water was not fit for drinking; it could easily have been contaminated by seepage from back-yard privies, nicknamed "the quiet places" or "the secret spots," though pumps in some yards provided water for washing down drains and floors. (According to Mr. Meischke, a drain ran from Rembrandt's house behind the Eliaszoon-Pinto house, and into the St. Anthoniesluis.) Pails of water drawn from pumps or the canal were carried into the house for scrubbing. The Dutch historian G. Renier says, "Many housewives brushed and scrubbed from morning till night, and maintained in the house a permanent dampness that caused ill-health and especially rheumatism." Water from the rivers was used by breweries, and eventually water from the Vecht River was brought by barges into the town canals and sold by the pail. But very little washing of the human body took place. Among the spices and fragrances to be smelled in Amsterdam was the smell of its people. Professor Renier believes the seventeenth century was the dirtiest period in European history; in the eighteenth century perfumes became fashionable, but the seventeenth century wasn't bothered by its own strong odor. If the English thought the Dutch strangely hygienic, it may have been because they noticed the Dutch upper classes washing their hands before meals. But this was not a common habit, and the unexposed parts of most Dutch bodies went unwashed for weeks or months. Hair was rarely washed. Head lice were picked out rather than shampooed away, as we can see from several contemporary paintings of mothers bending over the scalps of their children.

Fortunately, the making of the newly fashionable drinks, tea and coffee, involved boiling water. Many local bugs, which would have caused, say, dysentery, presumably were countered by what we now call antibodies. But there were many diseases that had no known cause and no reliable cure. Malaria and tuberculosis, unidentified as such, or smallpox and venereal disease, which were known, could all be fatal. Getting ill or simply feeling ill must have brought on great dread;

sickness was immediately a serious business. There was none of the almost auto-matic feeling of confidence we have that we can go to a doctor and get some pills to put things right, or if worse comes to worst, go to hospital for an operation that, we hope, will cure us. Then, fear must have arrived with a fever, and the agonies attendant on suspense with any novel pain or ache. One was lucky to escape smallpox, which could ruin one's looks (as it did those of Dorothy Osborne, Lady Temple). We can see in the portrait by Rembrandt what venereal disease did to the face of Gérard de Lairesse – an early admirer of Rembrandt's but later a classicist painter – before it blinded him. And all those who escaped the plague, the great destroyer of the age, counted themselves fortunate.

Plague visited the cities of Europe, often in successive years. It struck Venice in 1630 and 1631. Augsburg, in Germany, lost 11,000 people in 1642 and a similar number in 1643. Thirteen thousand died in Leiden in 1655, a quarter of the city's population. In Amsterdam nearly 18,000 died in 1656, and one can imagine that Rembrandt was more worried about its sweeping away his little family than he was about the problems of insolvency. Seven years later the city was devastated by its worst attack of the century, starting in the latter part of 1663, when 10,000 died, and running into 1664, when 24,000 were killed by it: the total fatalities amounted to nearly a fifth of the city's population. Only when plague seemed to be departing, with the end of the century, did people begin to think of it with less than horrified fatalism. In 1721 Daniel Defoe recorded the effects of plague in a brilliant and only lightly fictionalized account, *A Journal of the Plague Year:* "It was about the beginning of September, 1664, that I, among the rest of my neighbours, heard, in ordinary discourse, that the plague was returned again in Holland; for it had been very violent there, and particularly at Amsterdam and Rotterdam, in the year 1663, whither they say, it was brought, some said from Italy, others from the Levant, among some goods which were brought home by their Turkey fleet . . . "

Plague was caused by a bacillus, carried by a flea, that lived on the rat. Rats and fleas were encouraged by the conditions in which most city people had to live, packed together in ill-ventilated, unsanitary rooms. When it struck, people rightly got out of towns, if they could afford it and had somewhere to go; they avoided public meetings, church services, and staying at crowded inns. It was thought that plague often followed a mild winter. The plague was spread by shipping, which carried the rats from port to port. It hit mostly the poor, crammed in their cellars and hovels, but the rich and notable were not immune. In 1621 plague carried off Jan Pieterszoon Sweelinck, the eminent Dutch organist and composer, and Dr. Sebastian Egbertszoon, one of Nicolas Tulp's predecessors as dean of the Surgeons' Guild.

The scourge had its own practitioners – plague doctors – but their ministrations were primitive. It is hard to imagine the pain people suffered before modern drugs and anaesthetics, whether in childbirth or in the throes of plague. Defoe described "the terrible burning of the causticks which the surgeons laid on the swellings to bring them to break and to run, without which the danger of death was very great, even to the last. Also, the insufferable torment of the swellings, which, though it might not make people raving and distracted, as they were before . . . yet they put the patient to inexpressible torment." To avert the plague in London in 1658 ("very mortal this spring," wrote John Evelyn), there was public fasting. The sale of various nostrums and patent remedies boomed during such epidemics. People burned, according to Defoe, "smoaks of pitch, of gunpowder, and of sulphur" in order to fumigate their dwellings. One man kept a clove of garlic in his mouth, while his wife soaked her head-scarf in vinegar. Powerful smells were favored, and any assembly of people produced a mixture of aromas. Defoe described a church that was "like a smelling bottle; in one corner it was all perfumes; in another aromaticks, balsamicks, and variety of drugs and herbs; in another, salts and spirits, as everyone was furnished for their own preservation."

The pestilence finally passed away. No one knows precisely why, though changes in trade routes may have been a factor, and improvements in hygiene, better housing conditions, and cleaner streets undoubtedly helped.

One form of public gathering that, despite occasional setbacks, began to flourish in midcentury Amsterdam was the theater. In Leiden, when growing up, Rembrandt may well have seen one of the English companies of strolling players who now and then visited the United Provinces. Italian and French troupes also made tours through the Netherlands, performing plays, processions, and pageants in rented halls. Much of the native drama, like much of the native art, was based on the Bible: *The Tragedy of Samson; Esther, or the Picture of Obedience.* Vondel wrote two plays based on the life of Joseph. Classical inspiration was also common. Rembrandt's patron Jan Six wrote a play called *Medea*, for the printed version of which Rembrandt made a fine etching of *The Marriage of Jason and Creusa.* (It didn't as a matter of fact illustrate a scene from the play, which suggests that though the book was one of the items in the 1656 inventory, he may not actually have read it.) Many plays reflected the fact that the authors weren't paid for them. But some, showing a strong tie with traditional performances at fairs and kermesses, made their authors well known. The work of Jan Vos, the glass-maker and playwright, was often done by the amateur Chambers of Rhetoric at kermesses. In his *Arian and Titus*, one of the characters would collapse on stage with fake blood pouring from a bladder concealed under his jacket.

Samuel Coster, the teacher and playwright, had run a theatrical company at his academy, but it aroused the antagonism of the Calvinist elders, and Coster gave up. In 1638, however, a new theater was opened: a stone building, called the Schouwburg, or Show Palace, designed by the ubiquitous Jacob van Campen to replace the rickety wooden hut Coster's group had used. It was financed by the regents of the city orphanage, which received most of the profits from performances. It had an apron stage, two tiers of boxes with curtains giving privacy to the occupants (you can see why the church was down on it), and an orchestra of trumpet, cello, violin, and lute to provide the music. It was inaugurated, after a week's postponement, on January 3, 1638, by Vondel's play *Gijsbrecht van Amstel*, which was specially written for it. (The Calvinist authorities had objected to a section of the Catholic Mass used in the play, but the burgomasters let it proceed.)

Gijsbrecht was a smash hit. It celebrated Amsterdam's glory, and the people of the city flocked to see it. Rembrandt went to the theater and drew what he saw. Perhaps at rehearsals he sketched the actors and actresses – at first actors only, since the first actress to appear on the Dutch stage, Ariane Noozeman, was for ten years confined to a traveling company; she didn't get on the Amsterdam stage until 1655, when she was paid the "high" wage of 4.5 guilders per performance. Rembrandt drew the actors who dressed up in ornate women's gowns and headgear (the Calvinists found this less objectionable than women acting with men) to play such parts as Badeloch, Gijsbrecht's wife, a role first played by an actress in January 1656. (Men were still playing the chorus of nuns in this play in 1658, so the revolution was not all-encompassing.) Rembrandt drew a pudgy actor in his dressing room, with miter and episcopal robes hung up behind him, no doubt preparing to play in *Gijsbrecht* the part of Bishop Gozewijn. This may have been the actor William de Ruyter, who approached the part with no great reverence. At one rehearsal he got a laugh from his colleagues by pointing to his miter and adjusting his lines: "Put on my head this shit-pot, for it will not ill-become this anointed head." (If Vondel was on hand, he wasn't amused.)

Whether or not *Gijsbrecht* had a direct influence on *The Night Watch*, it undoubtedly appealed to the theatrical element in Rembrandt. Many of his pictures are visibly "staged." They take place under high, vaulted backdrops or proscenium arches. Christ is presented on a stage to the people – *Ecce!* Frans Banning Cocq and his men stride forth into, as it were, the spotlights. Although he gradually tamed the melodramatic streak, he still showed a sense of theater, perhaps a more intimate one, in the way he framed a girl, say, in a doorway or window, as on a stage of her own, or placed someone in a shadowed overarching space or against rich curtains, which thrust the character forward to our attention. He had his own prop-and-costume department for himself and his models. Several

An Actor Seated. *Drawing, c. 1636–1638. Devonshire Collection, Chatsworth.*
Reproduced by permission of the Trustees of the Chatsworth Settlement

times he drew an actor playing Pantalone, the comic elderly suitor of the commedia
dell'arte. Perhaps he felt too, as he saw himself in a mirror wearing a courtier's hat
or a rich Venetian robe, that he was an actor, playing a part; he had to get beyond
the act, by remorseless concentration, by application of paint, to the man within.

After himself, and Hendrickje, one of his most frequent models was Titus. We know very little about Titus other than what his father shows us. Titus inherited some of his father's looks (for example, most of his nose) but also his mother's frail physique. Did he go to school, or did he learn everything at home in the Breestraat, sitting at that desk which prompted Roger Fry's comments, trying to find the right word or for inspiration to strike and solve a mathematical mystery? The 1656 inventory lists "a book containing remarkable examples of calligraphy," and Titus may have studied this; calligraphy was then considered an important accomplishment. There were also paintings and drawings by Titus in Rembrandt's collection. Perhaps Rembrandt hoped his son would follow him in his profession, since it was often a family business in which son succeeded father; witness the van de Veldes, van Ruisdaels, Halses, van Mierises, Mierevelds, the Vrooms, and others. No artist makes anything great that doesn't spring from a deep personal concern, and Rembrandt's recurring visits to the subject of parental and filial love – Tobit and Tobias; the Prodigal Son; Jacob and Joseph; David and Absalom – must have sprung in great part from what he felt for Titus. Titus seems to have followed his apprenticeship by becoming his father's assistant and then business manager, running the partnership. The overwhelming fact of his father's occupation swept over the son, who would have had to be a strongly independent personality to resist the pull. He stayed with his father till his marriage at the age of twenty-seven.

Titus was thirteen years older than his half-sister, Cornelia, so there was a long period of childhood, or one childhood following the other, in the Breestraat house. Toys, dolls, and games were constantly in evidence. On St. Nicholas Eve children went to the baker's shop to decorate gingerbread, and in the morning they looked for objects the good saint had left in the shoes they had placed by the hearth: according to a picture of Jan Steen's, canes in the shoes of bad children, for their spanking, and candy and toys in the shoes of those who had been good. On Twelfth Night the child who had found a silver coin in the breakfast bread was made "king," and in the evening a procession of kings and other children went through the streets, carrying paper stars, and collected cakes and money. On some days children had the run of the town – for example, on the Saturday before Whitsun, when they ran through Amsterdam carrying greenery and banging on doors and throwing stones, and during the first week of the September fair, when they went in procession to the Stock Exchange and were allowed to play there for most of the day.

The illustrations on tiles of the time show that children flew kites, rolled hoops, swung, skipped, used catapults and ran egg-and-spoon races, played bowls, dice, and cards. They fished and swam and played *kolf*. In church they sometimes played marbles. In Rembrandt's house there were tric-trac and cribbage boards. Many children had a *rommelpot*. Rembrandt drew a small boy with one of these primitive

The Star of the Kings. *Drawing, c. 1642. Courtesy of the Trustees
of the British Museum*

instruments, which were made from a jar with a pig's bladder stretched over it, and a stick that could be moved up and down through a hole in this skin, producing, it is said, a rumbling sort of music. There were all sorts of instruments in his small painting room, and though we have no way of knowing what sort of music he and his family played, it would be surprising if they differed from their contemporaries. It was a musical century. Organ music had been restored in churches by public demand. Local musicians played the bagpipes, drums, and fiddles at celebrations, such as weddings, and at family parties everyone sang. In the better-off burgher houses, music teachers came to give lessons to young ladies learning to play the harpsichord, spinet, virginal, or lute.

How a child like Cornelia got her basic learning we can see (though in possibly exaggerated form) in a Jan Steen painting of a village school in the Scottish National Gallery. Children took lunch baskets and wrote with quills. Writing-boards with words to be copied were kept suspended on a cord from a child's wrist. There were primers and alphabet books with colored pictures, and at least at this Steen school a chance to act up or fall asleep. School seemed to be both a place for learning the three R's and an adventure playground.

Perhaps from his own childhood Rembrandt retained a fondness for household animals, and they were certainly among the residents of the Breestraat house. Whatever the truth of the monkey story told by Houbraken, we know he had

A Lion Resting. *Drawing, c. 1650–1652. Rijksprentenkabinet,*
Rijksmuseum, Amsterdam

cats and dogs. A cat figures in the 1654 etching of *The Virgin and Child*. A cat sits
by the fire in the 1646 painting of *The Holy Family*. A cat and a dog participate
in the etching of *The Pancake Woman*. Among the three works by Titus listed in
the 1656 inventory was one described as "Three small dogs done from the life by
Titus van Rijn." Rembrandt put dogs in his compositions as natural components
of the human scene. A greyhound nuzzles a child, wearing a *valhoed* (a protective
hat), who is being held up by its mother. A dog alone sleeps in its kennel. A dog
accompanies Tobias and the Angel and another scampers along at Joseph's feet in
the 1654 etching of *Christ Returning from the Temple with His Parents*. Houbraken was
annoyed by the impropriety of a dog mounting a bitch in the grisaille of John the
Baptist, and presumably felt the same way, if he saw it, about the dog crouching
in the act of defecation in a Good Samaritan etching. But in Rembrandt's etching
of the *Presentation in the Temple*, it seems only right that a wooly dog has flopped
down at the feet of two conversing elders.

Rembrandt missed by several centuries Artis, Amsterdam's zoological gardens
in the Plantage Kerklaan, a short walk from the Breestraat. Not every Amster-
dammer knows that the name of the zoo comes from the Latin motto of the place,

Studies of a Bird of Paradise. *Drawing, c. 1637. Cabinet des Dessins, Louvre.*
By permission of the Réunion des musées nationaux, Paris

Natura Artis Magistra, "Nature is the teacher of art." But Rembrandt let nature teach him too, and he went, perhaps with his children, to look at exotic birds and animals whenever they were on show in Amsterdam. With an enthusiastic pen he drew two birds of paradise; black chalk captured the wrinkled dignity of an elephant. As for the lions he often drew, getting across so well their heavily loaded front ends, these splendid drawings of splendid beasts seem to march with his own self-portraits: somewhat abstracted in the 1640s, powerful in the fifties, and full of vigorous majesty in 1660, when he may have been beginning to feel like an old lion.

Tower of the Westerkerk, *Amsterdam. Inscribed and signed in a later hand.*
Drawing, c. 1650–1652. Fodor Collection. Stedelijk Museum, Amsterdam

XVIII

Resolution and Independence

TOWARD THE END OF 1660 he found a small house to move to in the Jordaan
and stepped out of the front door in the Breestraat house for the last time.
Perhaps it did not seem such a disaster. He may have gone down the steps, taking
a deep gulp of air, glad at last to have it off his back. He may well have had enough
of collections, of possessions. He no longer burned to be a patrician painter. He
wanted to go on painting in his own way. His new home suited his reduced but
by no means down-and-out circumstances. It stood in the Rozengracht (roughly
where Number 184 Rozengracht is today), facing on to a canal, a house in which
he and his family had half a dozen rooms and his landlord and family lived too. The
British Museum has a drawing, possibly by one of his students, that shows what
may be the front hall of the house and the street outside. It suggests something of
the intimate quality of the Jordaan, a west-side neighborhood of artisans' homes
laid out beyond the great canals in the 1611 expansion plan.

The name "Jordaan" was perhaps derived from the fact that one reached it
across the Prinsengracht, as across the Jordan River, or else from the French
jardin – for the houses were built where there had been allotments and flower
gardens. Many of the streets and canals were named, like the Rozen (or roses)
gracht, after plants and flowers. The canals joined the Prinsengracht at an oblique
angle, following the course of old drainage ditches, and the streets of the area
follow former dikes and paths rather than the radial pattern common in much of
the city center. The singularity of the Jordaan came to be matched by its inhabitants,

Amsterdammers who thought of themselves as different, speaking their own argot and developing their own humor. The main landmark was the tower and tall nave of the Westerkerk. The 255-foot tower Jacob van Campen had added to Hendrik de Keyser's church was the tallest structure in the city, with a brick shaft, sandstone platform, and spire of wood and lead opening up as it got higher and thinner, and topped with the imperial crown of the city's coat of arms. From the front room and vestibule of his new lodgings Rembrandt could see canal water outside, as he had in the Weddesteeg in Leiden as a child. Across the way was a little park – the Doolhof, or Maze, with fountains and statues, a pleasant spot to sit or stroll in.

During his financial troubles and the move to the Jordaan, his circle of acquaintances naturally contracted. Some old friends drifted away. Jan Six was an interesting example, affected as he was perhaps not only by embarrassment at Rembrandt's money problems as by his own adjustment to a changing style of life. Rembrandt had done several sketches in Six's *Album Amicorum* in 1652. One, of Homer reciting, was accompanied by the inscription "Rembrandt to Jan Six." In 1654 Rembrandt had painted Six's portrait in a manner that suggested painter and sitter knew each other well. The informality and directness of the picture is still striking: the plain gray coat Six wears, the red-brown cloak, the slashes of color for fastenings, the swiftly painted hands. Six, pulling on a glove, has an inturned look, as if he were thinking about the way he was being regarded by the spectator, who was then his friend the painter. He gives this impression by means of an inclined head, set lips, and shadowed eyes divided by a V of light, which also emphasizes the strong, straight nose.

Two years before, Six had retired from the family business, running a dye works and silk mill, to concentrate on public duties and his literary ambitions – to write his play *Medea* and a long poem about the delights of the castle at Muiden, dedicated to P. C. Hooft, leader of the intellectual circle known as the Muiderkring. Six married a daughter of Dr. Tulp's in 1655, and the following year became Amsterdam's Commissioner of Marriages. Six wrote in his *Album Amicorum* about the portrait Rembrandt had done of him: "Such a face had I, Jan Six, who since childhood have worshiped the Muses." Although he owned other pictures by Rembrandt – a portrait of Saskia in a red hat; a John the Baptist preaching – he was twelve years younger than Rembrandt, financially secure, and an indisputable member of the city's ruling class; the Muses he worshiped were in the end not those who looked after the painter. Bol and Flinck, Rembrandt's successful pupils, painted portraits of Jan Six's wife. Six collected antique marbles and Italian paintings, and accepted the dedication of Jan de Bisschop's book on classical art, with its

disparaging remarks about a Dutch painter – obviously Rembrandt – who made his Danaë look like a washerwoman.

Whatever the contrary feelings Rembrandt aroused among his fellow citizens, his name was well known. A number of poets mentioned it or his work as a way of evoking the effects of splendor. One dramatist described the gold embroidery on the clothes of a character as eclipsing even Rembrandt's paintings, thus indicating that his audience was expected to recognize this as a high standard. Among the writers who admired his work were Hendrik Waterloos, who wrote some stanzas on "The Hundred Guilder Print," and Jan Vos, whose verses celebrating the reorganization of the Guild of St. Luke in 1662 put Rembrandt in the front rank of Amsterdam painters. Rembrandt did a first-rate portrait in 1666 of Jeremias de Dekker, a good friend, several of whose poems referred to the painter. De Dekker admired Rembrandt's "ingenious, worthy spirit"; thought that Rembrandt painted for love, not profit; and in one poem, specifically addressed to the painter, called him the Apelles of his day, adding – as if that reference to the fabulous classical Greek artist weren't enough – that Rembrandt's work surpassed that of Raphael and Michelangelo. However, the most famous poet of Rembrandt's day, Joost van den Vondel, showed little enthusiasm for the painter's work. Although in one poem on the handwriting teacher Lieven van Coppenol, whose portrait Rembrandt etched, Vondel talked of Rembrandt's "noble brush," the compliment may have been because Coppenol was paying for the poem; Vondel preferred the lighter, more "finished" pictures of Govaert Flinck, as did Arnold Houbraken, who recognized a reference to Rembrandt in a poem Vondel wrote about a painting by Philips Koninck:

> Thus art as well brings forth the sons of darkness
> Who like to dwell in shadows, like an owl.
> He who follows life can do without artifice of shadow,
> And, being a child of light, need not hide in gloom.

Among the friends who stuck with him in the shadows of the Rozengracht were many professional colleagues. He went on seeing fellow artists like Jan van de Capelle, who painted luminous calm seascapes and whose independent wealth from his family dyeing business made him one of Rembrandt's best customers. Capelle owned 500 drawings by Rembrandt, which he kept in portfolios entitled "The Life of Women and Children," and "Histories, Landscapes, Sketches." Many painters Rembrandt had known were dead: Nicolaes Eliaszoon died in Amsterdam

in 1654, the same year Fabritius was killed in the Delft "thunderclap." But his pupil Gerbrandt van den Eeckhout, who had studied with him in the late thirties and early forties, was among those who kept the master in mind. Having worked through various styles, he painted in 1667 a fine *St. Peter Healing the Lame*, very much in Rembrandt's manner. It was an act of homage that in the process brought Eeckhout to a level of excellence he rarely achieved. Houbraken says that the landscape painter Roelandt Roghman was another close friend. On one occasion Rembrandt refused – because of this friendship – to accept a pupil of Roghman's who had run away and wanted to study with Rembrandt.

It was also Houbraken who said, "In the autumn of his life Rembrandt kept company mostly with common people and such as practiced art." That last phrase perhaps included such eccentrics as Coppenol, who had several etchings of himself done by Rembrandt. After a fit of madness in 1650, Coppenol was never quite normal. He used to drive in a wagon round the countryside, displaying examples of his calligraphy. He called on poets and paid them to write verses, as Vondel did, celebrating the calligrapher and his fine penmanship. He also seems to have recommended Rembrandt to a relative of his wife's, Catrina Hoogsaet, a Mennonite lady whose portrait Rembrandt painted in 1657. In the same year Rembrandt etched a portrait of the renowned goldsmith and silversmith Jan Lutma the Elder. Among the painter's friends were men like Jacob Heybloek, the headmaster of the school in the Gravenstraat, for whose album he made a sketch, and print-dealers like Clement de Jonghe, whose portrait he had etched in 1651 and who sold Rembrandt's prints at his shop in the Kalverstraat, just off the Dam. His trusted acquaintance Abraham Francen also lived in the Jordaan. Gersaint, the eighteenth-century connoisseur who made the first catalogue of Rembrandt's etchings, wrote of Francen: "This curious [man] had an extreme passion for etchings, and as his situation did not permit him to satisfy this easily, he often deprived himself of drinking and eating in order to be able occasionally to acquire the pieces that gave him pleasure." Rembrandt etched this true amateur in 1656, looking at a print by the light of an open window, surrounded by valued objects: books, statues, religious pieces. Abraham Francen's better-off brother Daniel lent Rembrandt money, while Abraham himself was asked by Rembrandt to serve as Cornelia's guardian; it was Francen who gave her away when in 1670 she married a young painter, Cornelis Suythof. Rembrandt seems to have been dissatisfied with his etching of Francen. He kept making changes to the plate. He may have invited Francen to watch him at work, knowing what a thrill it would give the print collector, as Rembrandt altered the first state of the etching, burnishing the plate or giving it a new ground before re-etching, in order to fill in the window frame,

remove the curtain, take away the trees, darken the room, and move Francen's right hand.

In Amsterdam, Rembrandt was still talked about, though people might differ as to his qualities as a painter. He was a character. Baldinucci passed on the gossip that his fame was greater than his excellence. His colleagues chatted about him, about how he was splashing on the paint these days – though just how thick it was depended on your source. Baldinucci said his impasto was half a finger thick. Houbraken said that you could pick up one of Rembrandt's portraits by the nose. It became the thing to admire him – his application, ideas, color, and hard work – but also to deplore the fact that he didn't do much for the status of his profession. He didn't follow the Rules of Art, which the French Academy put forward and Houbraken gives us: "Great painting must handle noble and edifying subjects, particularly fine histories, and moral and spiritual emblems, which at once instruct and delight." This was the sort of code young Dutch painters like Gérard de Lairesse followed; de Lairesse thought Rembrandt "hopelessly old-fashioned." Rembrandt's work struck critics of this kind as unfinished.

Yet his fame was far-flung, and commissions continued to come to him. His etchings were known and copied in various parts of Europe: in Switzerland, France, Genoa, and Rome. His works were in several famous collections. The English royal family owned some of his paintings, and so did the Emperor Leopold and the Medici. Cosimo de' Medici, later to be Grand Duke of Tuscany, called on Rembrandt in 1667, in the course of one of two tours he made of the United Provinces. (He also met Jan de Witt and Sir William Temple; his guide to Amsterdam was Joan Blaeu's son, Pieter Blaeu.) In 1662 John Evelyn published in London a book called *Sculptura*, which was about engraving, and in the section on Flemish and German practitioners he wrote, "To these we may add the incomparable Reinbrand, whose etchings and gravings are of a particular spirit." Although Constantijn Huygens no longer commissioned work from him, he hadn't been forgotten in Huygens's family: Constantijn's brilliant sons Christiaen and Constantijn the Younger referred to Rembrandt in correspondence, and Christiaen at the age of sixteen chose a Rembrandt *Old Man's Head* to make a copy of.

Some people still thought of him when they wanted portraits done. From Dordrecht the patriarchal Jacob Trip and his wife, Margaretha, came for their matching portraits in 1661, perhaps while visiting their wealthy sons, Louis and Hendrick, who were in the armaments business in Amsterdam. (Rembrandt had painted two previous Trip family portraits in 1639). In the same year of 1661 Rembrandt's good client Don Antonio Ruffo (who had earlier bought the *Aristotle* for his splendid palazzo in Messina, Sicily) commissioned two historical portraits,

an *Alexander* and a *Homer*. Ruffo objected to the first *Alexander* Rembrandt painted, and didn't let the fact that it took three months for a painting to make the sea voyage from Amsterdam to Messina prevent him from sending it back, perhaps rightly. Rembrandt seems to have worked over and enlarged with strips of canvas an old portrait of Titus; he declared that the seams wouldn't have shown if hung in the right light. However, he also said that he would paint a replacement for 600 guilders, which was a hundred more than the price agreed for the first, and this satisfied the Sicilian nobleman.

Obviously Rembrandt's independent manner and pride in his own way of doing things could cause difficulties, particularly where the commission expressed the taste of a group rather than of an individual, who might know better what he would be getting. One wonders what reservations there were among the burgomasters and councilors when it was suggested that Rembrandt paint one of the Batavian conspiracy pictures for the Town Hall. It was perhaps Hendrik Uylenburgh, who was involved in the decoration works of the new building, who got his former partner and relative-in-law this commission. Govaert Flinck had died in February 1660, before proceeding very far with the entire project, and the job was shared out among various artists, including Jan Lievens and Jacob Jordaens. Rembrandt was asked to paint the lunette in which the visitors to the Burgerzaal would look up and see the beginnings of the uprising.

At roughly sixteen feet square, it was the largest picture Rembrandt ever painted. It followed the account of the Roman historian Tacitus of the conspiracy against the empire in some respects that were original, and it departed, also in original ways, from the account in various details. Tacitus wrote that the chief of the Batavi "summoned the chief nobles and the most determined of the tribesmen to a sacred grove. Then, when he saw them excited by their revelry and the late hour of the night, he began to speak of the glorious past of the Batavi and to enumerate the wrongs they had suffered, the injustice and extortion and all the evils of their slavery." When they were thoroughly worked up, "he at once bound them all to union, using the barbarous ceremony and strange oaths of his country."

Rembrandt set this drama, not in a sacred grove, but in a vast, lofty hall. (Our ideas about the picture depend partly on a preparatory drawing for the work, since the painting itself was cut down in size and only a section of the original remains.) What Tacitus called *barbaro ritu* he cleverly rendered by showing the tribesmen making their oaths by touching their own swords to the wide, uplifted blade Civilis holds. You can almost feel the current where the swords touch. Tacitus had mentioned the fact that Civilis had lost one eye, and Rembrandt's accurate depiction of this crucial Odin-like detail was powerful in effect. The other Town

The Conspiracy of Claudius Civilis. *Painting, 1661–1662.*
Nationalmuseum, Stockholm

Hall painters carefully portrayed Civilis in profile, so that his disfigurement didn't show, or they ignored it altogether. Rembrandt, with almost naïve emphasis, painted the leader larger than his followers, seeming to look askance with the eye he had left, as if averting it from the glare of light from the middle of the table. This light partly silhouettes the foreground figures, illuminates those behind with the swords, and irradiates a glass goblet that stands at one end of the table like a grail.

Like a good number of Rembrandt's major works, it is a mysterious picture. It recalls other rites. It is both a Last Supper and a meeting of a Dutch corporation, here warrior chiefs. It is marvelously unsentimental in its approach to these folk heroes, who look (as Professor H. van de Waal has said) like bargees and peat-cutters — or, for that matter, like garage mechanics and real estate speculators. The tabletop is a long line of light, reflected upward, interrupted by a head, a bowl held out by a participant who obscures the source of the light, and interrupted too by a figure standing or kneeling on a chair, possibly the priestess Velleda. The light seems to be the incandescence of a moment when men are stirred to action and their spirits aroused. The colors are browns and reds, terra cotta and burned orange, translucent white and gold. Civilis wears a ridiculous domed hat or crown,

very much like the hat Rembrandt had borrowed from the Pisanello medal of Gian Francesco Gonzaga for the horseman in the late state of his *Three Crosses* etching; though here the hat is of silver satin and azure velvet, decorated with gold trim. In some ways the painting recalls the excessive turbulence of *The Night Watch*, but here the drama has been frozen into a still moment by the upraised swords, the stare of that surviving eye, and the blanched, nervously intent face of the man who – lips pursed – takes the sword oath on Civilis' left.

But it was a moment the burgomasters apparently did not wish to share; they felt no kinship with these Batavian bandits. Was this the William the Silent who had led their noble freedom-loving ancestors? Rembrandt's painting was installed for a brief while in the intended lunette but removed afterward in circumstances that are still a matter for conjecture. The painting seems to be mentioned in a contract Rembrandt signed in August 1662 as a result of his continuing money problems. This states that one of his creditors should receive a quarter of the sum due to Rembrandt for "the painting delivered to the Town Hall, and of any amounts on which he, van Rijn, has claim, or stands to profit by repainting." Did he take the picture back to work on it and make it suit the city fathers' wishes? Did he take it back and not work on it? Did the burgomasters turn down Rembrandt's claim for extra payment, for his extra work, and elicit a defiant refusal to have anything else to do with the project? All we know for certain is that a timid piece by his German pupil Juriaen Ovens went up in its place, and the cut-down and perhaps altered fragment of Rembrandt's *Conspiracy* arrived in Stockholm in 1760 or thereabout, and has remained there till this day.

He was now, as we have already seen in part, running against a prevailing current of his time. He was allowing his life to move – whether consciously or as an adaptation to inner prompting and outer circumstance – toward simplicity. As the times became more polished, he became plainer. If we compare any picture he did in the fifties and sixties with one done in the late twenties and the thirties, it will be seen that the later work is far less fussy or fancy. In some senses he can be talked of in terms art historians tend to use in regard to the Baroque age: words of movement such as "flow," "surge," and "rhythm." "The lights and darks roll on in a common stream," Heinrich Wolfflin writes at one place in his *Principles of Art History*. This was the age that accepted motion as the basis of all natural processes. "The appropriate method of scientific explanation was to formulate the laws of motion with the help of mathematics," writes Professor W. von Leyden in the *New Cambridge Modern History*, Volume V. Although Rembrandt shared the contemporary rhythm and felt the Baroque necessity for involving spectators in the world he created, he soon cast off what Sir George Clark, author of *The Seventeenth Century*, has called "the

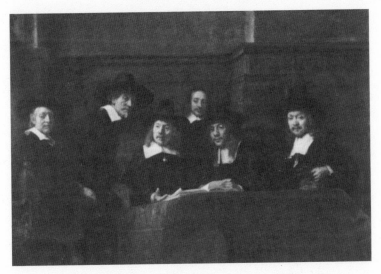

The Syndics of the Cloth Draper's Guild. *Painting, 1661–1662.*
Rijksmuseum, Amsterdam

tricks of the baroque" – the contortions, inversions, deliberate difficulties, and grotesqueries. Indeed, as time went on the movement in Rembrandt's work ceases to be restless (*onrust*, as the Dutch say, a word they frequently use to name boats and houses) but is instead the steady, inevitable motion of the sea.

The Dutch patrician class, represented in the Civilis case by the authorities of the new Town Hall, were moving in another direction: toward smoothness, lucidity, the refined and controlled. The brick and tile floors of early de Hooch paintings give way in his later works to marble halls; expensive silk curtains and elegant paneling cover the old whitewashed walls. Something of the heartiness and good cheer of the early seventeenth century disappears and is replaced by an earnestness, cool civility, and somewhat haughty paternalism – the *deftige* qualities, or "regents' mentality" that Jan de Witt had, and that may have in part provoked the mob reaction to the regents' rule in 1672. French novelties now became fashionable. Some said it was a plot, inspired by Madame de Maintenon, to undercut traditional Dutch virtues and soften up the Dutch people for Louis XIV's invasion.

Yet a basic simplicity remained. The papal nuncio to Cologne, Pallavicino, was impressed by the plainness of things in the Netherlands even in 1676. The great

drainage engineer Adriaen Leeghwater wrote in his memoirs that there were only three pairs of shoes in his village, De Rijn; they were lent to the aldermen if they had to travel to The Hague on village business. And in the Amsterdam regent class there were men who, in 1661–1662, at the same time as the Civilis fiasco, thought Rembrandt was the artist best equipped to record their looks and function for posterity. The Staalmeesters, the Syndics of the Cloth Drapers' Guild, picked well. He painted the six men at a meeting, four of them sitting at a carpet-covered table, the minutes book in front of them, one standing and one in the act of rising. They wear wide-brimmed black hats, black coats, and plain white collars. They exude an austere *deftige* confidence in themselves and their actions. They are at once individuals and a group, given coherence by composition and the harmonies of color, and by the way they each look out at the same point, as if at someone who has suddenly come into their room. It is a business very beautifully balanced, between the demands of the patrons and those of the painter – between their ethos and temperament and his. They have such calm dignity. They have their affairs and their lives under as much control as men ever can; but the person who sees them on equal terms, who has caught them at this moment and caught their attention forever, is Rembrandt.

XIX

Among Scholars

MUCH OF OUR IMPRESSION of Rembrandt is due to scholars who are devoted to him, but scholars are subject to another imperative, which is their own life. To begin with, a scholar has the good fortune of having an enthusiasm that he can pursue, for years if need be; within this are particular joys, like absorption in a book. I sat one recent afternoon in the silent library of the Rijksacademie for Fine Arts, set in the back of a building not far from the Rijksmuseum, happily reading Professor van de Waal's article on the *Faust* etching and faintly aware of student footfalls on the stone staircase, birds in the sunlit green trees outside, the librarian busy with his catalogue cards. For me the apparatus of learning includes the men who lug the heavy boxes containing Rembrandt drawings to my desk in the Rijksprentenkabinet; the youth who goes to a far room in the Amsterdam Historical Museum to get a rare page photocopied for me; the girl who sits in the Poelen café in the Staalstraat drinking wine with me, translating the difficult seventeenth-century words into English, unsure whether she has been brought here for the advancement of knowledge or seduction. There is a way of learning by osmosis – walking, looking, sitting, brooding; some of the knowledge-encouraging force rises up through my feet as I walk on those hand-made yellow-brown bricks paving the area around the Oudekerk.

My own short past is involved – "reading" Dutch, my eyes skimming a text for meanings I can quickly pick up, or for things I ought to copy out and slowly translate later. I recall sitting with my wife, Margot, in the Prentenkabinet in

1957, painfully copying out some of the 437 documents Hofstede de Groot had assembled – before we discovered that an English translation existed. In the library of the Historical Museum one of the young assistants translates for me a passage from an article on the St. Luke's Guild by Miss I. H. van Eeghen, a Dutch scholar, and dismisses my thanks with "I'm glad to know about it myself." In the London Library, where members can wander through the. curiously ordered stacks on perforated steel catwalks, I prepare myself for the mild electric shock one gets touching the steel shelves in European History L–N (it is something to do with leakage or faulty grounding of the fluorescent lights). There one is often waylaid by books one wasn't looking for. In Dutch topography, at foot level, I pull out a dusty vellum-bound volume just for a look. It is the second edition of Jacob Orler's book on Leiden, printed in 1641 – *Beschrijvinge der Stadt Leyden* – the first work to have a biographical account of Rembrandt's life to that point.

The documents (together with his work) are the foundation on which one builds, though some records – like that registering the marriage of Rembrandt's aunt in 1584 – are of peripheral interest. One depends, too, on numerous "finds" made in recent years, and on scholarly articles written by such people as Miss van Eeghen or Mr. Wijnman, who have an intimate knowledge of the Dutch seventeenth century. Many academics are anxious to help; they recommend learned articles I might not have discovered, show me where books can be found on shelves, call up friends and write introductions for me. One also has to face a natural skepticism. "Rembrandt?" Many Dutch people can't imagine how it is possible to tackle such a subject, which has pervaded their lives and strikes some as freshly as windmills, tulips, and wooden shoes. Experts occasionally are forthright: it just isn't feasible to write about Rembrandt without spending years in the archives and penning an article now and then for the *Jaarboeken*. "I shall write my Rembrandt book in a few years' time," says one distinguished scholar; but one wonders if in fact he ever will. The functions are almost separate. It is a rare person who can do the difficult groundwork, sifting out of old documents the invaluable small fact, and set those facts in a larger, life-giving context. The scholar is also prey to the feeling that *he doesn't know enough*. It is what drives him on through the archives, and it is disabling for a writer. I have felt this – it prevents one from being confident enough to get on with a book. Often, in order to write a book, you have to convince yourself that you do know enough and that the book will never get written if you spend your days happily enough reading scholarly journals in comfortable libraries . . . You have to put out of your mind the inevitable remarks scholars will make about those who assemble their hard-won nuggets into books, having heard them say, when you mention the author of a book about Rembrandt you are reading, "Oh, *So-and-so!* Well, of course he is *absolutely* wrong about such-and-such, and he sits

on the fence in the crucial dispute about whether Rembrandt did this-and-that, which since Professor X's article we are bound to believe . . . " and so on.

One wonders what Rembrandt himself would have said if confronted with a future in which his life and work were material for scholarship. Perhaps nothing rude. He admired men of learning. His poets and philosophers are real. He knew what learning is. At school he had read the ancient historians – Livy, Tacitus, and Plutarch – and the interest seems to have stuck with him. We owe to a scholar, F. Schmidt-Degener, the perception that he had arranged the busts of Roman emperors in his *kunstkamer* collection in strict chronological order, though interspersed with other art objects. When it came to doing his *Aristotle Contemplating the Bust of Homer* he painted around Aristotle's neck a gold chain with a medallion portrait showing, it seems, Alexander the Great, whom Aristotle had taught as a boy. In the *kunstkamer*, the busts of Aristotle and Homer stood next to one another. A chronological framework for ancient history was then a fairly recent achievement, brought about by such scholars as Scaliger.

But there was nothing pedantic about Rembrandt's treatment of the past; he was accurate in such matters when it served the reality of his vision. Dr. Valentiner says that Rembrandt, having read his Latin authors, put Europa's hands in the right spot as the bull carried her off. In 1641 Philips Angel, writer and artist, praised Rembrandt's historical accuracy in a speech at the Leiden St. Luke's Day celebration. In Rembrandt's painting of *Samson's Wedding Feast*, Angel said, "one could perceive how this bold mind, by reflecting deeply, had observed the particularity of the seating (or better, the reclining) of the guests at table: the ancients used little beds to lie on, and they did not sit at table as we do now." But Rembrandt was perfectly capable of putting his Roman soldiers in Oriental dress; taking the pose and costume of Asnath, Joseph's wife in the wonderful painting of *Jacob Blessing the Sons of Joseph*, from what scholars believe to be a Burgundian statue – her hood is a late-medieval garment called a "hennin"; or, in a painting of *Christ in the House of Mary and Martha* that has disappeared but that we know about from Houbraken, showing Martha baking cakes in a Dutch fireplace in an iron pan – an act that roused Houbraken to pontificate, "Such are the blunders committed by those who are ignorant of history and antiquity." On the contrary: he was one of the few people of his time who really saw the antique world and brought it sometimes fiercely, sometimes gently, to life.

Rembrandt's life is, through scholarship, clearer to us now than it has been hitherto – or at least not so sensational, a romantic riches-to-rags story. It is not a portrait done in vivid light and dark, like his own early chiaroscuro, but full of subtle harmonies, half-tones, deeper ambiguities and mysteries. How he worked and what he made are still in dispute, and our view of him goes on being gradually

altered (like a dune being moved by the wind, grain of sand rolling after grain of sand) as works are taken in and out of the canon, portraits are reidentified, and pictures once thought to be his are attributed to pupils (or vice versa), and the dates of paintings moved. One is grateful to the men who bit by bit make it possible to see him whole – like Frits Lugt, who before the First World War walked around Amsterdam and environs discovering spots where Rembrandt had lived and worked, or Seymour Slive, whose study of Rembrandt's reputation in his lifetime and after finally put paid to the legend of the artist completely forsaken after *The Night Watch*. Scholars uncover facts that matter and are a pleasure to know. It is Kenneth Clark who points out that the origin of the rider in the late state of the *Three Crosses* etching was in a medallion by Pisanello. Professor Horst Gerson enlightens us with the news that the Syndics of the Cloth Drapers' Guild in Rembrandt's group portrait included two Catholics, a Remonstrant, a Mennonite, and one strict member of the Reformed Church, who was the chairman.

The scholar's job is not without risks. Schmidt-Degener thought the ornamentation of the gorget worn by van Ruytenburgh in *The Night Watch* contained the letters GYSB, an obvious reference to Vondel's *Gijsbrecht van Amstel*. But this delightful notion was shot down later by the painting's restorers, who said that, since the picture was cleaned, it didn't appear as if the brush strokes on the gorget represented letters at all. (Of course there might be a case for replying that some of the original brush strokes might have disappeared in the course of restoration. Another hard "fact" to be considered is that neither paint nor brush strokes are immutable.) Scholarship, at least for me, poses another dilemma. Undoubtedly one needs to know in many instances the subject of his painting. In his picture of *Bathsheba*, for instance, our knowledge of the Biblical story gives point, intensity, to the woman's pensive expression. And yet there is also a sort of learned game that goes on, and incestuous scholarly quarrels aplenty. Does this picture show Haman or Uriah; that painting Saskia or Rembrandt's sister, Lijsbeth? "A drawing in the museum of Groningen," writes Otto Benesch, "was considered a scene from the Bible until Dr. Valentiner recognised it as an illustration of the tragic story of Marcius Coriolanus as recounted by Livy and Plutarch." And yet again, an academic preoccupation with such details is undoubtedly preferable to the sounds of a scholar going off the deep end. I quote, for example, from Dr. Benesch the words of Alois Riegl, who in an article entitled *The Group Portrait in Holland* tells us that "the great, unique personality of Rembrandt was the incarnation of a higher, spiritual power, and his artistic achievements, however sublime and epoch-making, were nothing but the predetermined instrument of a superior historical dynamic."

Did he sometimes lay traps for blinkered scholars – who were, witness the interest in emblems, as taken with intricate by-ways in the seventeenth century as

they not uncommonly have been since? The curious muddle of a picture he called *The Concord of the State* will provide a happy hunting ground, for a long time to come, for students in search of symbols. Then there is the *Danaë*, so-called – one of his finest paintings of the 1630s, showing a nude woman welcoming a lover to her bed. Danaë was the girl who was kept locked up by her father, King Acrisius of Argos, because an oracle had told him he would be killed by a grandson. This didn't stop Zeus, of course, from appearing as a shower of gold and taking advantage of Danaë. The trouble in the case of this painting is that Rembrandt has left out the shower of gold. Thus the "subject" of the picture is still in dispute.

At some points in the course of my library sessions I felt an urge to deliver Rembrandt from his scholarly admirers. They go on – as at other moments I of course acknowledge they must – about Rembrandt's debts and influences. This comes from Pieter Lastman, that from Maarten van Heemskerk. Origins of themes and figures and compositions are found in stained-glass windows in the Oudekerk and works by Caravaggio, Lucas van Leyden, Cranach, Dürer, Titian, and so forth. Well – he was manifestly a magnificent pupil of European art. Imitation was the customary way of learning. He borrowed, copied, took, and learned from other artists. Kenneth Clark's book *Rembrandt and the Italian Renaissance* is an excellent demonstration of the ways in which Rembrandt used the tradition, the greater and lesser works of his predecessors. He also made use of contemporary and non-European work, such as the miniature portraits of the Moghul shahs, which he copied. But though the hunt for sources and influences is a natural and useful activity, it sometimes seems to be a reaction against the powerful effect of Rembrandt's work, and unwittingly, perhaps belittling. So I felt now and then the need to shake him free of his creditors, artistic as well as financial, and say, Look, here's your man, copying no one.

Some days here I have taken the liberty of an enthusiast and foreigner and gone to see some of the experts in the field. This course of action has the salutary side effect of demonstrating that scholars are not necessarily or even usually stooped, dryasdust figures. One wears a denim suit and silver bracelet; another a University of North Carolina T-shirt. One woman scholar is a good-looking blonde. They are generous with useful thoughts and suggestions – and, what is also of great help, the amiable acknowledgement that they have blank spots too. Some of my questions they would also like to have answers for.

At moments, however, when the weight of scholarship seems intimidating, and Rembrandt nonetheless elusive, I seek evidence I can take in my own hands. I returned one recent morning to the Prentenkabinet of the Rijksmuseum. There, it is necessary to follow the cautious protocol that museums have in order to guard

their tangible treasures. One rings a bell for an attendant to let one in. One's bona fides and genuine interest need to be established – and the fact that one is not the sort of person liable to hijack or attack a work of art. At a table in the print room the attendants bringing the boxes of drawings point out the procedure to be followed: the drawings, in thick mounts, have to be lifted from the box with both hands, placed for inspection in a stand-up rack or flat on the table on a thick rubber pad, and then placed in the top of the box. No pens or ballpoints to be used. A close watch is kept, to start with, to make sure one is handling the work of the master with the right reverence – and this can make one either uneasy or almost too careful in the handling. But pretty soon the drawings make themselves felt. Here is the real thing. Peter Schatborn, a young member of the curatorial staff, had said, after explaining the workings of the print room to me, "It would help if you didn't go through the boxes too fast. They are quite heavy, and the attendants have to bring them to you one at a time." There were nine boxes, each containing ten or eleven drawings, and I wasn't going through them fast at all. The drawings put me into a state of slow-burning wonder.

Some were mere scraps. Rembrandt occasionally patched bits of paper together to draw on, and once or twice used whatever was to hand: a sketch for *The Conspiracy of Claudius Civilis* he did on the back of a funeral invitation. Some of these in the Print Cabinet, despite the old brown ink and sometimes faded paper, might have been dashed off yesterday. They have an inimitable mixture of freshness and experience. The observation in them is so much of the moment in which they were done, while the expression seems to reside in a mature economy – a score of thick, squiggly lines, a dollop of wash, a lot of white space left in the right places, and behold! – a drawing. So he conveys old men's faces: the way their lips turn in, toothless mouths compressed. As Jael prepares to knock the spike into Sisera's head, the mallet brought back to the extent of her arm's swing, what a calm, concentrated look! He creates a sleeping child and its bed cover out of fifteen rapid lines, the pillow with nine strokes, the right hand almost carelessly done but no matter, because one's attention is held by the detailed drawing of the face.

The viewer is impressed by the moments he has seized – someone has just come to a window to find out what's happening in the street; a young man is reaching into his pocket for money to pay the pancake woman; the oar blades leave their marks on the Amstel's surface as the solitary man rows his boat; the sudden look of pleasure fills a mother's face as her child takes its first steps. One admires the paraphernalia that works but doesn't intrude: the pancake lady's big frying pan; a moneybag hanging over the belly of an old man; interesting hats and wicker baskets; various chairs, including that armchair of his that stood near his bedside.

Much of the subject matter presumably reflects what was in the back of his mind at the time: concern for his parents, the presence in the house of pregnant women or young children, problems of composition for paintings or practical lessons for his pupils. Since most of these sketches are obviously drawn directly, from observation, it is not clear why so many scholars have believed that most of Rembrandt's Biblical drawings were done out of his head. (Otto Benesch writes, "Never before have imaginings of an artist been so real as though they were studies from nature.") My own half-considered assumption had been that Rembrandt usually took for these drawings a common scene he had observed – a father saying goodbye to a son, a mother with child, a woman being dismissed from the household – and through the addition of the right props and costumes turned them into illustrations of the Bible. However, Nigel Konstam, the English sculptor I have mentioned before, has suggested that most of these Biblical sketches were done from life, using students and models posed in his studio. By using mirrors, Rembrandt (and his students) could draw variations of one scene – as it were, a back view and a front view. With a group set up, he could dash off several drawings on the same theme.

This means, if Mr. Konstam is right (and he has made extremely convincing models and illustrations to back up his theory), that drawings on one subject that scholars have dispersed to various periods may well have been done at the same time. He gives as an example three drawings of *The Dismissal of Hagar*, which scholars have dated *c.* 1640–1643, 1650–1652, and 1656. It means, moreover, that if these drawings were done quickly from staged studio events, the chances are greater that work now attributed to Rembrandt's students and followers may be by Rembrandt himself. Experts have previously considered many works not Rembrandt's because of faulty passages in a drawing, touches considered beneath the master's ability. An imperfect drawing may not originate with a student but with the master's desire to try things out, possibly in a rush as a model tired of holding a pose or the light changed. Mr. Konstam writes:

Rembrandt's exploratory use of drawings is constantly in evidence. Changes of gesture and regrouping are commonly misinterpreted as indicating the unsure hand of a student. The underdrawing of Job and his Comforters, for example, is of far too high a standard to deserve the description "a student work corrected by Rembrandt." . . . I am convinced that this and many other drawings so labelled are in fact Rembrandt experimenting dramatically, entirely without regard to the improvement of the drawing as an "object." Rembrandt simply does not care what you or I think of it; he is not out to please or impress. He has had another idea and it must be tried.

Young Man Pulling a Rope. *Drawing,* c. *1645. Rijksprentenkabinet,*
Rijksmuseum, Amsterdam

The scholars will assuredly tussle with Mr. Konstam. But he represents the sort
of fresh thinking that Rembrandt attracts from time to time, as well as reverence and
dedication. An occasional loosening of dogma as to what is or is not a Rembrandt
is no bad thing, and there is no reason that it shouldn't take place at the same time
as an effort to determine a corpus of his works. A group of Dutch scholars are
presently at work on this by way of a detailed study of his technique at different
periods. Perhaps every age needs to conduct a wide sweep, hauling the works into
a net, bringing some aboard, and pitching some back into the sea again. Expert

View in Gelderland. *Drawing*, c. *1645–1650*. *Rijksprentenkabinet,*
Rijksmuseum, Amsterdam

study and intuitive response are both needed. Mr. Konstam refers to a drawing of
Isaac Refusing to Bless Esau, of which Professor Slive says, "Crudities in the drawing
suggest it is probably a copy after a lost original made around 1635." Konstam
replies, "It struck me not merely as a 'Rembrandt' but as a 'masterpiece.'"

I find myself in a similar position in regard to one of the drawings I saw in
the Rijksprentenkabinet – which is one of the rooms of Rembrandt's house now
extended, as it were, by way of museums, throughout the world. Among the many
drawings that held me spellbound – a boy pulling on a bell rope, the man rowing
on the Amstel, a woman holding her baby out to a kneeling old man – was a view
from a hill: a track turning a corner and a gap in the far bank showing an expanse
of plain stretching away with fields, trees, and a distant blur perhaps suggesting a
church and a town. The tracks and the banks were simply indicated. The shadows
were beautifully balanced. I wanted to stop to look at the view and then walk on
around the bend.

Afterward, when Mr. Schatborn asked me how I'd got on, I told him my feelings
about this drawing. He smiled, as if he knew what I meant. But later I realized his

sympathy may have had other causes as well. Consulting Seymour Slive's edition of Rembrandt drawings, I read in regard to this one:

> There is agreement that this view of a plain from a hill shows a landscape in Gelderland but not everyone agrees that it is an autograph work by the master . . . Benesch sees later additions on the left, but the whole drawing seems to be the work of one hand. Begemann notes it is a hand which does not coordinate pen and brush work as successfully as Rembrandt did in the late 1640s – the date generally assigned to the work.

This perhaps indicates some of the problems and emotions aroused by the work of a Dutch artist in the mid-seventeenth century. I have to echo Mr. Konstam: as I held this drawing in my hands it struck me not merely as a Rembrandt but as a masterpiece.

XX

Chiaroscuro

ALTHOUGH HE KEPT ON WORKING as hard as ever and was not – either by modern standards or some seventeenth-century standards – old, he aged greatly during the insolvency process. The self-portrait of 1652, now in Vienna, shows him standing up, hands on his hips, elbows out, with a determination to face anything the world can dish out. But by 1658, when he painted the portrait of himself that is in the Frick Collection, the mood and the man are different. He sits as on a throne, wearing one of his splendid Venetian robes, one hand holding a silver-knobbed stick like a scepter, the other around the end of the chair arm – the king of painters, though his kingdom may be in tatters and many of his courtiers fled.

When he was younger he had pulled all sorts of faces in the mirror, seeking the lineaments of various emotions: pride, rage, cowardice, self-consciousness. He had dressed in various disguises or uniforms to swell forth some feeling about himself, and then, catching his own eye, seemed to ask "Is that you? And who are you?" And almost every year he made one or two of these self-portraits, an effort that was almost entirely for himself, since no great market existed then for portraits an artist made of his own features. But this interest in himself as a living creature, material for a moment in time (like the sparrow, described by the Anglo-Saxon chronicler Bede, that flashes through the lit hall between dark and dark), holds our attention, and will no doubt continue to do so as long as pictures last. Now, in 1658, he looked and saw within this face the other, earlier faces; but now too

he warily foresees the faces that are to come. The wrinkles will deepen, the chins multiply, and the jowls sag; the cheeks puff out and the hair go stringy gray. In the self-portrait at Kenwood, painted in the early 1660s when he was fifty-seven, he looks older than his years. He holds palette and brushes in his hand. The wonderful red of his smock is echoed in a blotch of red on the tip of that farmer's nose of his. Where before, in 1658, one felt that the insolvency had not affected his pride, he now seems to have gone beyond pride: he is looking at an old painter who happens to be himself.

In some ways he was well prepared. He was interested in old age all his life. In Leiden he drew, etched, and painted his parents as they aged, asleep in chairs, holding the Bible, dressed up as Biblical characters. He drew for pleasure the old hawkers and women he saw in the streets, and accepted commissions to paint elderly burghers and their wives. Throughout his career he seemed to take a great interest in the elderly, who populate so many of his pictures. In this, as in many other things, he was a Dutchman in his own way. That perceptive visitor Sir William Temple was impressed by the way the Dutch cared for old people, although he thought "they are generally not so long-liv'd as in better airs; and begin to decay early, both men and women, especially at Amsterdam." He was much taken with the homes set up for old people, like the hospital for old seamen he visited at Enkhuizen. This was so ordered "that those who had passed their whole lives in the hardships and incommodities of the sea, should find a retreat stored with all the eases and conveniences that old age is capable of feeling and enjoying."

The Begijnhof around the English Church was one of seventy-five such sheltered hospices set up in Amsterdam by the end of the eighteenth century. Founding one of these places, which the Dutch familiarly called a *hofie*, was of course a means of ensuring that one left a monument to oneself; and helping to administer it as a regent or trustee, one had one's portrait painted in a group picture – which was a step to immortality if the painter happened to be someone like Rembrandt or Frans Hals. But it also meant that one did something to ensure that old people weren't shunted aside and forgotten. They had lived through a lot; their experience mattered. Perhaps the Bible, read and believed, helped establish this respect in which anyone on the way to being a patriarch was held.

Rembrandt, moreover, was not alone in closely examining his own aging. In Delft, Anthonie van Leeuwenhoek meticulously described his own condition as – aged eighty-four – he approached what he thought was his end. He recounted to a friend the "divers motions" of the membranes that compose "the coats of the guts," the way in which "the bile congeals in the gut into sharp particles," and how "the

Portrait of Margaretha de Geer, *wife of Jacob Trip.*
Detail from the painting, c. 1660–1661. *Reproduced by courtesy of the Trustees,*
The National Gallery, London

long strainings of the stomach" affect the diaphragm and lungs, one thing leading to
another. (In fact, he lived on another six years and wrote many more long epistles
describing new microscopic observations of other things.)

Rembrandt's interest in himself and his retreat to the Rozengracht likewise did
not exclude the rest of the world. Perhaps there were no landscapes now, and he
appears to have almost given up etching, where the production of prints might have
involved him with numerous customers. But his paintings of these years, which
the art historians Rosenberg and Slive rightly call "mature" (he had no *later* years,
if you take into account the fact that he was only sixty-three when he died) – these
mature works convey the essence of contact between one person and another. In
earlier pictures he used the common-enough device of people coming and going,

entering rooms, delivering letters. But now in greater stillness one witnesses acts of communion: a touch, a laying-on of hands, an embrace. Aristotle's hand lying on Homer's head seems to draw forth the power within. Old Jacob's hand extends to bless the sons of Joseph. The woman who washes Bathsheba's feet draws out the act as if to hold her there, in safety. The angel softly touches the elderly St. Matthew on the shoulder, not to startle him. In *The Bridal Couple*, often called *The Jewish Bride*, the man has one arm around the shoulders of the young woman, the other hand lying gently on her breast, while her hand touches his; and the contact for a moment overrides their fundamental loneliness – for they look beyond one another, as we all do. The 1668 Brunswick family portrait is all touch between father, mother, baby, one child and another. And then, in one of his last pictures, he achieved the absolute summit of that ambition, expressed to Huygens years before, to create the greatest and most inward emotion. In this painting, *The Return of the Prodigal Son*, the old man bends over the kneeling youth, his hands on his son's shoulder blades, in a moment without words.

In the summer of 1661, Hendrickje was ill. A notary arrived and she made her will, in which she was described as "sick of body, yet standing and moving about." She wanted Titus to be her heir if her own child, Cornelia, died before having a child of her own. But Hendrickje hung on for two more years, and it is something, at least, that we know she achieved a respectable status in the Jordaan. In a deposition of October 20, 1661, regarding the behavior of a drunken man in the neighborhood, she was described as *juffrouw* and *huÿsvrouw* – in other words, she was considered to be a housewife and married woman, just like the wife of the gold-wire–maker, who also gave evidence. Then, on July 24, 1663, she died. Rembrandt, needing the money, had sold the grave in which Saskia was buried in the Oude Kerk, and Hëndrickje's body was carried to their local church, the Westerkerk, for a simple burial. In many Dutch families then prayers were said by relatives and friends around the bed of a dying person. After the eyes were finally closed, curtains would be drawn, and mirrors and pictures turned to face the wall. After the funeral, drinks were served to those who called at the house to pay their respects. The Rozengracht house had another loss at this time, for the son of the landlord died, and Rembrandt, once more a widower, put down his signature as a witness on a legal document for the house owner. In 1666 the landlord died and the house was sold, but the man who purchased it did not object to Rembrandt, Titus, and Cornelia staying on. Titus was the surviving partner of the art firm, which employed his father; but Titus, also, was not well.

We are able roughly to furnish the rooms they had in the Rozengracht. On October 4, 1669, a day after Rembrandt's death, an inventory was made of the

contents of the rooms they lived in. Three locked rooms contained various unlisted works of art and antiquities, and keys were kept by a notary. The inventory was later damaged by fire but a translation of the legible portions is as follows:

The Best Room

1. A bed and bolster
2. Five pillows and a bolster
3. Six silk bed curtains and three valances
4. A bedspread of the same stuff
5. Four green window curtains
6. An oak table and cover
7. A mirror
8. Four unfinished pictures
9. An ironing chair
10. An iron griddle

Vestibule

11. Twenty-two finished and unfinished pictures
12. Four Spanish chairs
13. An oak press and wooden stool

The inner room

14. A pine cupboard, or chest, for valuables
15. Two tin dishes with tin candlesticks
16. A stand for jugs, and six jugs with metal covers
17. Four cheap little paintings
18. Six cloth cushions
19. Five plain chairs
20. A small square table
21. Two curtains with two valances
22. A Bible
23. A brass basin and ewer
24. A brass pestle
25. Two brass candlesticks with a lantern
26. Iron candlesticks
27. A big lantern
28. A warming pan
29. A tin bowl, funnel, two earthern jugs with metal covers.
30. A flatiron

The back kitchen

31. Gridirons
32. A pot hook, three snuffers, *hengel* (a fire rod?), and an ash shovel
33. Seven earthen dishes, a number of bowls and plates
34. A small table
35. Various pots, pans, and odds and ends
36. An iron pot
37. Four worn chairs

The small back room

38. Two beds with bolsters and four cushions
39. (word not clear) tablecloths
40. (word partly destroyed)
41. (word not clear) sheets old and new
42. (word not clear) men's shirts
43. Four bolster slips
44. Six pillowcases, old and new
45. Eight cravats, old and new
46. Ten nightcaps
47. (erased)
48. Various cravats and cuffs
49. Eight handkerchiefs
50. An old mirror and clothes stand

Once again his little family expanded only to shrink again. In February 1668 Titus married Magdalena van Loo, daughter of the silversmith Jan van Loo; she was the same age as Titus. But Titus was dead in early autumn, and buried in the Westerkerk. Magdalena had a baby girl, Titia, six months later. Cornelia, aged fifteen, went on looking after her father. The money her mother had left her, kept in Hendrickje's cupboard, and the remainder of Titus's share of his mother's estate, left to Titia, was (despite Magdalena's disapproval) dipped into now and then to keep the household going.

Although his own time was running out, he went on working to the end, a craftsman turning out some pedestrian work and numerous masterpieces. In Leiden at his parents' house he had worked late, sitting with his family and drawing by candle- or oil-light. We take artificial light so much for granted now that we perhaps forget about life before electricity. Day was day and night was very much night. Once the sun had gone down there was no glow in the sky above Amsterdam.

Moonlight was valuable, and nights with it were safer that those without. But artists of the time were interested in night: poets and playwrights wrote "night-pieces" and painters painted them. In Amsterdam in the 1660s it was fashionable to have night funerals. At the beginning of the century, influential night-painters were the German Adam Elsheimer and Dutch artists of the Utrecht school, including Hendrick Terbrugghen and Gerard van Honthorst, who painted scenes in which the figures were spotlit or underlit from hidden sources of light. Tallow candles were costly; wax candles, which were more effective, cost more still. The common source of lighting in houses was an oil saucer and wick; but this gave poor light, and after one read or drew for a while one's eyes would sting.

Rembrandt as a young man clearly felt the impact of Caravaggio's chiaroscuro and the night-paintings of his contemporaries, but this interest in the contrasting effect of light and shadow was not superficial or fashionable; it sprang from a deep impulse in his own character. And as time went on he refined his use of it. In the early works, the light draws attention to itself, making the viewer look for its source. Gradually he learned to employ this powerful device in a more subtle fashion. There are various lights and darks in a single painting; the colors are softer, richer, more harmonious; the figures, placed on the borders of the light and shadow, are often lit and shaded as from within. They glow with their own life. The light and dark are part of the earth and air, the elements they define and inhabit. These effects gave no sense of being imposed, and one has to remind oneself that they were in fact achieved by the application of paint to canvas, or of pen and brush to paper. He drew a city gate from the inner side, so that the gatehouse is in bright sun and the shadowed tunnel of the gate draws the eye through; the movement in the drawing is simply sun plus shadow.

Some of the darkness associated with Rembrandt's work has come with time. *The Night Watch* restored, cleaned of smoke and old varnish, was visible as a "Day Watch." Many of Rembrandt's browns were undoubtedly less somber and more golden when he laid them on. But he nonetheless enjoyed painting in a darker fashion than most of his contemporaries, as Vondel's poem attested. The darkness gradually expanded, and the light flickered within it. In those last years he may (if lying sleepless, as the old often do) have felt the nights overlong – hearing the night guard parade through the dark streets, whirling their rattles and chanting out the hours; hearing the chimes of the Westertoren, the tower of the Westerkerk. He waited for dawn and light by which to paint again. In what must have been one of his last self-portraits (now in Cologne), he grinned at himself in the mirror as he dabbed and swirled on the colors that made light fall on the mottled countenance and painting hat, bounce off the broad, almost golden, collar of his coat, with

mahlstick in hand, and the bust of an antique god, perhaps Terminus, the figure of death, standing in the gathering shadows at the left. Rembrandt was smiling as if to a friend in what he must have known was the last of the light.

The last picture he worked on, found unfinished on his easel, was a *Simeon in the Temple* for one of the van Cattenborch brothers, a painting of an old man holding a baby – perhaps Titus's posthumous daughter, Titia.

XXI

Negatives

SOME OF THE MOST POSITIVE ASSERTIONS we can make about Rembrandt are negative. They concern things that we do not know about or he did not concern himself with. We can say he wasn't a great traveler. He wasn't much of a correspondent, at least of letters that people thought worth saving. We know nothing for sure that he actually said, although various remarks are perhaps reasonably attributed to him – like the anecdote recorded by the French writer Roger de Piles, in his *Abrégé de la Vie des Peintres* (Paris, 1699), concerning Rembrandt's tendency in later years to associate with ordinary people and not cultivate the wealthy and influential. De Piles says that when asked about this, Rembrandt replied, "When I want to refresh my spirits, I don't go looking for honors but for freedom."

Certainly there is no need to sentimentalize Rembrandt's hard luck as a forced descent into the working classes. Art is hard work. (Van Gogh said, "Being a laborer, I feel at home in the laboring class." A not uncommon seventeenth-century gablestone and doorway motto was *Niet Zonder Arbeit*, "Not without labor.") We don't know if or when he became a *poorter*, or citizen, of Amsterdam. He is not listed in the membership registers of any Amsterdam churches. He painted neither great houses nor great ships, neither battles nor tulips. We don't know his politics. It would be hard to say whether he favored the regents' party, led after 1652 by Jan de Witt, or the Orangists, who were in eclipse during the childhood of William III, during the painter's last years. (He owned several casts – a death mask and possibly a life mask – of Prince Maurice, but then he also had among his Roman

Winter Landscape. *Drawing*, c. *1649*. *Courtesy of the Fogg Art Museum,
Harvard University. Charles Alexander Loeser Bequest*

emperors a bust of Caligula.) We don't know if he ever took a holiday. We know
that he died on October 4, 1669, aged sixty-three years and three months, that
his funeral cost 20 guilders, twice the cost of Titus's funeral the year before, and
that there were sixteen pallbearers. But we do not know which of his fellow artists
were there. His grave in the Westerkerk has never been identified. We don't know
what he died of.

Although there exist many more documents relating to Rembrandt's life than to
Frans Hals's or Jan Vermeer's, various aspects of his career remained unresolved.
It is unclear how much of that magnificent collection of art and art objects was for
himself – a demonstration of success and personal taste – and how much was for
sale – a dealer's gallery; though even that would establish criteria for his taste, since
few dealers buy things they don't have a feeling for. We can set negative limits
of a sort to his swank: as far as we know he didn't own a clock, which wealthy
people throughout Europe were beginning to have (and show off); he didn't keep
a carriage. We shall presumably always have to speculate about what first turned
him to being an artist: whether it was a reaction against the miller's life of his
father, the fame and glory advertised by works of past Leiden painters he saw as
a boy, or the ability to make a living by exercising his talent while at the same
time being able to choose, for subjects, interesting moments from history, which
clearly fascinated him. Perhaps it was an amalgam of all these.

Etching is also a process of negatives and positives – the plate worked on with
wax, needle, acid, varnish, and ink, and the paper pressed against the plate to

make a print. It is an art that involves the artist in looking ahead to see in reverse what will appear on the paper. Corrections are more difficult. You have to sign your name backward so that the signature in the print appears the right way round (once in a while Rembrandt forgot). But the etcher sometimes smoked and thus darkened the wax ground in which he scratched his lines, so that he had a clearer impression of the work he was creating. If I have darkened the plate that is, as it were, "Rembrandt," by holding it over the thick, smoky swirl of his time and place, it is in the hope of showing up more clearly the sparse lines he made.

XXII

Continuing Presences

"I FINALLY FOUND the house in the Breestraat where Rembrandt lived," wrote Vincent van Gogh to his brother Theo in 1877. I have had greater difficulty finding a house that conveyed more vividly than the present Rembrandt House what his domestic conditions must have been like. However, as it turned out, I didn't have far to go. A few hundred yards up the Oude Zijds Voorburgwal from where I am living, past the Oude Kerk, which sits obliquely in a surrounding half-oval of houses on the western side of the canal (the pink-lit prostitutes' windows forming at night a gaudy pink necklace around the old church), there, at Number 40, is a tall house on the canal and two houses on the side alley, all interconnected and jointly known as *Ons' Lieve Heer op Solder*, "Our Lord in the Attic," the name eventually given the clandestine Roman Catholic Church that functioned for more than a century in the combined upper stories of the three houses. Like numerous other Catholics, two of the Syndics of the Cloth Drapers' Guild whom Rembrandt painted – Jacob van Loon and Aernout van der Mye – had "secret" Catholic chapels in their homes. Although Catholic worship was tolerated in private, it wasn't officially allowed to take place in public until 1795, under the French occupation.

The houses and church were built in 1661–1663 by one Jan Hartman and have been a museum open to the public since 1888. A sectional map of the building is provided for visitors but doesn't prevent them from getting pleasantly lost. There are, in fact, usually very few people wandering through the many different levels of the houses, going up and down the inner stairs and narrow passageways, past

little "hanging-rooms," and into surprisingly large spaces, like the high-ceilinged living room, or *sael*, which occupies part of the first floor, over a low, ground-floor kitchen, and under the church. The *sael* is classical, symmetrical, and aristocratic; the sort of elegant room Pieter de Hooch and Jan Vermeer often painted. The walnut mantelpiece is upheld by ornate marble columns; the marble tiles on the floor echo the pattern made by the ceiling beams and recessed panels between them. A cupboard bed is tucked away in a wall behind walnut doors.

Some of the short flights of inner staircase are cleverly carpentered to make use of the available space. One such flight leads to a small living room-cum-bedroom, overlooking the canal – a simple, straightforward room with plain oak door, dark table, chairs and cupboard bed, white-washed plastered walls. I believe I would have thought it right for the "mature" Rembrandt even if there hadn't been an armchair like the one he used to keep near the foot of his bed: with carved arms and legs and leather back and seat stretched between the wooden members. In the back houses are an assortment of little rooms at different levels, antique plumbing arrangements, tongue-and-groove–boarded partitions and inner windows, suggesting a proper mixture of security and privacy. As for the church, which was first called "the Hart," after Jan Hartman, it is astonishingly like a church, with a narrow set of pews under two tiers of balconies and an organ in its own organ loft. One reminder of the inevitable compression of things is the pulpit, which is stored in the altar and can be pulled out for use. Most of the décor and furnishings date from 1735, and although the church is undoubtedly much more done-up than it would have been when first opened, it makes an excellent, calm spot to sit and think.

One way or another I find myself daily here struck by the feeling of a world still affected by Rembrandt – a world in which his life, by way of his work, radiates a constant energy. Buoyed up by this sensation, I have recently been calling on people I met during previous visits to Holland: a young man who was an economics student when I first met him in 1968 is now a business consultant and a member of the Amsterdam City Council; he gives me glimpses of a councilor's point of view on the government of his city, its commercial progress, and its conservation. Dr. Arie Querido, who has now retired from being professor of social medicine at the University of Amsterdam, had talked to me in 1968 about contemporary urban crowdedness and its effect on health, and this time discussed with me Dr. Tulp and matters of social hygiene in the seventeenth century. (Dr. Querido remarked reassuringly, "When you are unable to find out anything to the contrary, you have to conclude that people in the seventeenth century were much the same as we.") And I went, earlier this night in which I am writing, to have dinner with Ton Koot and

his wife. Mr. Koot was for many years secretary of the Rijksmuseum and curator of Muiderslot, P. C. Hooft's little castle just to the east of Amsterdam. During the Second World War he was one of the editors of an underground newspaper, *Vrij Nederland*. He has written numerous books, including a historical guide to Amsterdam and a popular work on *The Night Watch* and its career. In 1957 he introduced my wife and me to the workings of the Rijksmuseum Prentenkabinet, and one afternoon drove us out to Muiderslot, which he was then restoring. There, with him for guide, we got an idea of what it must have been like to be the seventeenth-century seigneur of such a place, with a study in which Hooft sat writing a history of the Netherlands modeled on Tacitus, and a view through the window of the Zuider Zee and perhaps the East Indies fleet sailing home to Amsterdam from the Indies, crammed with silks and spices.

This evening we talked about the Isaac de Pinto house in the St. Anthoniebreestraat (not to be confused with the Daniel Pinto house, which no longer exists), a seventeenth-century town mansion that Mr. Koot, together with a society called the Friends of the Inner City, had helped save; the house has been restored and turned into a public library. So we also talked about the pilings, and moved easily from this expensive subject to money. The "florin," said Mr. Koot, came from Florence, hometown of the once-widespread Italian banking system, whereas "guilder" – which is another name for the same piece of currency – is a good Dutch word. I remembered that the Daniel Pinto house had been raised within by three feet and two thumbs, and Mr. Koot said the Amsterdam thumb was a slightly different unit of measurement from the Rotterdam thumb. His grandfather used to measure things by thumbs – Amsterdam thumb, of course. There have been Koots in Amsterdam for 400 years. His father, in his nineties, was still hale. Mr. Koot told me he was proud to have "an Amsterdam face" – and indeed he has the face of the standard bearer in *The Night Watch:* firm nose, slightly protruding eyes, high cheek bones with a slight hollow beneath them.

I had planned to raise the subject of Rembrandt at dinner so as to harvest any odds and ends Mr. Koot cared to throw my way, but the twentieth century intruded. Mrs. Koot explained as we sat down at table that today was May 4. Tomorrow would be the anniversary of the liberation of the country from the Germans, with celebrations, and tonight just before eight there would be two minutes of silence, when all of the Netherlands took part in an act of remembrance. Mr. Koot had switched on the radio, quietly, and when, during the soup, there was a short announcement and then silence, we went to the bay window of the apartment living room and stood there, looking out over the Stadionweg, a usually busy thoroughfare in south Amsterdam, three floors below. In the windows of many

other apartments we could see people standing as we were. In the street, a solitary person was standing still. A tram had stopped, and several cars – the only ones in sight – had pulled to the curb. Dutch flags were flying at half-staff from the apartment building. There was a faint buzz from the radio, underlining the silence that prevailed all over Holland, where traffic had halted and trains had stopped on their tracks and in the bars and restaurants all was still. Then, the two minutes up, the radio let forth the strains of the "Wilhelmus," national anthem and battle hymn of the struggle William the Silent had led against Spain.

It was a little while before we resumed our meal. Mr. Koot said that each year at this time he was unable to work for three or four days before and after the fourth of May. His mind was full of the war: of adventures in obtaining paper and ink for the illegal newspaper; of listening to the BBC; of getting batteries charged by a windmill, so as to be able to listen to the news from London after the Germans cut off the electricity; of encounters with German officials, and random arrests and reprisals; of friends seen one day and never again; of the all-pervading fear, which was occupation – one's mind was occupied.

This occasion impressed me. Here, I thought, was the right sort of historical memory. The Dutch were not forgetting or letting slip a vital part of their past and of human experience. Each year they made this point of remembering what had happened during the war and honoring the memory of those who had not survived it. And the remembrance was a form of resolution renewed. As it said on the coins minted by the city government of Leiden during the long Spanish siege in 1574, *Haec Libertatis Ergo*, "All this for freedom's sake." I wondered how long the Dutch had retained their memories of the Spanish war, all its horrors and occasional triumphs. Rembrandt was born three years before the trace of 1609. Presumably he grew up with the idea of Spain as the enemy.

Although the late-night trams and buses were still running, I walked back from the Koots' into the center of the city. There is a drab section between the new south and the old city. It is like walking through the moribund nineteenth and late eighteenth centuries before reaching the Prinsengracht – and even there, on the Vijzelstraat, for instance, there are ponderous, gray modern banks and offices. I turned off what would have been the shortest route back to my room and followed a canal to the right, crossed a bridge, went along another canal, and then another, avoiding the brighter shopping streets. Soon, high over the house gables, with their steps and bells and cornices, I could see the spot-lit tower of the Zuiderkerk. Across the Amstel, past where Rembrandt and Saskia had lodged by the sugar bakery, I walked up the Groenburgwal, the old canal where Hendrik de Keyser had lived

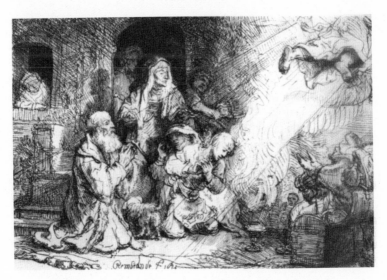

The Angel Leaving Tobias. *Etching, 1641. Courtesy of the Trustees of the British Museum*

in view of his church. As I crossed the St. Anthoniesluis bridge a duck stirred on the canal beneath and flew low along the surface, a blur of wings. I stopped for a moment in front of Number 4 Breestraat, where scaffolding was up for painters to work on the windows and shutters. (Since Anthonie Thijs moved out, the house has never been so well looked after.)

Perhaps the duck's wingbeats were what made me think of Rembrandt's angels. Here is another piece of contrariness that we learn to expect with him! In so many ways he is the first "modern" artist: on his own, with thoughts of his own, taking risks to paint what he wanted to paint. And yet there he was, often drawing, etching, and painting angels. Some of the early ones, like himself, were militant – out to make their mark, in their case by smiting with sword or supernatural wrath, like the winged creature in the 1626 *Angel and the Prophet Balaam*. But many arrive as bearers of good tidings, walk along as companions and guardians, and, when they depart, leave things better than they were. Some have wings very much like swans' wings – an adaptation also followed in Vondel's play *Gijsbrecht van Amstel*, where the Archangel Raphael was let down from heaven (a trap door over the stage) in order to foretell Amsterdam's future greatness. Some have wings that are barely rendered. With angels we are in regions of impossibility and faith, but

those of Rembrandt are not only unobjectionable, they stir old associations. Some have the form of winged victories; others have a homely familiarity – the soles of the feet of the angel in the 1641 etching *The Angel Departing from Tobit* are surely the same as those of the male figure, seen in the etching *Het Ledekant*, making love to a woman. In the Tobit etching, the angel has helped bring about an occasion of joy. Tobias, back home, has followed Raphael's advice and cured his father's blindness. The old man, Tobit, has recovered his sight. He is on his knees, as is Tobias, praising God, while the angel – the effect of his being there registered on the faces of the people looking on – disappears up a shaft of sunlight.

Afterword

THIRTY-SIX years after the publication of *Rembrandt's House* in 1978, I want to note in this new edition of the book several things that require revision or updating – and to remark on a few things that interestingly remain the same. *Het Rembrandthuis*, first opened as a museum in 1911, had a major makeover in 1998–1999. As if to highlight a change of mood the exterior window shutters of the house were repainted a cheerful rose pink on their opened sides and lime green on their closed sides. Display cabinets dating from the early twentieth century were replaced and a long-standing exhibition of Rembrandt's etchings was moved into new quarters right next door. This was within a new metal- and glass-fronted six-story building on the Jodenbreestraat that made a surprisingly effective foil for the seventeenth-century house flanking it that Rembrandt had bought with his wife Saskia in 1639. The new wing also provided room for an auditorium and cinema, shop, library, public conveniences, and elevator, and allowed the main entrance to be moved – from the old front door off the street reached by steep steps into the Rembrandt house – to a lower, ground-floor way-in via the new building. From there the visitor can proceed through a basement and through a doorway in the party wall into the cellar of Rembrandt's house. From the cellar a fairly spacious spiral staircase goes up from the kitchen and through the house, past the old entrance hall, anteroom, salon, the artist's office, his studio, gallery, and cabinet of treasured possessions, into the small studio on the smaller top floor where apprentices worked.

The most recent remodeling of the house gave the museum trustees an opportunity to enhance the impression of it being the home of a prosperous artist of the Dutch golden age. By way of the plenitude of art and objects Rembrandt spent so much on that are displayed within, it suggests some of the factors that caused his money problems. Moreover, the costs of keeping up his house were mounting; he couldn't afford to make his mortgage payments; the neighborhood was going downhill; the wars with England were disrupting Dutch trade; and markets,

including the art market, had tumbled. He eventually had to sell up and move from the wide street of the Jews to more circumscribed and down-at-heel quarters in the Rozengracht. Nowadays some 200,000 people a year visit the Rembrandt house. They see some of the old pottery excavated from the house's cesspit including two earthenware pots, one containing dried lead white, the other chalk and glue mixed ready for priming. The visitors peek into cupboard beds, closely examine the kitchen stove and etching press, and watch demonstrations with copper plates, rollers, and etching needles – the inky hands, nitty-gritty of real artistic work. Rembrandt's 1656 insolvency record gave the recent restorers much evidence for what art objects and pieces of furniture were needed in the house. The temptation is considerable to actually get into a cupboard bed, close the doors to keep in the warming pan's warmth, and test the eiderdown and mattresses.

Rembrandt's neighborhood has gone on changing. Modern office blocks line the far side of the Breestraat. The Second World War more than decimated the formerly strong Jewish population of the district. The next-door corner house that Daniel Pinto bought in 1645, whose remodeling seems to have given acute concern to his neighbor Rembrandt, has gone upmarket, no longer as in 1978 a caftan and denim emporium but now a chic bistro. The well-known flea market still flourishes in the Waterlooplein behind the house, but many of the goods on sale there seem to be discounted new items rather than flavorful second-hand. The artist himself, whose residence and workplace this was, has in the meantime had his character tweaked and tugged. He has been seen as a forceful marketing man by the art historian Svetlana Alpers while Gary Schwartz, the most prolific current writer about Rembrandt, has raised doubts about the artist's character, seeing in Rembrandt's "conflicted family life and troubled financial affairs" and in particular his relationship with his servant Geertje Dircx, evidence of "sneaky and sometimes cruel behaviour." Geniuses are notoriously hard to live with, and Rembrandt was no exception.

In these last decades an increasingly thorough examination of his work and the ramifications of it has been going on. This process has only increased our sense of his artistic stature. The man whom the classicist painter Gérard de Lairesse at one point called "the greatest painter of his time and still unsurpassed" continues to be both of those things. However, in the last 40 years, attempts have been made to cut him down to size. His oeuvre has been ransacked and proposals made to throw out various works judged not up to his highest standards. Doubts as to the genuineness of attributions of many paintings to him have arisen, particularly from the small body of experts that formed the Rembrandt Research Project. This group of men (all men) yoked together their skills as connoisseurs to produce a definitive catalogue or *Corpus* of his paintings, giving committee-sanctioned verdicts of Yes or No to one work at a time. Yet after several costly volumes of the *Corpus* had been published, it became clear that this task was an impossible one. More shades

of doubt, more "maybe's" were needed, more awareness that Rembrandt had many ways of painting a picture, and often had plenty of Monday mornings – not everything from his brush was a masterpiece, and some had had studio assistance.

The members of the Project have dropped away, and the last man standing is Ernst van de Wetering. Van de Wetering has gone from being a research assistant with the Project to being its chairman since 1993. He has inherited the job of producing the final volume of the *Corpus* on his own but gives every sign of making a fresh approach to the task. On several recent occasions he has come down in favor of inclusivity rather than exclusion, deciding for instance that a seventeenth-century portrait hanging in an old abbey in Devon was not a pupil's work, as had been thought, but was a self-portrait by the master at the age of 29.

Van de Wetering is the foremost living Rembrandt scholar. A big teddy bear of a man, he is not only an art historian but a practicing artist, with a hands-on knowledge of pigments, panels, and canvases. His book *Rembrandt: The Painter at Work* (Amsterdam, 1997) should be the book first looked at in any up-to-date bibliography of Rembrandt studies. In it van de Wetering provides much detail about Rembrandt's working habits and portrays the artist as an original explorer in the field of painting technique. Van de Wetering has analyzed the grounds Rembrandt employed, often a chalk and glue priming covered with a thin light-brown coat of oil paint. However, sometimes the master used the nearest substance to hand, the residue of oils and dirty colors from a container in which he left his brushes lying to soak. Rembrandt began by painting on ready-made oak panels and only in 1631, when he was 25, did he begin to paint on canvas. He started as what was then called a "fine painter," sitting at his easel with a small palette, but by the end was painting in a much rougher manner. According to Arnold Houbraken's biographical work on seventeenth-century Dutch artists, *De Groote Schouburgh*. Rembrandt in his later period applied his paints as though smearing them on with a bricklayer's trowel. Van de Wetering elsewhere describes the painter's brushwork as paint plastered on as though with a shaving brush. One defining characteristic of his technique was the use of "the blunt end of the brush to articulate locks of hair." Although he had apparently explored "the inherent possibilities and limitations of each pigment" he used, Rembrandt worked directly on his pictures without the aid of prior drawn studies, improving his paintings while inventing in the process, often leaving *pentimenti*, signs of mistakes he had corrected, and evidence of experiments he had made to produce the effect of various textures, heightenings, and marks of spontaneity with which he had grasped an image. He left many indications of the random strokes and loose brushwork he had used to render the person, scene, or event he was depicting. He had ways of leaving parts of his picture in focus and parts out of focus, and so gave the imagination of the viewer a role in involving itself in the process of bringing the intended image into mind.

The Rembrandt Research Project's intended last volume did not appear. Van de Wetering is now winding up the Project and while doing so attempting to frame a less abrasive way of determining Yes or No, In or Out. As of 2011, 240 works had been described and accepted as genuine; another 80 await probable acceptance, van de Wetering believes. Some pictures remain doubtful, like the striking *Man with the Golden Helmet* in Berlin, now considered to be "from the Circle of Rembrandt." A long tussle over the Frick Collection's *Polish Rider*, thought by the Rembrandt Research Project's previous chairman Joshua Bruyn to be by the little-known seventeenth-century Dutch painter Willem Drost, caused anguish among many scholars and admirers of Rembrandt who believed it to be by him, not Drost. This controversy[*] has been resolved by van de Wetering who believes *The Polish Rider* is by Rembrandt, albeit possibly unfinished and with later additions. Van de Wetering is now putting together a final fifth volume of the *Corpus*, summarizing the Project's findings on the 80 as yet uncatalogued works, and illustrating the 320 he believes to be authentic Rembrandts. These include a few pictures van de Wetering has recently taken on board and thereby – swing of the pendulum! – provoked a few critics to complain about what they now see as the Project's excessive inclusivity.

I prefer inclusion to exclusion. I am with those who favor the presence of doubt and Monday mornings, the existence of imperfections and revisions, and believe that Rembrandt was an experimenter and hard-to-pin-down artist. I like the hand Ernst van de Wetering holds out to wider possibilities than those suggested by traditional connoisseurship. One factor in this worth continual consideration is Rembrandt's grasp of human emotions, praised by Goethe, and left out of the range of identifying Rembrandtian characteristics at one's peril. Many art historians have shied away from this; the word "feeling" causes some scholars to start shuddering. But van de Wetering, on the contrary, seems happy to discuss emotions and the "mirror neurons" involved in our bodily responses to Rembrandt's work. He considers the similarity of those sensations to those we feel when absorbed in "really good poetry." He is moved by Rembrandt's brushwork in what he admits is a mysterious way and – trying to define it – writes: "When we are looking at spontaneity or at its traces, we seem to enjoy the experience of the artists' movements, and, as it were, taste their spontaneity or freedom." He also declines to join with several scholars who have taken up the modish view of Rembrandt as a man utterly beholden to market forces. Of course Rembrandt painted to make a living, a very healthy living at first, but as time went on his income shrank. Even so his choice of subjects remained largely his own, whether portraits of himself, of devoted patrons, or of characters from the Bible. "He painted for painting, not for money," says van de Wetering.

[*] Examined by the present author in his book *Responses to Rembrandt*, New York, 1994.

Bibliography

I am conscious that some bibliographies seem pretentious, but the following list is meant to indicate my indebtedness, sometimes for a single fact, sometimes for several ideas. Moreover, I have enjoyed and found useful bibliographies in other books, for example that of the indispensable Rosenberg, Slive, and ter Kuile *Dutch Art and Architecture: 1600–1800*. Their extensive bibliography should be consulted for many sources and contemporary documents and works – which I have not listed below – by Orlers, Huygens, Sandrart, de Piles, and Houbraken.

Rembrandt

Benesch, Otto. *Collected Writings*, Vol. 1: *Rembrandt*. London, 1970.
————. *Rembrandt as a Draughtsman*. London, 1960.
Bailey, Anthony. *Responses to Rembrandt*, New York, 1994.
von Bode, Wilhem, and Hofstede de Groot, C. *The Complete Work of Rembrandt*. Eight vols. Paris, 1897–1906. (Volume 8 includes an English translation of *Die Urkunden uber Rembrandt*, published in Dutch in The Hague, 1906.)
Boon, K.G. *Rembrandt, The Complete Etchings*. London, 1963.
Bruyn, Josua, Haak, B., Levie, S. H., van Thiel, P. J. J., van de Wetering E., *A Corpus of Rembrandt Paintings* (5 vols.). Vols I, II, and III, Amsterdam, 1982, 1986, 1989; ed. Ernst van de Wetering, Vols IV and V, Dordrecht, 2005, 2011.
Clark, Kenneth. *Rembrandt and the Italian Renaissance*. New York, 1968 (includes a translation of the inventory of 1656).
Fromentin, Eugéne. *Masters of Past Time*. London, 1948.
Fry, Roger. *Transformations*. New York, 1926.
Fuchs, R. H. *Rembrandt in Amsterdam*. Greenwich, Connecticut, 1969.
Gerson, Horst. *Rembrandt Paintings*. London, 1968.

Haak, Bob. *Rembrandt, His Life, Work and Times*. London, 1968.

Heckscher, W. S. *Rembrandt's Anatomy of Dr. Nicolaes Tulp*. New York, 1958.

Held, Julius S. *Rembrandt's Aristotle and Other Rembrandt Studies*. Princeton, 1969.

Kok, J. P. Filedt. *Rembrandt Etchings and Drawings in the Rembrandt House*. Maarsen, 1972.

Knuttel Wzn., G. *Rembrandt*. Amsterdam, 1956.

Landsberger, Franz. *Rembrandt, the Jews, and the Bible*. Philadelphia, 1946.

Lugt, Frits. *Wandelingen met Rembrandt in en om Amsterdam*. Amsterdam, 1915.

Rosenberg, Jakob. *Rembrandt* (revised edition). London, 1964.

Rosenberg, Jakob, Slive, Seymour, and ter Kuile, E. H. *Dutch Art and Architecture: 1600–1800*. Harmondsworth, 1966.

Schwartz, Gary. *Rembrandt's Universe*. London & New York, 2006.

Slive, Seymour. *Drawings of Rembrandt*. Two volumes. New York, 1965.

————. *Rembrandt and His Critics*. The Hague, 1953.

Valentiner, W. R. *Rembrandt and Spinoza*. London, 1957.

Visser, t'Hooft, W. A. *Rembrandt and the Gospel*. New York, 1960.

de Vries, A. B. *Rembrandt*. Baarn, 1956.

van de Waal, Henri. *Steps Toward Rembrandt*. Amsterdam, 1974.

van de Wetering, Ernst. *Rembrandt: The Painter at Work*. Amsterdam, 1997.

White, Christopher. *Rembrandt and His World*. London, 1964. (Dutch edition, with notes by H. F. Wijnman, The Hague, 1964.)

The Seventeenth Century

Barbour, Violet. *Capitalism in Amsterdam in the Seventeenth Century*. Ann Arbor, Michigan, 1963.

Barnouw, Adriaan J. *Monthly Letters*. Assen, 1969.

————. *Vondel*. New York and London, 1925.

Baron, Salo W. *Social and Religious History of the Jews*, Vol. XIV. New York, 1973.

Blok, P. J. *History of the People of the Netherlands*. London, 1898–1912.

Bloom, H. I. *Economic Activities of the Jews in Amsterdam in the Seventeenth and Eighteenth Centuries*. Williamsport, Pennsylvania, 1937.

Blunt, Wilfrid. *Tulipomania*. Harmondsworth, 1950.

Boxer, C. R. *The Anglo-Dutch Wars of the Seventeenth Century*. London, 1974.

————. *The Dutch Seaborne Empire*. London, 1965.

Burke, Peter. *Venice and Amsterdam*. London, 1974.

————. *The New Cambridge Modern History*, Vol. V. Cambridge, 1961.

Carter, Alice Clare. *The English Reformed Church in Amsterdam in the Seventeenth Century*. Amsterdam, 1964.

Clark, G. N. *The Seventeenth Century*. Oxford, 1929.

Dobell, Clifford. *Anthony van Leeuwenhoek and His "Little Animals."* London, 1932.

Evelyn, John. *Diary*. Edited by E. S. de Beer. Oxford, 1959.

Fremantle, Katharine. *The Baroque Town Hall of Amsterdam*. Utrecht, 1959.

Friedrich, Carl J. *The Age of the Baroque*. New York, 1952.

Gans, Mozes Heiman. *Memorboek*. Baarn, 1971.

van Gelder, H. Enno. *De Nederlandse Munten*. Utrecht, n.d.

Geyl, Pieter. *The Netherlands in the Seventeenth Century*. Two vols. New York, 1961–64.

Hampshire, Stuart. *Spinoza*. London, 1956.

Huizinga, J. H. *Dutch Civilisation in the Seventeenth Century and Other Essays*. London, 1968.

Koeman, C. *Joan Blaeu and His Grand Atlas*. London and Amsterdam, 1970.

Murray, J. *Amsterdam in the Age of Rembrandt*. Norman, Oklahoma, 1967.

Nonnekes, P., and d'Ailly, A. E. *Guide to Amsterdam and Its Surroundings*. Amsterdam, 1956.

Pevsner, Nikolaus. *Academies of Art*. Cambridge, 1940.

Praz, Mario. *Studies in Seventeenth-Century Imagery*. Rome, 1964.

Price, J. L. *Culture and Society in the Dutch Republic*. London, 1974.

Rasmussen, Steen. *Experiencing Architecture*. London, 1959.

Ray, John. *Travels through the Low Countries*. London, 1738.

Renier, G. *The Dutch Nation*. London, 1944.

Salomon, H. P. *The De Pinto Manuscript*. Assen, 1975.

Temple, Sir William. *Observations upon the United Provinces*. London, 1673.

Vere, Francis. *Salt in Their Blood: The Lives of the Famous Dutch Admirals*. London, 1955.

Vlekke, B. H. M. *Evolution of the Dutch Nation*. New York, 1945.

Wijnman, H. F. *Historische Gids van Amsterdam*. Amsterdam, 1971.

Willey, Basil. *The Seventeenth-Century Background*. Cambridge, 1934.

Wilson, Charles. *Holland and Britain*. London, n.d.

Zumthor, Paul. *Daily Life in Rembrandt's Holland*. New York, 1963.

Journals and Catalogs

Art in Seventeenth-Century Holland. Catalogue to the London National Gallery exhibition, 1976.

Bouwen in Amsterdam. Pamphlet series published by *Vrienden van de Amsterdamse Binnenstad*. Amsterdam, 1973–1975.

Bulletin van de Koninklijke Nederlandse Oudheidkundige Bond. Article by R. Meischke on the Rembrandt house, 1966, p. 143.

Burlington Magazine. Articles by W. Martin on the methods of Dutch artists. Vols. VII, VIII, and X, 1905–1907. London.

Delta, Review of Arts, Life and Thought in the Netherlands. Summer 1969 issue, devoted to Rembrandt.

Dutch Pictures from the Royal Collection. Catalogue to the exhibition at the Queen's Gallery, Buckingham Palace, London, 1971–1972.

Gazette des Beaux Arts. Articles by J.-F. Backer on Rembrandt's financial troubles, Vols. IX–X, 1924–1925. Paris.

Jaarboek Amstelodamum. Articles by R. Meischke on the Rembrandt House, Vol. XLVIII, 1956; and by I. H. van Eeghen on the St. Lucas Guild. Vol. LXI, 1969.

Konstam, Nigel. Introduction to the exhibition at Imperial College, London, 1976.

De Kroniek van het Rembrandthuis. Various issues.

Kroniek van het Rembrandthuis. Various issues.

Maandblad Amstelodamum. Article by I. H. van Eeghen on Rembrandt's residences during his first years in Amsterdam: Vol. XLVI, 1959.

Oud-Holland. Articles at various dates by Jan Białostocki on The Polish Rider; by R. W. Scheller on Rembrandt's collection; by Arie Querido on Dr. Tulp's Anatomy Lesson; and by A. M. Vaz Dias on Rembrandt's quarrel with Daniel Pinto.

The Orange and the Rose. Art Council catalogue to the exhibition at the Victoria and Albert Museum. London, 1964.

Print Collectors' Quarterly. Article by Frits Lugt on Rembrandt's Amsterdam, Vol. V, 1915. Boston.

Rembrandt: a Genius amd his Impact ed. Albert Blankert Melbourne. Australia.

Rembrandt 1669/1969. Catalogue to the exhibition at the Rijksmuseum. Amsterdam, 1969.

Studia Rosenthalia: Journal for Jewish Literature and History in the Netherlands. Various articles by H. F. Wijnman, I. H. van Eeghen, and H. P. Salomon. Amsterdam.

La Vie en Hollande au XVIIe Siècle. Catalogue to the exhibition at the Musée des Arts Décoratifs, Paris, 1967.

Index